PICTURING
RESISTANCE

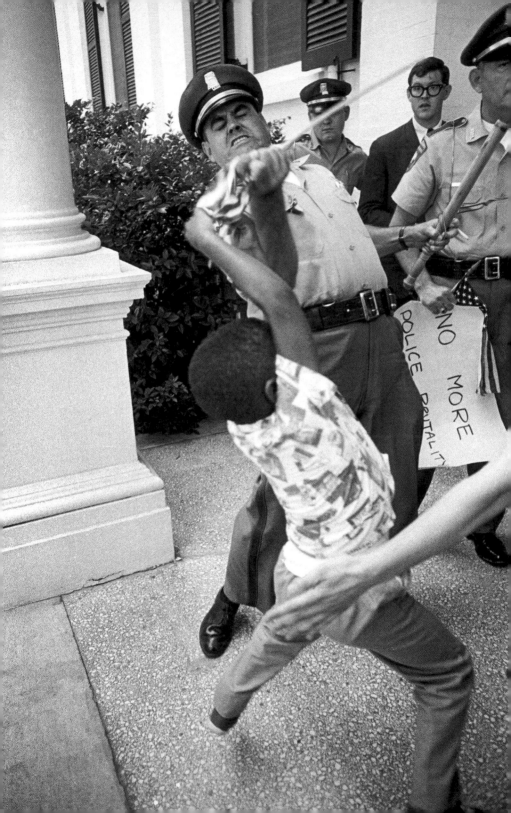

MELANIE LIGHT AND KEN LIGHT

PICTURING RESISTANCE

Moments and Movements of Social Change from the 1950s to Today

TEN SPEED PRESS
California | New York

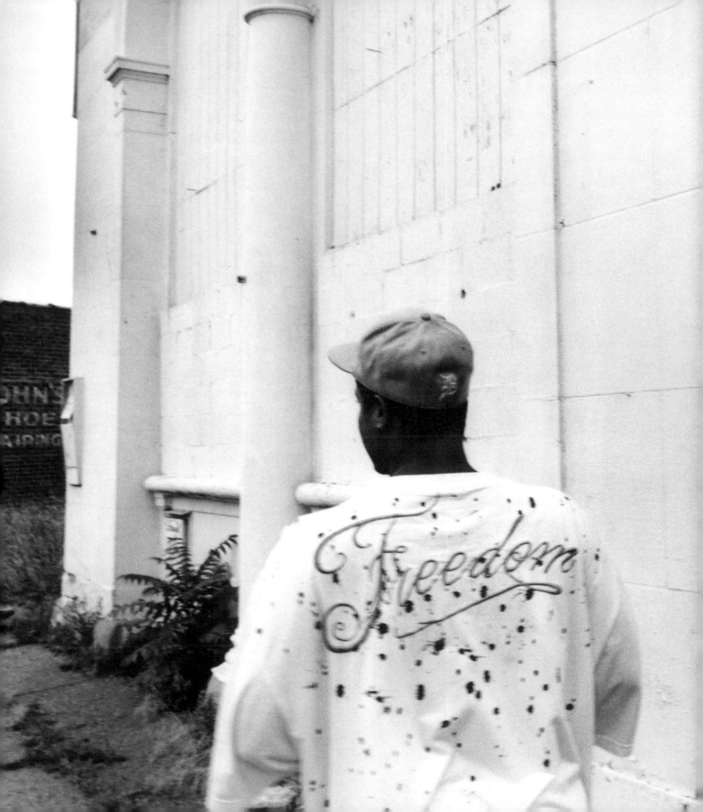

CONTENTS

INTRODUCTION 1

CHAPTER 1 **1954–1964** 5
A VISION TAKES HOLD

CHAPTER 2 **1965–1974** 29
YOUTH RISING

CHAPTER 3 **1975–1980** 99
EXHAUSTION AND BACKLASH

CHAPTER 4 **1986–1992** 121
IT'S ALL ABOUT THE ECONOMY

CHAPTER 5 **1994–2010** 149
A NEW ERA IN ACTIVISM

CHAPTER 6 **2011–2019** 181
ACTIVISM IN A TIME OF
REPRESSION AND UPHEAVAL

ACKNOWLEDGMENTS 212

ABOUT THE AUTHORS 213

BIBLIOGRAPHY 214

INDEX 229

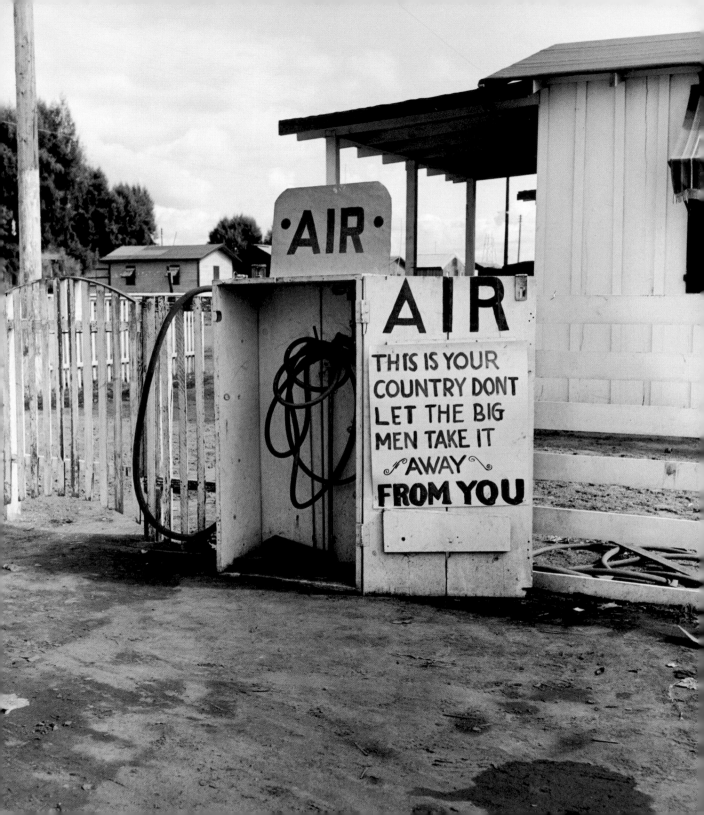

Resistance is the lifeblood of America.

Protesters—chanting in crowds of fifty thousand or hundreds of thousands for justice, freedom, or redress—know this. When individuals gather for the higher good of our national community, there is a feeling of being deeply alive and deeply connected across all divides. When hundreds of Black and white people link arms for the first time in public, or you look out over a sea of pink pussy hats, the possibility that all people can live in peace and tolerance becomes real, if only for a moment.

America has boldly declared that government should serve its people, that all are created equal, and that people have inalienable rights, among them being "life, liberty, and the pursuit of happiness." These words are enshrined in the Declaration of Independence, which declared independence not only from England but also from the destructive characteristics of human nature that foster tyranny, fear, prejudice, and oppression. Those words emerged after years of protest and resistance during colonial times.

This credo is not a set of operating instructions, though. It offers guideposts for the work of citizenship. Indeed, we have considerably broadened the interpretation since the 1776 drafting. The Founding Fathers principally had themselves in mind: powerful, white, landowning men. Some owned slaves. White men without land could not vote. Their wives had no rights at all, and they thought nothing of taking the indigenous people's land for their new country's benefit.

It was clear, even then, that there was much work to do to create "a more perfect union." Right after the Declaration was signed, British abolitionist Thomas Day wrote "If there be an object truly ridiculous in nature, it is an American patriot, signing resolutions of independency with the one hand, and with the other brandishing a whip over his affrighted slaves."

This desire to fully realize the American experience is at the root of the resistance and protest movements that have shaped, moved, and stunned the world. For over two centuries, millions of women, poor people, immigrants, African Americans, Native Americans, and nonwhite people living in America have devoted their lives to ensuring the full range of liberties guaranteed in that precious founding document. They've marched and chanted; they've testified and organized. They've held sit-ins, led boycotts, gone underground, and leveraged technologies to their advantage. They've risked their lives and been beaten, harassed, imprisoned, and killed. Some lived to see their efforts bear fruit. Many did not.

Every social justice struggle takes much longer than expected to effect positive change. Social norms must catch up with the visionaries; the organic nature of grassroots organizing and the leadership must be effective over time. That righteous rage against the desecration of truths you have learned must give you the courage

and solidarity to fight for your rights over the course of time. If a country's consciousness is ready, you can get a law passed. A law gives you a tiny ledge on which to build ideas into mainstream acceptance and practice. To get there, many people must stand up and speak out persistently, often at significant personal cost, to chip away at the barriers to equality: prejudice, denial, and hatred. It can take generations. This is what Dr. King meant when he said, "The arc of the moral universe is long, but it bends toward justice."

The collective bond created by surviving the tribulations of resistance is what motivates activists and protestors to keep taking risks. Civil rights activist Bob Moses describes being jailed with twelve others in subhuman conditions during the Freedom Rides to register voters in the South: "Later, Hollis [Watkins] will lead out with a clear tenor into a freedom song. [Robert] Talbert and [Ike] Lewis will supply jokes, and [Chuck] McDew will discourse on the history of the black man and the Jew." And these true believer communities operate on trust. The hundreds of thousands of protesters who flocked to Washington, DC, to protest the Vietnam War over the years arrived with no place to stay, and local protesters and fellow travelers took them in. The power of a movement is a kind of magic that people remember for the rest of their lives. Grandparents have saved their buttons and posters; if persuaded to bring them out, they will tell of some of the most cherished moments in their lives.

A movement unleashes creativity and ingenuity. Over the years, the means of calling people together to fight for justice has changed. The civil rights movement started with plain signage; as it branched out into the Free Speech, feminist, anti-war, and other corollary movements, protest materials exploded with color and design. Street theater used delightful props and costumes. We've gone from broadsides, to mimeographed handouts, to Instagram. The actions are innovative and powerful, always springing from the primal call to unite for a higher purpose.

This book celebrates the path of resisters in America in the modern era. It begins with the Supreme Court case *Brown v. Board of Education of Topeka* and the civil rights movement that followed, setting the tone and inspiring the decades of activism to come. The tumultuous sixties gave way to the seventies, the backlash of the eighties and early nineties, and the digital revolution and rapid globalization of the twenty-first century. Each photograph tells a story. Some are iconic images taken at watershed events in big movements; others illustrate smaller but no less important moments.

The images show every phase of resistance, suggesting a paradox: consistent and disciplined organizing coupled with the emotional outburst of people moved to their core. The marches, actions, and movements depicted in these images stem from years of work by people with clear, unstoppable vision. And at every protest, march, or vigil, the visual journalists and independent photographers are there. Photographers bring the voice of the people to the insulated offices of government and persuade calcified communities to shed their outmoded ways of thinking. The long hard work of social change agents is nothing without the visual record. If a protest is not recorded or shared, it cannot be effective, falling prone to being forgotten or suppressed.

The mother of modern social movement photography is Dorothea Lange. She left her comfortable portrait studio in San Francisco to document people's suffering during the Great Depression. Her work endures as one of the most effective

campaigns ever to persuade an insensitive Congress to legislate aid to those suffering.

Digital photography, smartphones, and social media have changed how events are documented. Photographs look and feel very different across the decades. Before the internet, photographers would create whole stories for the cultural gatekeepers of underground newspapers, newsletters, and posters. Some images made it into mainstream media, too. Though from a limited point of view, the upside of that era is that there are historical repositories of images.

Today, photographers want a single shot that can be quickly loaded onto a digital platform to grab attention. Formal composition considerations and the idea of a narrative comprising a collection of images often fall by the wayside. Once shared, an image can be lost or forgotten among a million others. The message might be more about the photographer's experience at an event: "I was there" rather than "Protesters want this change." With so many more people on the scene, all sharing billions of photographs across a vast platform, it can be difficult to find usable images of recent activism.

Even so, photojournalists, documentarians, and independent photographers of social movements have built a record of the people's voice over time, which illustrates a measure of our progress. The early good work of LGBTQ+ and AIDS activists created more inclusion and acceptance, yet the existence of the Black Lives Matter movement today is an embarrassing indicator that we have not yet done the deeper work to understand and remedy our cultural racism.

Celebrate with us that dance, both glorious and fierce, between politicians and people—both conservatives and progressives—that moves our society toward a higher consciousness. The images here work to unite people across the decades, so resisters today can viscerally grasp the historic value of their efforts, inspired by each other's vision of a safe, just, and prosperous life, country, and world.

We hope you find your place among these stories. Those who march, demonstrate, and agitate in the twenty-first century are part of a long legacy of uprising and resistance.

It is in our blood.

—Melanie Light

CHAPTER 1

A VISION TAKES HOLD

The American civil rights movement was arguably the most important and successful nonviolent grassroots effort in modern times. Its nonviolent but confrontational resistance strategies and modeling of effective coalition-building and grassroots volunteer recruitment still influence contemporary movement leaders, from Black Lives Matter to #MeToo to the Fight for $15.

Centuries of Black-led resistance had paved the way leading to the Civil Rights Amendment: eighteenth-century slave revolts; the Underground Railroad; abolition and suffrage; Reconstruction; anti-lynching crusades; the founding of women's clubs, Black-led unions, and organizations like the NAACP; the Harlem Renaissance; and desegregation of the military.

Many mark the beginning of the modern civil rights movement with *Brown v. Board of Education of Topeka*, the 1954 class-action lawsuit that found racial segregation in schools unconstitutional, overturning the "separate but equal" *Plessy v. Ferguson* decision of 1896. *Brown* spurred more legal challenges to segregation and opportunities for Black communities to mobilize and engage in boycotts, walkouts, sit-ins, and marches.

The brutal murder of Emmett Till—and the bravery of his mother—gained national attention and outrage as photographs from his funeral appeared in *Jet* magazine and other African American publications. Soon activists in Montgomery, Alabama, were engaged in the Montgomery bus boycott, and the young Dr. Martin Luther King, Jr. emerged as an influential leader. New regional organizations like the Southern Christian Leadership Conference (SCLC) built on the boycott's success, and the civil rights movement focused on ending segregation, increasing Black voter registration, and passing comprehensive civil rights legislation.

Dr. King acknowledged the critical importance of photojournalism in a 1961 letter: "The world seldom believes the horror stories of history until they are documented via the mass media." Many white Americans outside the South could not deny the relentless brutality of segregation and life under Jim Crow.

Journalists and young photographers who volunteered for organizations like the Student Nonviolence Coordinating Committee (SNCC) documented Black life under Jim Crow brutality. Their powerful black-and-white images captured everyday inequalities—signs labeling segregated facilities and back entrances to public buildings—as well as the barbaric violence inflicted on Black citizens. From Emmett Till's mutilated corpse, to Black schoolchildren being spat on, to peaceful protesters being attacked by police dogs, these photographs forced Americans to see what was *really* going on.

By the early sixties, other resistance movements emerged; civil rights activists—especially college students—joined the antinuclear movement, the Free Speech Movement (FSM), and the women's rights movement. The civil rights movement's nonviolent training and tactics, combined with growing distrust in the government, fueled a decade of unprecedented unrest and resistance.

©Danny Lyon/Magnum Photos, 1963

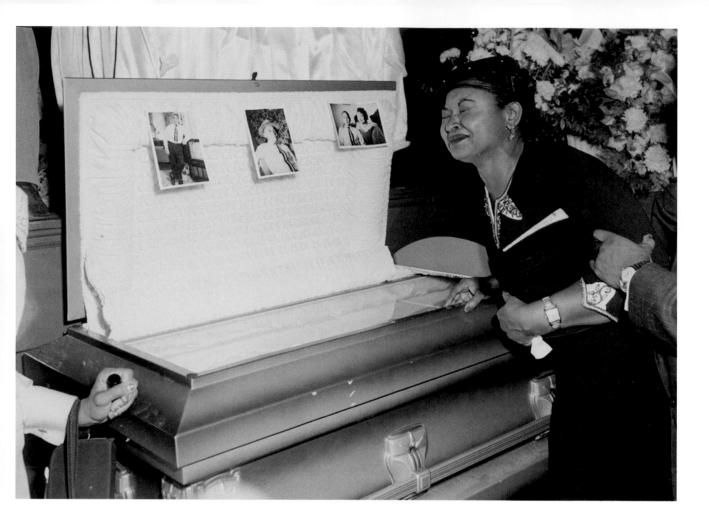

In 1955, Mamie Till-Mobley heard the news that changed her life—and the course of the civil rights movement. Her only child, fourteen-year-old Emmett, had been brutally murdered while visiting family in Money, Mississippi. He'd been accused of whistling at a white woman. In an act of racist vigilantism, Emmett was kidnapped, tortured, shot, wrapped in barbed wire, attached to a seventy-five-pound fan, and thrown into the Tallahatchie River.

Mrs. Till-Mobley insisted that her son's body be sent home to Chicago. After viewing his mutilated corpse, she insisted on an open-casket funeral and contacted the press to publish images of Emmett's body. She wanted the world to see what the scourge of racism had done to her baby.

Over fifty thousand people attended Emmett's funeral on the South Side of Chicago. Under the headline "Negro Boy Killed for Wolf Whistle," *Jet* ran multiple photos, including explicit images of Emmett's mangled corpse. These horrific images shocked the nation, stirred the hearts and minds of the Black community, and launched a wave of civil disobedience and activism that propelled the civil rights movement forward. Rosa Parks later told Till-Mobley that Emmett's face was foremost in her mind when she stayed at the front of the bus.

©Associated Press Photo/*Chicago-Sun Times*

Mamie Till-Mobley, mother of Emmett Till, pauses at her son's casket at a Chicago funeral home, September 3, 1955, Chicago, Illinois.

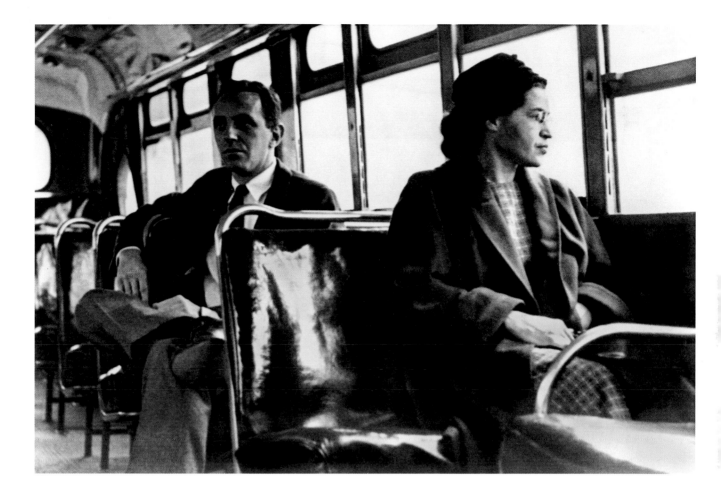

This photo is a recreation of that fateful moment on December 1, 1955, when civil rights activist Rosa Parks refused to move to the back of a segregated public bus in Montgomery, Alabama. It was taken on December 21, 1956, one day after the Supreme Court ruled that Montgomery's segregated bus system was illegal. The man behind Parks is reporter Nicholas Criss.

Parks was not the first Black woman to refuse to give up her seat: in March of 1955, fifteen-year-old Claudette Colvin was arrested on a bus in Montgomery, and in October, eighteen-year-old Mary Louise Smith. But Parks's case gained national notice.

Following her arrest, the Women's Political Council, led by Jo Ann Robinson, called for "grown-ups and children" to stay off the buses on Monday. Local civil rights leaders—including Dr. King and Ralph Abernathy—decided to officially launch the Montgomery bus boycott, a mass coordinated effort that lasted 381 days.

The homes of Dr. King and civil rights leader Ed Nixon were bombed and over eighty boycott leaders were charged with conspiracy, but the boycott persisted. Finally, the Supreme Court struck down laws requiring segregated seating on buses, a great victory that spurred people to fight other discriminatory practices.

Rosa Parks on the bus, Montgomery, Alabama, 1955.

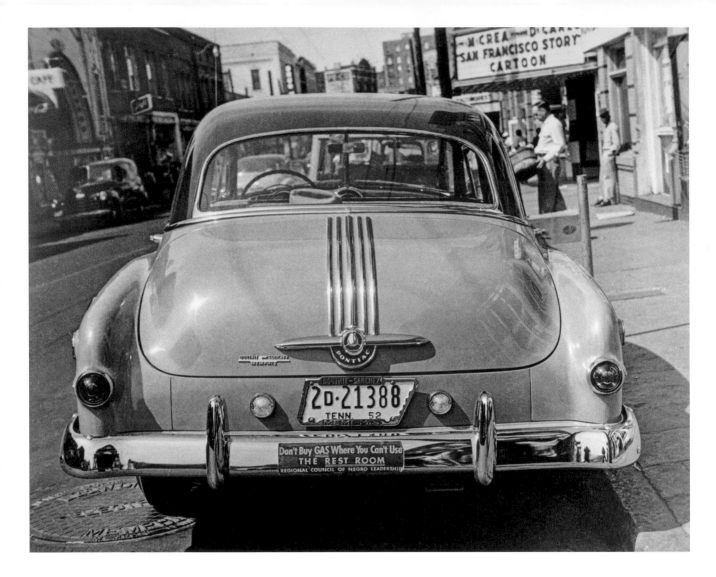

This bumper sticker was part of a campaign to boycott service stations in Mississippi that did not provide restrooms for Black people. The campaign was developed by the Regional Council of Negro Leadership, an early civil rights organization led by entrepreneur T.R.M. Howard.

One of the key organizers of this boycott was Medgar Evers, a young World War II vet and recent college graduate who was an employee and protégé of T.R.M. Howard. Evers distributed over twenty thousand stickers, encouraging folks to take their much-needed business elsewhere if there were no restrooms for Black people at gas stations. The boycott proved effective when many service stations began installing separate bathrooms. The campaign was a bold and important step toward the larger coordinated civil rights boycotts that would follow.

Evers served as a major player in the civil rights movement until his assassination by white supremacists in 1963. He fought to desegregate the University of Mississippi, investigated the murder of Emmett Till, and organized numerous voter registration drives as the first field secretary for the Mississippi chapter of the NAACP.

Bumper sticker campaign organized by the Regional Council of Negro Leadership, Mound Bayou, Mississippi, 1952.

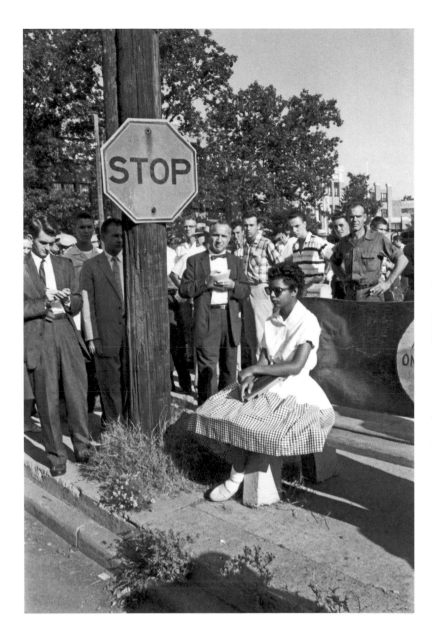

Elizabeth Eckford sitting at a bus stop in Little Rock, Arkansas, 1957.

Fifteen-year-old Elizabeth Eckford became one of the "Little Rock Nine," chosen by the NAACP to be the first Black students to desegregate the all-white Central High School in Little Rock, Arkansas.

Local clergy were to escort the students, but Eckford never learned of the plan because her family didn't have a phone. Arriving alone, she was met by an angry mob of shouting white people and armed guards who blocked her entry. Pro-segregation governor Orval Faubus had called in the Arkansas National Guard to "preserve the peace" by preventing the nine Black students from entering the school. Eckford made her way to a bus stop, where journalists surrounded her to shield her from the mob—a subtle but powerful act of resistance. Three weeks later, President Eisenhower finally intervened by sending federal troops to protect them.

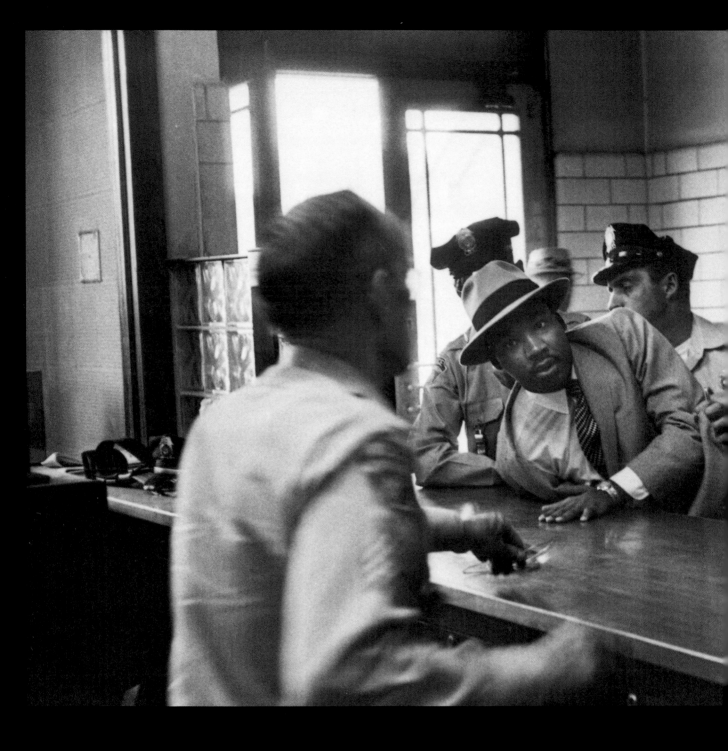

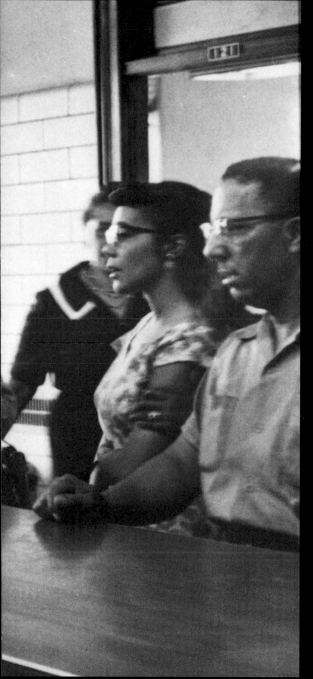

Dr. Martin Luther King, Jr. went to the courthouse in Montgomery, Alabama, to support his closest friend, civil rights leader Ralph Abernathy. Upon entering the courthouse, Dr. King was stopped and arrested by police, his arms twisted and restrained behind his back. This photo of Dr. King's mistreatment appeared in newspapers across the nation, outraging both Black and white Americans.

Dr. King was arrested and imprisoned twenty-nine times for his strategy of civil disobedience and nonviolent resistance. After his indictment during the Montgomery bus boycott, where he paid $1,000 in fines, Dr. King had declared that he would never again pay for crimes he did not commit. For this arrest, he chose to accept the jail sentence of two full weeks, telling the judge he would serve only because of his "love for America and the sublime principles of liberty and equality upon which she is founded." This arrest marked a shift for Dr. King, moving him toward a more radical stance.

His leadership and commitment to the struggle for racial equality awakened

This image of an unknown man emerging from the "White Men Only" courthouse bathroom speaks volumes. Black people throughout the segregated South committed these brave acts of quiet resistance to Jim Crow laws. If discovered, they could have suffered severe punishment in the form of beatings or lynchings.

During the Freedom Summer of 1963, the Congress on Racial Equality (CORE) organized voter registration drives in the parishes north of Baton Rouge, Louisiana, where large populations of unregistered rural Black folks lived. College students traveled south to help urge rural Black families and the elderly to register to vote, accompanying them through the registration process.

This effort to empower Black American citizens by reclaiming their right to vote was central to desegregating the South and making the Jim Crow laws illegal. It took many years and many activists like the man pictured here to finally overturn these laws and unravel the legal system of segregation in both the North and the South with the *Brown v. Board of Education* case, the Civil Rights Act of 1964 and 1968, and the Voting Rights Act of 1965.

©Bob Adelman Estate

Segregated restrooms in the parish courthouse, Clinton, East Feliciana, Louisiana, 1963.

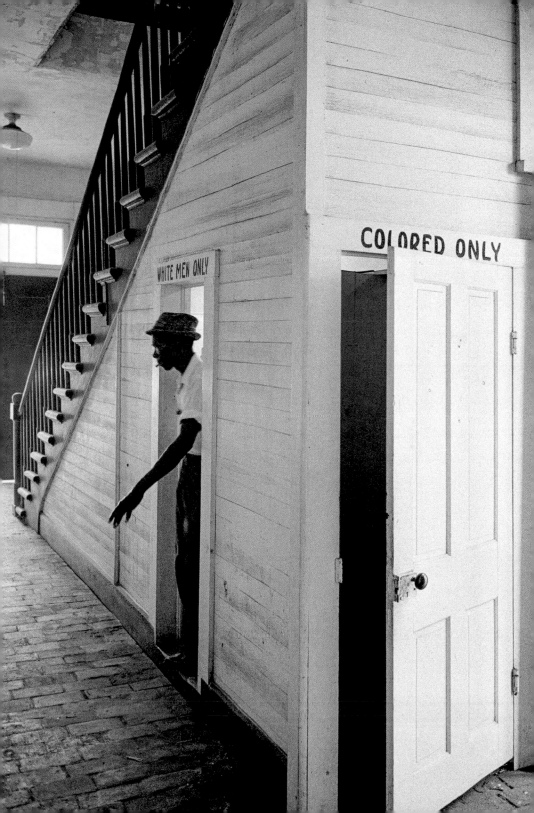

WHITE MEN ONLY

COLORED ONLY

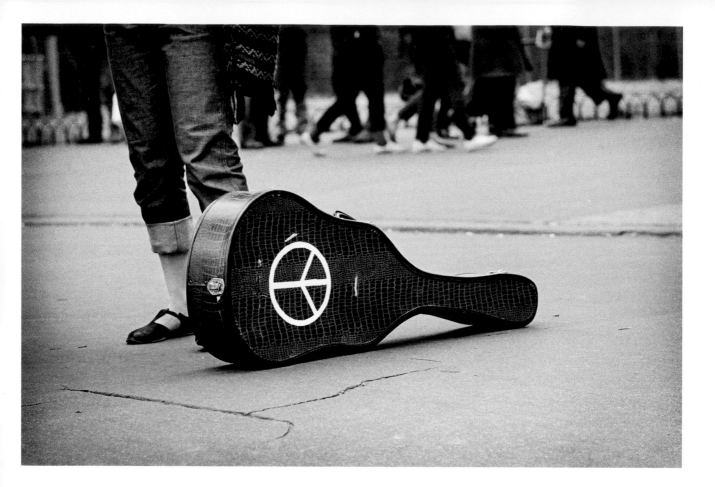

The peace sign was originally created in 1958 for the first large-scale antinuclear demonstration in the UK. Gerald Holtom designed it by combining the semaphore symbols for "N" and "D" ("nuclear disarmament"). He also imagined the vertical line and two smaller diagonal lines as a person in despair, with arms cast downward, representing his despair about war and nuclear proliferation. Holtom made the image into a small badge that he wore on his lapel, and the symbol immediately caught on. It was picked up by the American antinuclear movement, which began in 1961 with the Women Strike for Peace marches.

The symbol spread like wildfire; by 1964 the peace sign was seen on buttons, stickers, signs, and flags displayed on college campuses. By 1965, as the US escalated its bombing campaign in North Vietnam, the peace sign was the *de facto* symbol of the anti-war movement, used by antinuclear activists, hippies, anti-war protesters, feminists, and ecologists alike throughout the sixties.

The peace sign's role as a "handshake" between members of a special counterculture has since been co-opted into mainstream society and commercialized by advertising and fashion, yet its power endures. The symbol is continually picked up by resisters to protest war, injustice to the earth, and racism.

©Jim Marshall Photography LLC

Peace sign in New York City, 1963.

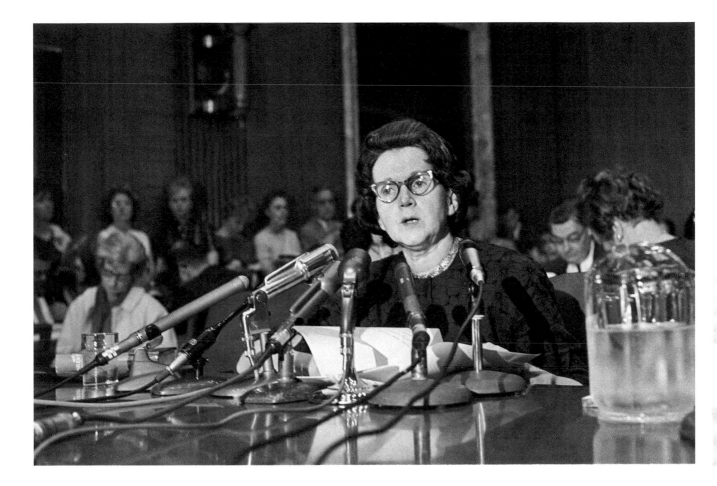

Activist and author Dr. Rachel Carson testifies before a Senate Government Operations Subcommittee to urge Congress to curb the sale of chemical pesticides and aerial spraying, Washington, DC, June 4, 1963.

The synthetic pesticide DDT was developed in 1939 to protect US troops in the South Pacific from malaria-carrying insects. With its unprecedented power to destroy myriad insect species, DDT became available for civilian use in 1945. Author, biologist, and conservationist Dr. Rachel Carson became concerned about DDT when she learned that many birds were dying in areas where it had been sprayed. She spent four years researching and writing her landmark book *Silent Spring*, published in 1962. Pairing rock-solid scientific evidence with her beautifully evocative writing, Dr. Carson meticulously outlined the dangers of DDT, linking it to cancer, genetic damage, and food chain disruption.

In one of her final public appearances, Dr. Carson testified before a Senate subcommittee about the dangers of DDT and offered policy recommendations. She defied relentless criticism from powerful politicians and chemical industry leaders trying to discredit her and her science. Dr. Carson succumbed to breast cancer less than one year later.

President Kennedy's Science Advisory Committee evaluated and then corroborated Carson's research. Her work profoundly influenced environmentalists' campaigns to ban the use of DDT and other pesticides in 1972 and led to the creation of the Environmental Protection Agency in 1970. *Silent Spring* continues to educate and inspire millions of people to fight for a sustainability agenda.

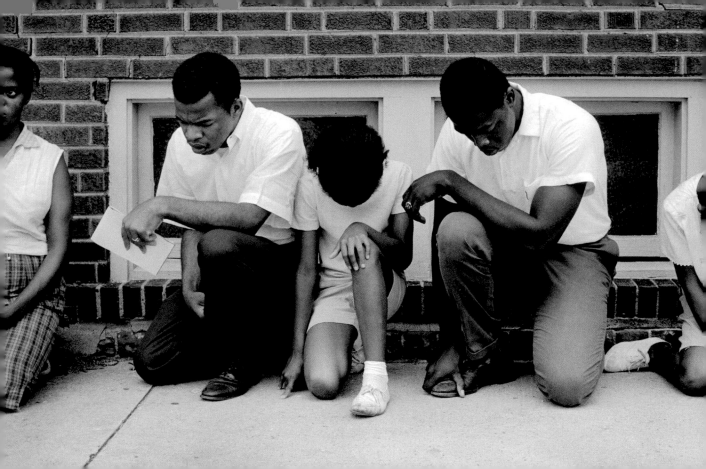

In 1962, twenty-two-year-old activist John Lewis traveled to the small town of Cairo in southern Illinois to help coordinate an ambitious desegregation campaign. Lewis was the field secretary for SNCC, a major civil rights organization formed in 1960 to increase voter registration, political literacy, and civic engagement among Black Americans. Racism was not just a Southern problem, and Cairo was notorious for its strict racial separation and brutal treatment of Black residents.

In 1961, Black youth in Cairo had formed the Cairo Nonviolent Freedom Committee (CNFC). They joined efforts with the SNCC to launch "Operation Open City," an eleven-point plan to desegregate Cairo. This photograph shows Lewis and several Cairo residents participating in a "kneel-in" at one of the recreation facilities forbidden to Black residents—one of many nonviolent direct actions coordinated that summer. Opposition was fierce; white residents often attacked and beat the activists. In response, Illinois' governor eventually ordered the town to comply with statewide desegregation orders.

Along with other leaders developed through the SNCC and CNFC campaigns, including Robert Moses and Stokely Carmichael, Lewis continued his civil rights work throughout his career. In 1987, he became the US representative for Georgia's 5th district.

©Danny Lyon/Magnum Photos

John Lewis, future chairman of SNCC (left), and others demonstrate at Cairo Pool, which did not allow African American people, Cairo, Illinois, 1962.

In 1943, Harlem was Malcolm Little's home base. His path lead him away from Harlem until he returned in 1954 to serve as a charismatic religious and political leader for his community. During that period away, he was imprisoned; joined the Nation of Islam (NOI), which encouraged Black self-reliance and an eventual return to Africa; and changed his last name to "X," shedding the name imposed on his ancestors by slave masters.

By 1963, Malcolm X was a sought-after speaker on national TV, university campuses, and radio stations. Malcolm X rejected Dr. King's nonviolence, saying Black people should defend themselves by any means necessary. He declared Harlem not a "hopeless ghetto" but a powerful place where the Black Nationalist movement could flourish. His eventual renunciation of the NOI caused a schism. In 1965, Malcolm X was assassinated by members of the NOI while giving a speech at the Audubon Ballroom.

Malcolm X planted the seeds of the Black Power movement. He empowered Black Americans through the teachings that Black Is Beautiful and the only way to achieve equality is through unity. "Whites can help us, but they can't join us. There can be no Black-white unity until there is first some Black unity."

©Bruce Davidson/Magnum Photos

Malcolm X rally in Harlem, New York City, 1963.

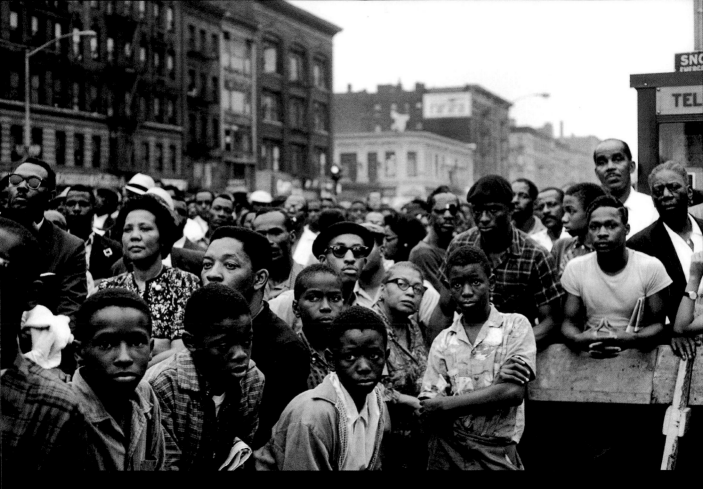

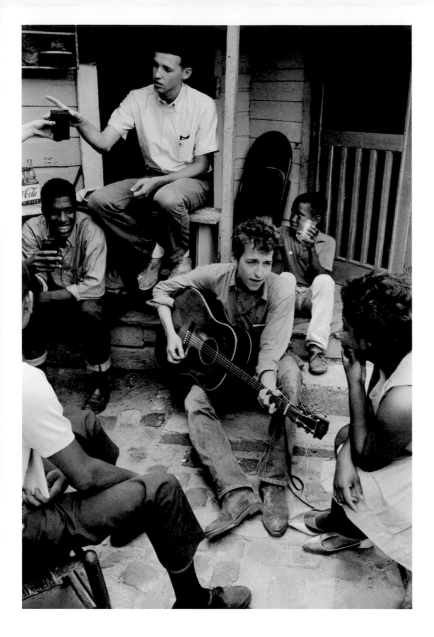

Two weeks after activist Medgar Evers was gunned down by members of the Ku Klux Klan, Bob Dylan and Pete Seeger went to support the SNCC voter registration drive in Evers' hometown of Greenwood, Mississippi. Dylan performed "Only a Pawn in Their Game," which he wrote about Evers' murder.

Greenwood was home to one of the largest cotton processing centers in the state, and in 1962, it was also home to one of SNCC's most intensive voter registration drives. Poor Black sharecroppers made up about half the county's population and the majority of the labor force, but only a tiny fraction were registered to vote. This high caliber of celebrity support signaled to mainstream America that racism was a national issue and that the concerns and rights of Black people needed to be heard and respected.

Bob Dylan plays on the back porch of the SNCC office after giving a concert in a cotton field, Greenwood. Mississippi, 1963.

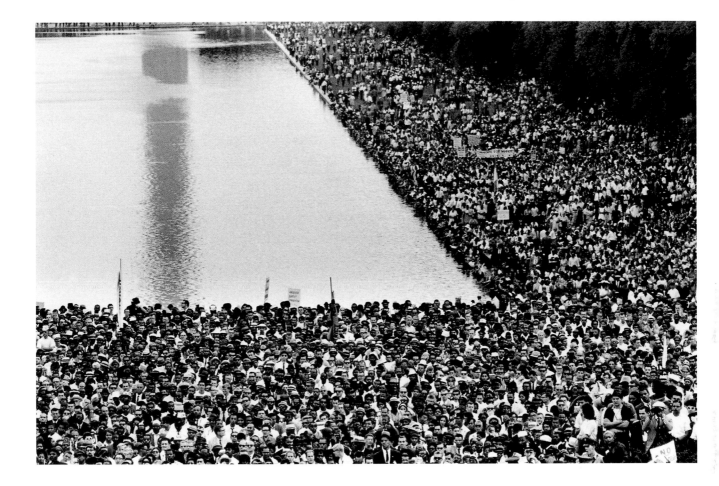

©Bruce Davidson/Magnum Photos

Crowds pack the National Mall during the March on Washington for Jobs and Freedom, Washington, DC, August 28, 1963.

Dr. Martin Luther King, Jr.'s "I Have a Dream" speech at the March on Washington for Jobs and Freedom, on the hundredth anniversary of the Emancipation Proclamation's signing, was a defining moment for the civil rights movement. More than 250,000 demonstrators marched on behalf of racial and economic equality, elevating the civil rights movement to national awareness and involvement.

The vision of a mass mobilization of Black demonstrators began developing as early as 1941. Labor leader A. Philip Randolph and activist Bayard Rustin (an openly gay man whose leadership was frequently challenged by homophobic members of the civil rights and labor movements) called for a hundred thousand Black people to march on Washington to protest segregation in the Armed Forces. The threat of that march led President Roosevelt to issue Executive Order 8802, outlawing racial discrimination in the defense industry.

Twenty years later, Randolph and Rustin built the Big Ten—a multiracial coalition of civil rights, labor, and religious leaders—to demand passage of bipartisan civil rights legislation. Their strategy revolved around a March on Washington.

After the march, the Big Ten met with President Kennedy and Vice President Johnson, successfully laying the groundwork for the Civil Rights Act of 1964 and the Voting Rights Act of 1965.

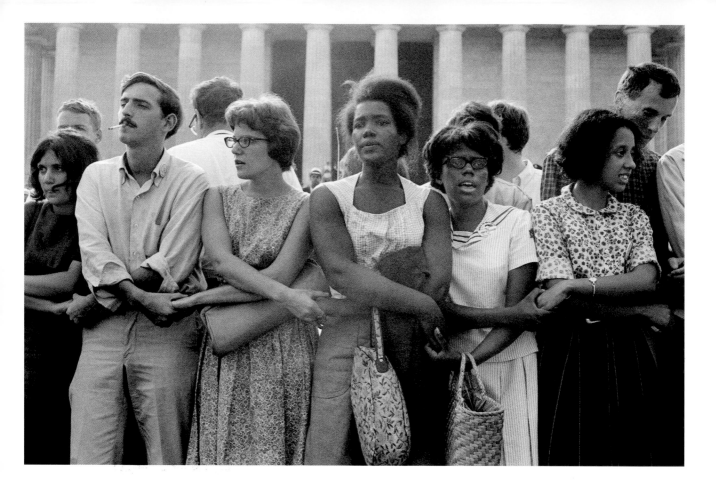

The March on Washington's leadership team and attendees represented a broad-based, interracial coalition of people from all over the country. Most were Black, but many white people and other allies of color also came in large numbers. Images of diverse demonstrators standing in solidarity appeared live on major national television networks and printed in newspapers and magazines. It was a radical sight then to see Black and white people publicly holding hands.

However, prior to the March, many of these same media outlets had fanned the flames of racist fear, running op-eds and articles predicting riots and violence. The Pentagon stationed nineteen thousand law enforcement officials in the DC suburbs in case of unrest; inmates in surrounding jails were moved to make room for the anticipated hordes of arrestees. Ultimately, there was a grand total of three arrests.

Though the March's organizers prided themselves on creating a diverse coalition of leaders, women were not allowed to speak in the official program, despite vocal protests from women such as Anna Arnold Hedgeman. Bayard Rustin led a brief tribute to women in the movement, followed by a brief statement from Daisy Bates, pledging support to the male efforts in the movement. Female civil rights leaders like Dorothy Height, Diane Nash, and Rosa Parks were directed to march with the wives of male civil rights leaders.

Marchers joining hands in front of the Lincoln Memorial during the March on Washington, Washington, DC, August 28, 1963.

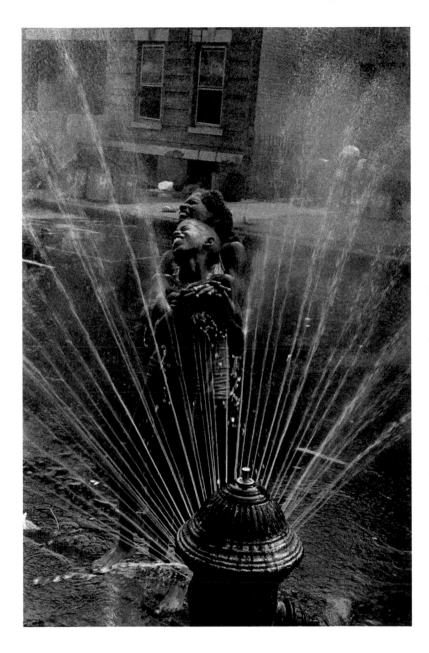

The fire hydrants are opened during the
summer heat, Harlem, New York City, 1963.

Summer temperatures in New York City often soar well into the 90s, with the
pavement temperatures exceeding 100 degrees at times. The process of prying off the
cap of a fire hydrant—commonly known as "uncapping"—has been a quintessential
summer tradition for over a century, especially among children living in low-income
communities of color, from Bed-Stuy to Hell's Kitchen to Harlem. While the city's
wealthier white families have traditionally escaped the heat by heading to summer
camps and vacation homes in cooler climates, folks in less-advantaged communities
generally lacked access to public pools and cooled down in a hydrant spray. Prying
off the cap was a small act of rebellion and a fun way to keep cool.

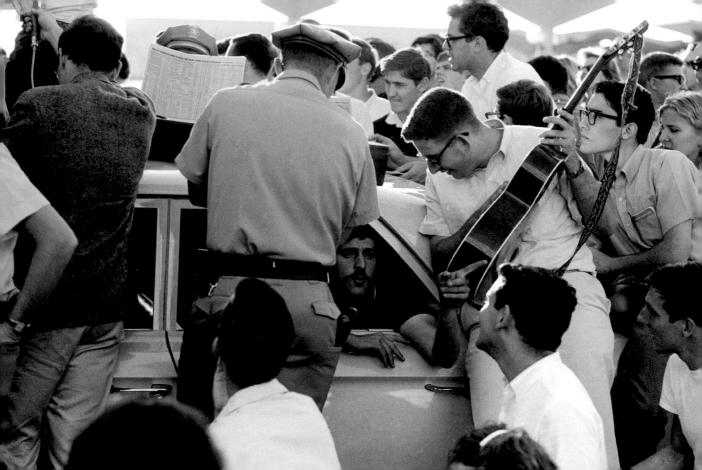

The civil rights movement touched every state in the country. In California, Jack Weinberg, head of Congress on Racial Equality (CORE) on the UC Berkeley campus and a recent graduate, set up a table to raise money for the organization's mission of racial justice—and to challenge the school policy against distributing information and taking donations for non-university causes.

A campus policeman asked him for his ID; he refused and was threatened with arrest. A crowd gathered to witness the commotion. When they finally arrested Weinberg, he went limp. As the officers carried him to a car, someone shouted: "Everyone sit down!" Within seconds, hundreds planted themselves on the ground, blocking the car.

The spontaneous protest lasted thirty-two hours. Weinberg sat in the car while student activists negotiated with campus officials. Protestors, including Mario Savio, took turns standing on the car, giving impromptu speeches about censorship and their right to speak freely on campus. Up to three thousand students took part.

Two days later, a group of student activists met and the Free Speech Movement was born. Their activism pushed the university to establish a more open policy for free expression on campus. This moment was the foundation for all the student protests that followed.

Activist Jack Weinberg in a police car after his arrest, Berkeley, California, October 1, 1964.

The Free Speech movement marked a turning point for activism and the awakening of political consciousness on college campuses, but it wasn't the first organized political action taken by American college students. Notable examples include student walkouts at Fisk University, 1924; Depression-era actions of the American Youth Congress; the Greensboro lunch counter sit-ins of 1960, initiated by four freshmen at North Carolina Agricultural and Technical State University; the 1960 founding of Students for a Democratic Society (SDS) in Ann Arbor, Michigan; and the 1962 publication of their manifesto, the Port Huron Statement.

The Free Speech movement was directly inspired by the civil rights movement— many of its core leaders and most active participants, including Jack Weinberg, had recently spent time in the South working with groups like CORE and SNCC on voter registration and desegregation campaigns. They brought conscious engagement, passionate commitment, and mass civil disobedience tactics like sit-ins, marches, and the singing of protest songs to college campuses, putting a new kind of pressure on university administrations. As the US involvement in the Vietnam War escalated, the Free Speech movement's energy and momentum helped fuel anti-war activism on college campuses across the nation.

©Chris Kjobech/Oakland Museum of California
Free Speech Movement, Berkeley, California, 1964.

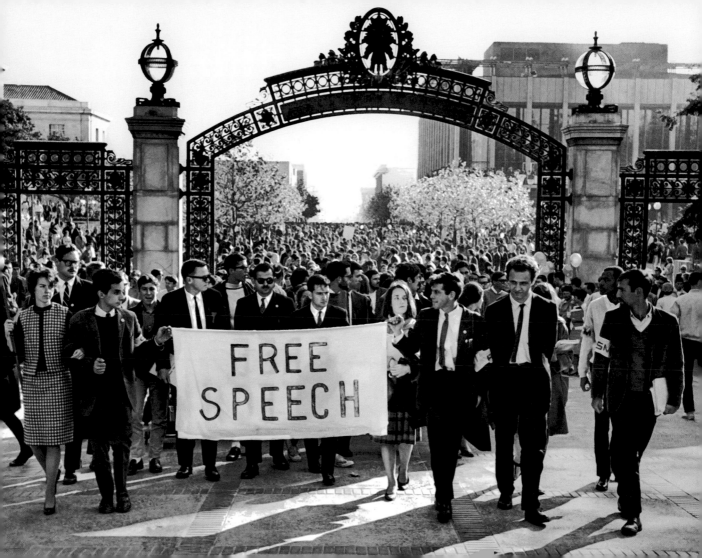

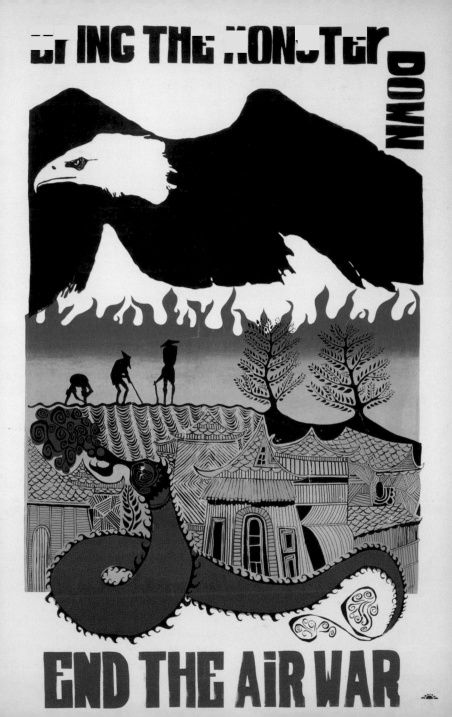

YOUTH RISING

The civil rights movement awakened America. Millions saw a country and government at odds with its mission of "All Men Shall Be Equal" and took to the streets in protest. Concurrently, minds were expanding. By 1970, at least two million Americans had dropped acid, and one-third of college students had smoked marijuana. Soon social disruption touched every quarter of American life, fueled by the cutting-edge technology of the day: television, radio, the telephone, and affordable cars that could travel on the new highway system.

Latinx farmworkers demanded union protection; feminists, an end to misogyny and discrimination; disabled people, recognition, respect, and accessibility; Native Americans, land and treaty rights; Puerto Rican citizens, independence; and nonwhite college students, curriculum and faculty reflecting their cultures and histories. The Asian Americans movement embraced a pan–Asian American identity. The times they were a-changin'.

Even government seemed to embrace these ideals. In 1964, President Lyndon Johnson introduced the Great Society, a sweeping set of laws to eliminate poverty and racial injustice by expanding civil rights, and establishing public broadcasting, Medicare, Medicaid, and environmental protection. Influenced by the efforts of civil rights, labor, and religious leaders, Johnson initiated the War on Poverty, passed the Voting Rights Act in 1965, reformed immigration, and boosted public education funding.

Many of these policies were not favored by Congressional conservatives, who sought to crush the various movements. Resources flowing to Vietnam starved Johnson's domestic agenda, especially his promises to urban communities, leading to outcry about Johnson's glaring hypocrisy: professing to eliminate injustice at home, while killing American soldiers and Vietnamese citizens abroad.

By 1970, what began as peaceful, nonviolent resistance had become a dark, violent time for America. Malcolm X was murdered in 1965. In 1968, Dr. Martin Luther King, Jr. and Democratic presidential hopeful Senator Robert Kennedy were assassinated. Police brutality to protesters rocked the 1968 Democratic National Convention. Anger fueled many anti-war protests, leading to violent conflicts with police and the National Guard, called in to quell rioting crowds. The Guard's 1970 shooting of unarmed students at Kent State devastated the country and galvanized the anti-war movement.

Much of the protests ended when the Vietnam War did, but America was left disillusioned and grieving. The Watergate scandal revealed extensive corruption and illegal activity within the Nixon administration. Rather than face impeachment for obstruction of justice and other charges, Nixon resigned on August 9, 1974.

Despite the deep feeling of betrayal by the government these years were fruitful for human justice issues and some aspects of the Great Society—laws and concepts now taken for granted, such as improved accessibility for people with disabilities, Miranda rights, environmental protection, and Title IX.

©Doug Lawler, 1972

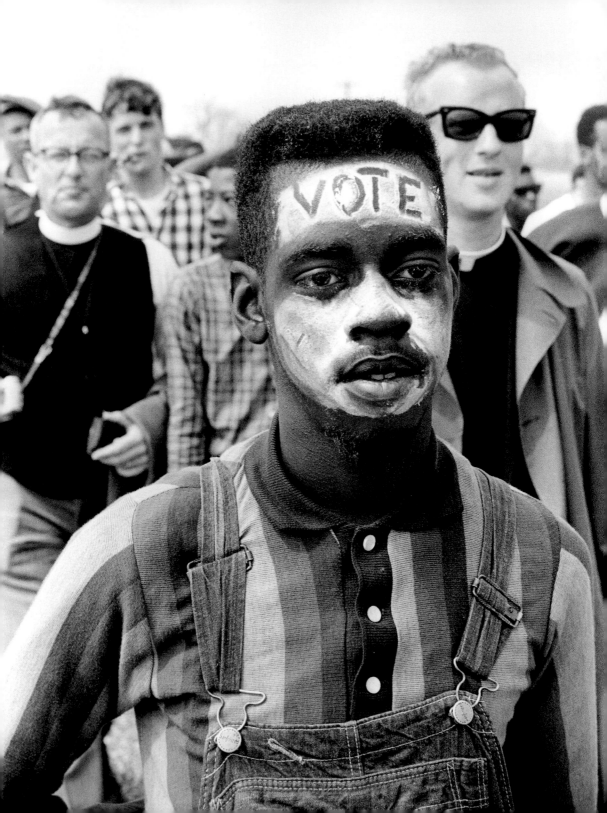

The Civil Rights Act did not end the mass voter suppression that had prevailed in Southern states since the late nineteenth century. One key aim of the civil rights movement was to end those practices, so people continued to march.

In February 1965, activist Jimmie Lee Jackson was murdered by Alabama state troopers while participating in a peaceful voting rights march. In response, SCLC leader James Bevel called for a fifty-four-mile march from Selma, Alabama, to the state capital of Montgomery. During the first attempt, on March 7, marchers were attacked by police as they attempted to cross the Edmund Pettis bridge. March organizer Amelia Boynton was beaten unconscious, and the horrific attack became known as Bloody Sunday.

After the second attempt was again thwarted by violent police, activists demanded that President Johnson provide protection—and finally pass meaningful civil rights legislation. On March 15, Johnson publicly introduced the Voting Rights Act to Congress. Six days later, thousands of marchers set out again from Selma. On March 25, over twenty-five thousand marchers arrived in Montgomery. By August 1965 the Voting Rights Act became law, effectively ending nearly a century of voter suppression.

©1976 Matt Herron
Selma to Montgomery March for Voting Rights, Alabama, 1965.

The Fair Labor Standards Act of 1938 was designed to ensure basic worker rights. But in order to pass the bill, certain labor categories—agricultural workers in particular—were exempted as a concession to the segregationist Southern Democrats. Undocumented Latinx, Asian, and poor white workers had virtually no legal protections, leaving them at the mercy of mostly white farm and ranch owners.

Strikes from the 1930s and on were not successful until organizers Dolores Huerta and Cesar Chavez formed the United Farm Workers (UFW) union in 1962. In 1965, Filipino-American workers from the Agricultural Workers Organizing Committee struck against table and wine grape growers for better pay and conditions. They asked the UFW to join them to form a massive group of strikers. To bring it to the attention of California lawmakers—and the nation—Cesar Chavez called for a *peregrenación*, a three hundred-mile march from the farm town of Delano to the state capital. They set off with seventy marchers, and by the time they reached Sacramento on Easter Sunday, 1966, their numbers had swelled to nearly ten thousand.

The grape boycott spread nationwide. Millions pledged to stop eating grapes until the growers offered UFW members a fair contract. In 1970, after five years of boycotting grapes, table grape growers signed their first union contracts, granting about seventy thousand members better pay, some benefits, and protec-

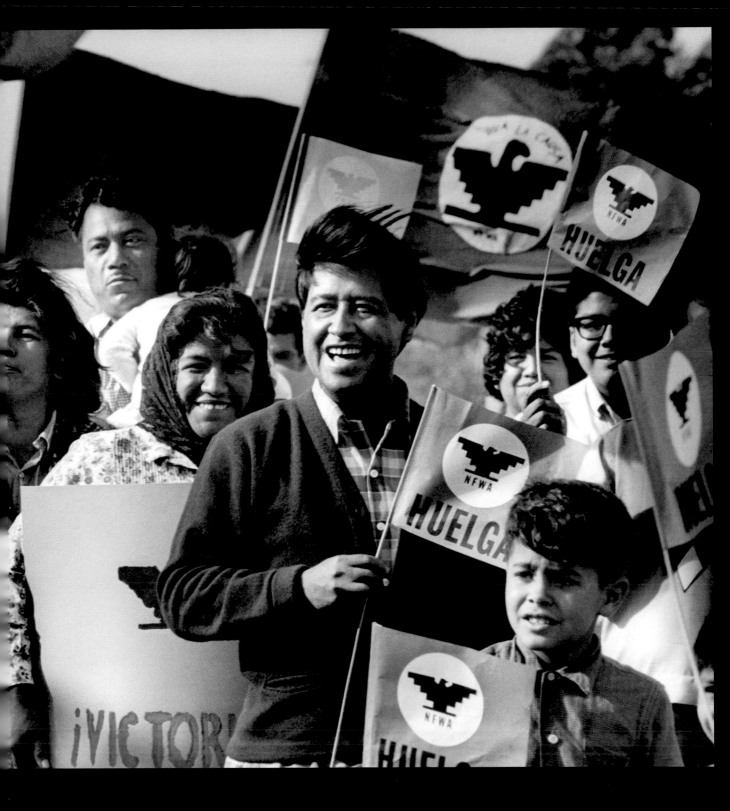

Jan Rose Kasmir was a seventeen-year-old high school student when she joined one hundred thousand anti-war activists in the March on the Pentagon in 1967. The demonstration was organized by the National Mobilization Committee to End the War in Vietnam (known as "the Mobe"), a coalition of anti-war groups including Women Strike for Peace, SCLC, and the Youth International Party, aka the Yippies.

Kasmir didn't know that this photo was being taken—someone had handed her a flower, and her decision to turn and bravely face the heavily armed soldiers was spontaneous. Two years after it was taken, the photo appeared in *Look* magazine, with the title "The Ultimate Confrontation: The Flower and the Bayonet." It was reprinted around the world, and came to be seen as a symbol of the "flower power" generation: the young, idealistic hippies who embraced peace and a countercultural, nonconforming lifestyle.

Jan Rose Kasmir confronts the National Guard outside the Pentagon during the anti-Vietnam march, Washington, DC, 1967.

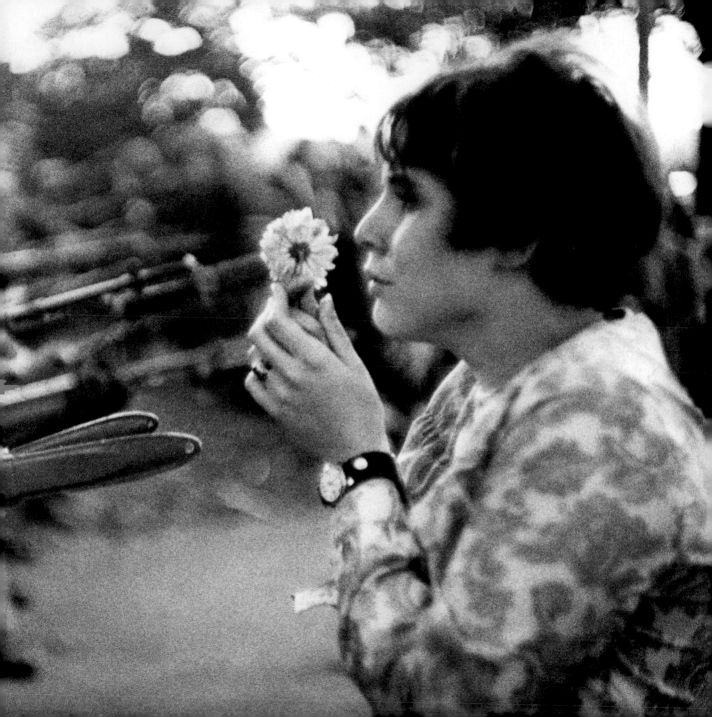

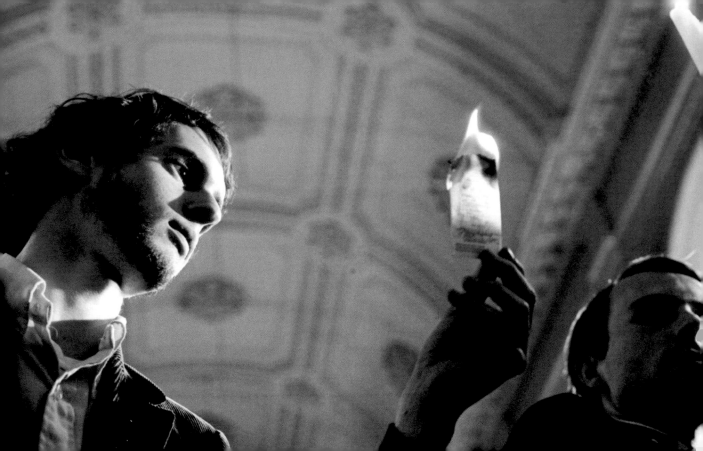

Young man lighting his draft card on fire at the Arlington Street Church, Boston, Massachusetts, 1967.

The Selective Service Act of 1948 required all American men aged eighteen through twenty-six to register with a local draft board; in case of war, these men could be drafted to fill vacancies in the US armed forces. Once registered, each man was issued a small identification card. The law required them to carry this "draft card" at all times.

When the government began calling up masses of young men to serve in the Vietnam War, opposition to the draft began to brew. Many young men evaded the draft as a personal form of resistance: they protested at induction centers, refused to register for the draft, and even lived underground or emigrated to other countries, including Canada and Mexico. The number of young men who put their own welfare on the line to oppose the war is estimated have been as high as 570,000.

One powerful way to protest the draft was to publicly burn draft cards. In 1964, fifty anti-war activists gathered in New York City to burn their cards, and by 1965, it was so common that Congress amended the Selective Services Act to punish anyone who "knowingly destroys, knowingly mutilates" his draft card.

On October 16, 1967, the Mobe organized a large-scale draft-card burning protest, with participants in thirty cities burning 1,400 cards. At Boston's Arlington Street Church, card-burners used a candle said to belong to a revered nineteenth-century Unitarian priest. The practice continued as long as the war did. After such vehement opposition, conscription officially ended in 1973.

In February 1968, more than 1,300 all-Black sanitation workers in Memphis, Tennessee, walked off the job and went on strike. They demanded decent wages, overtime pay, recognition of their union, and an end to rampant racial discrimination and the dangerous working conditions that led to the deaths of Echol Cole and Robert Walker, crushed to death by a malfunctioning garbage truck while trying to seek shelter from a downpour.

Garbage began piling up in Memphis, but city leaders refused to meet the strikers' demands. The mayor demanded they return to work; they refused. It was more than a labor strike: it was about dignity for Black workers and their families. The strikers' slogan became the simple yet profound phrase "I *AM* A MAN."

On March 18, 1968, Dr. Martin Luther King, Jr., came to Memphis and delivered a speech in support of the striking workers to a crowd of twenty-five thousand. A subsequent demonstration turned violent, with one protester killed by the police. The mayor declared martial law and brought in the National Guard. Public support for the strike began to wane. On April 3, Dr. King returned to lend his support again, delivering his now-famous "I Have Been to the Mountaintop" speech. The next evening, he was assassinated at the Lorraine Motel.

Several days later, his widow Coretta Scott King led over forty thousand people in a silent march through the streets of Memphis. One week later, the city council finally voted to honor the sanitation workers' union, promising higher wages and the dignity they deserved.

©Bob Adelman Estate

Mourner with sign at the Dr. Martin Luther King, Jr., memorial service, Memphis, Tennessee, 1968.

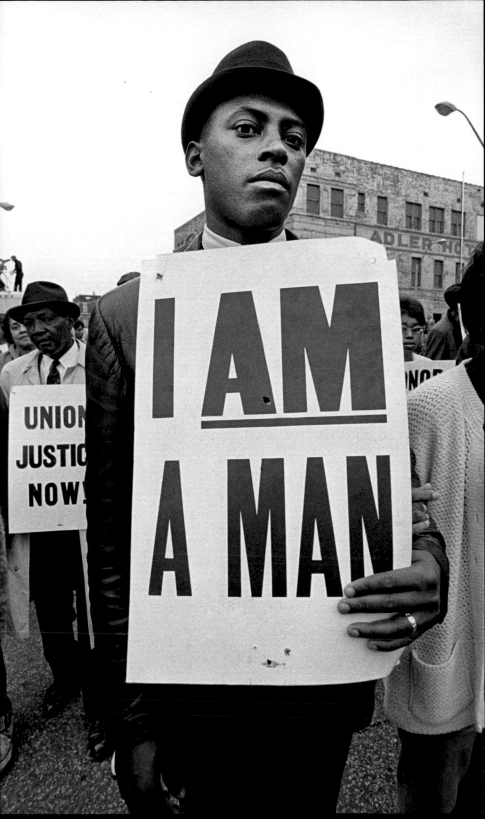

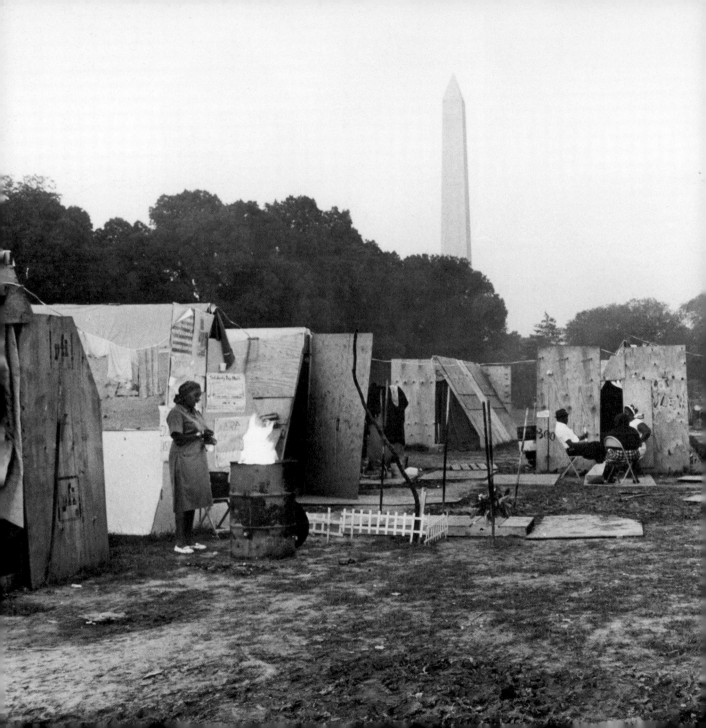

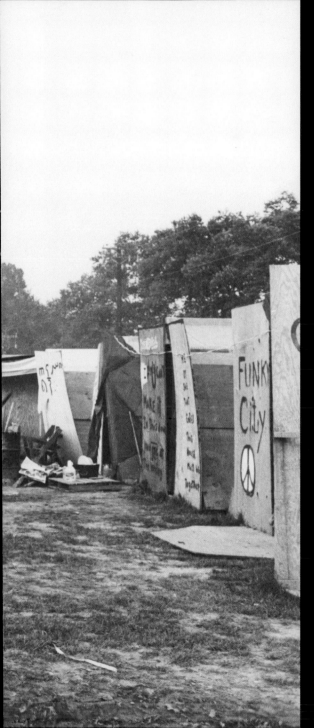

Dr. King never made it to Washington to see his vision of including the plight of the nation's poor in the civil rights movement fulfilled. He and his SCLC associates had developed the Poor People's Campaign, a six-week march on Washington that would include "Resurrection City," a tent city on the National Mall. As Coretta Scott King said, "What good is the legal right to sit in a restaurant if one cannot afford the price of food?"

A key aspect of the Poor People's Campaign was the multiracial coalition formed by groups previously set against each other through fractious community disputes and cultural prejudice. Different racial groups unified to work together for a common goal and to leverage their similar experiences of poverty. In all, seventy-eight non-Black leaders—Chicano activists, Puerto Rican independence activists, poor white coal miners, Native American land rights activists, and more—came together to endorse and plan the campaign. They built a village of three thousand wooden shanties where thousands of people lived for forty-two days, carrying out actions to bring about a fundamental change in attitudes toward poverty. On Mother's Day, Coretta Scott King and the women of the National Welfare Rights Organization led a march of seven thousand through Washington's streets, and

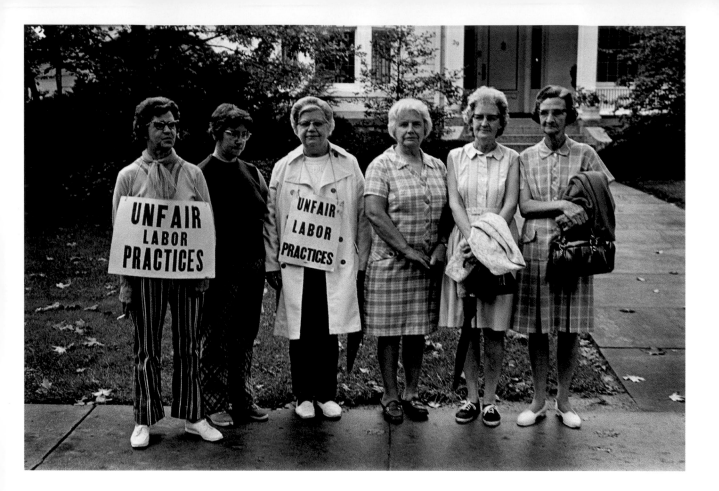

Title VII of the Civil Rights Act prohibits employment discrimination based on race, sex, religion, or national origin, providing new opportunities to previously discriminated groups, both overtly or covertly. Union ranks quickly swelled as women and people of color entered the workforce in large numbers and in new ways.

The Ohio University cafeteria workers were members of the American Federation of State, County, and Municipal Employees (AFSCME), the country's largest public employee trade union and the same union that represented Memphis sanitation workers. With a progressive political stance, AFSCME was known for its focused recruitment and empowerment of women and Black workers.

Previously it had not been socially acceptable for working women to push for better working conditions. The women's movement, as well as various labor strikes— the Memphis sanitation workers' strike and the massive US postal worker strike of 1970—empowered women to speak out on their own behalf. During the 1971 AFSCME strike, demands included equal classification of jobs. Positions usually held by women and people of color tended to be classified with lower salaries and fewer benefits and protections. The Ohio University cafeteria workers were all women, and with union support, they demanded equal pay and treatment.

©Ken Light/Contact Press Images

Cafeteria workers strike at Ohio University, Athens, Ohio, 1971.

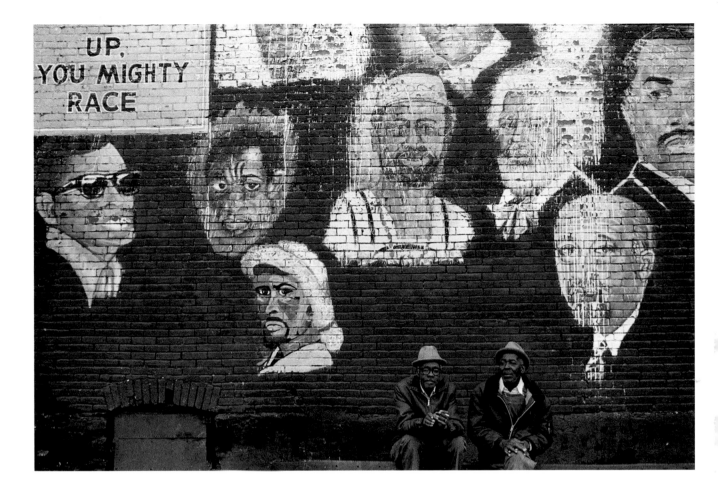

UP,
YOU MIGHTY
RACE

The artists who created this mural are unknown, but the style and empowering sociocultural content reflect the Black Arts Movement (BAM), a Black-led arts movement, begun in the sixties, that communicated Black pride and consciousness through art and literature. In the top left corner of this mural is part of a quote from early Black nationalist leader Marcus Garvey—the full quote is "Up, up, you mighty race! You can accomplish what you will!"

Public murals were a significant part of BAM. This one in St. Louis was likely inspired by Chicago's hugely influential "Wall of Respect," a large-scale mural depicting over fifty Black cultural heroes, from Nina Simone to W.E.B. DuBois. The "Wall of Respect" was created in 1967 by a coalition of artists and residents of a South Side neighborhood. It inspired a nationwide public mural movement, and within eight years more than 1,500 murals were painted in Black neighborhoods across the nation.

The presence of this mural in a predominantly Black St. Louis neighborhood was significant. The city had a long history of segregation, housing discrimination, and brutal racial violence—including the 1917 East St. Louis massacre and the 1949 Fairground Park riots. By the late 1960s, the Black Panthers were active in St. Louis, as were a similar group called the Black Liberators.

Race Wall, St. Louis, Missouri, 1971.

As American culture evolved during the 1960s, attitudes toward recreational drug use relaxed. Cannabis use increased dramatically, especially on college campuses, triggering an inevitable backlash from the media, federal government, and law enforcement.

Federal efforts to restrict cannabis use began in 1906 with the Pure Food and Drug Act, which required drug labels to list addictive or dangerous ingredients such as alcohol, morphine, opium, and cannabis. The Marijuana Tax Law of 1937 made possession and usage illegal. A part of this condemnation also stemmed from racism toward Mexican immigrants, who introduced recreational cannabis use.

In 1963, Beat poet Allen Ginsberg advocated marijuana legalization after fellow beatnik Neal Cassady was arrested for possession in 1958. Along with countercultural icon Ed Sanders, Ginsberg founded LEMAR ("LEgalize MARijuana") and began wearing irreverent signs at "pot rallies" in New York City.

In 1970, Timothy Leary, a clinical psychologist conducting experiments with therapeutic uses of LSD, successfully sued the US on the basis that the Marijuana Tax Law breached the Fifth Amendment. Leary won, the law was repealed, but a conservative Congress retaliated with the Controlled Substances Act of 1970, putting cannabis, LSD, ecstasy, and peyote on the same regulated list as heroin and Quaaludes.

©Benedict Fernandez

Allen Ginsberg at a marijuana legalization rally at the Women's House of Detention in Manhattan, New York City, 1963.

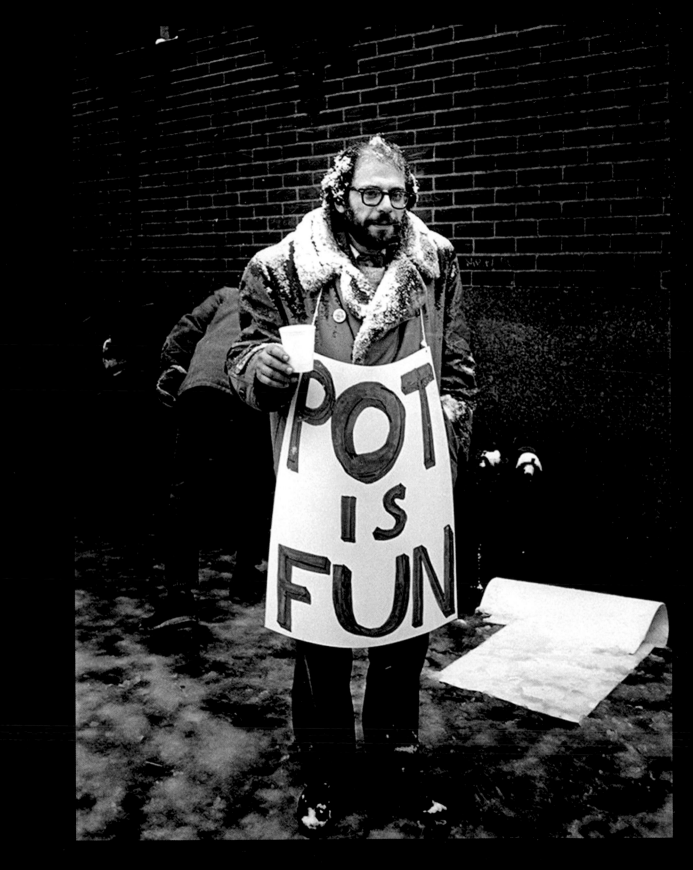

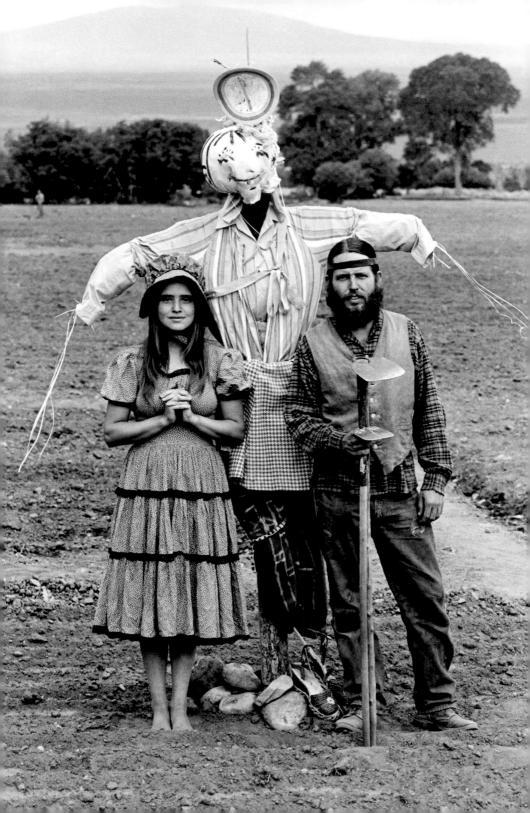

After years of protesting and shouting "No!" to society, young Americans wanted a place to congregate and live separately from mainstream conformity as a form of protest against a country that seemed to have lost its moral center. Among them were mainly college dropouts, but also young professionals, artists, and college professors. Most lacked real skills for surviving a rural lifestyle, but they acquired them and a number of these rural communities persisted. Their earnest rejection of conventional futures as working professionals was an attempt to heal a shattered culture through the practice of the core American virtues of self-reliance, simplicity, and spiritual awakening, similar to Thoreau's writings about living close to nature.

This photo is a salute to of Grant Wood's 1930 *American Gothic* painting, which presents a stoic man and woman standing in front of a farmhouse in Iowa and is seen as a classic depiction of a traditional Midwestern American aesthetic. The pair in this photo display similarly serious faces in a rural setting, but the details (her bare feet and piously clasped hands, the fanciful scarecrow, his long hair and headband) give it a hippie twist, challenging the idea of what "normal" America looked like.

©Dennis Stock/Magnum Photos

Portrait of a couple in *"American Gothic* style," USA, 1969.

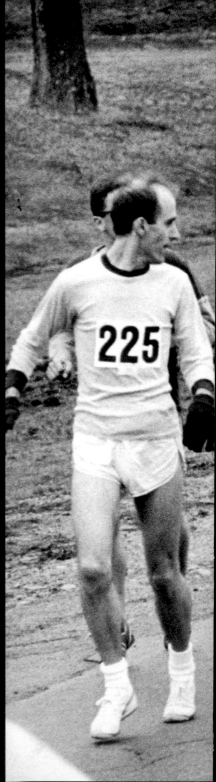

The Boston Marathon has been an American athletic institution since 1897 and the oldest marathon in the country. Women were considered physiologically and mentally incapable of running long distances and therefore not allowed to participate.

In 1966, Roberta "Bobbi" Gibb snuck into the race, becoming the first woman to unofficially run it. The following year, Kathrine Switzer, a journalism student and cross-country runner at the University of Syracuse, applied to participate in 1967, with support from her coach, Arnie Briggs. She signed her application "K. V. Switzer" and received a race bib and number, becoming the first woman to formally enter the race—unbeknownst to the officials.

Switzer showed up on race day with Briggs and her boyfriend, Big Tom Miller, an All-American football player. She got smiles and cheers from fellow runners and onlookers until Mile 4, when a press truck appeared, with photographers taking photos.

Jock Semple, the volunteer race director, was outraged at Switzer's act of defiance. Semple ran up, screamed in her face, and physically attacked her, trying to pull off her race bib. Big Tom knocked Semple to the ground.

Switzer and her two running partners sprinted away with the press truck in hot pursuit, madly documenting the moment. The truck eventually left, and she finished the race in just over four hours—an hour behind Bobbi Gibb, who was unofficially running again. In 1972, the Boston Marathon policy finally changed, allowing women to run.

Jock Semple, Boston Marathon volunteer race director, tries to remove Kathrine Switzer, No. 261, from the course during the race in April 19, 1967.

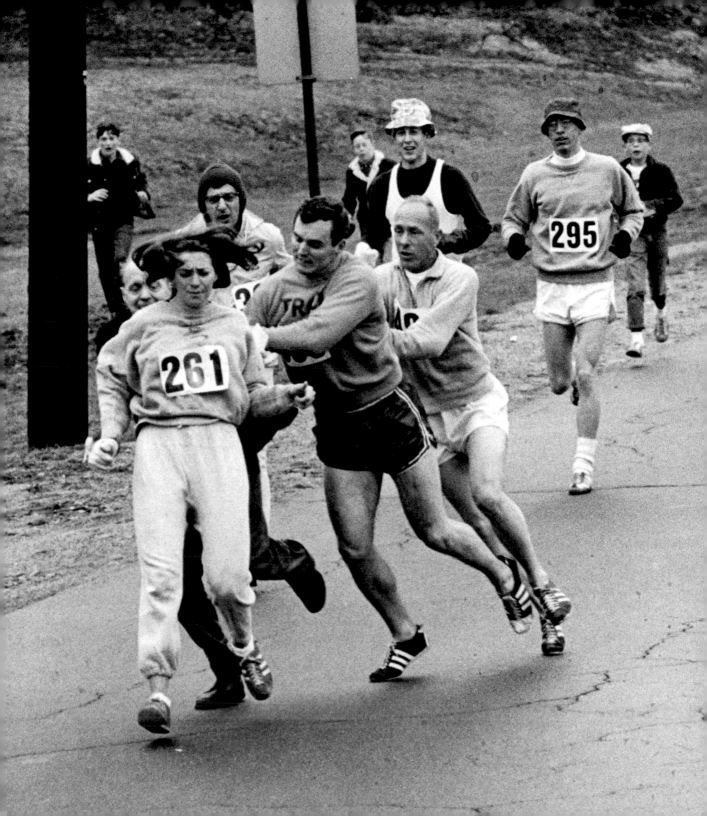

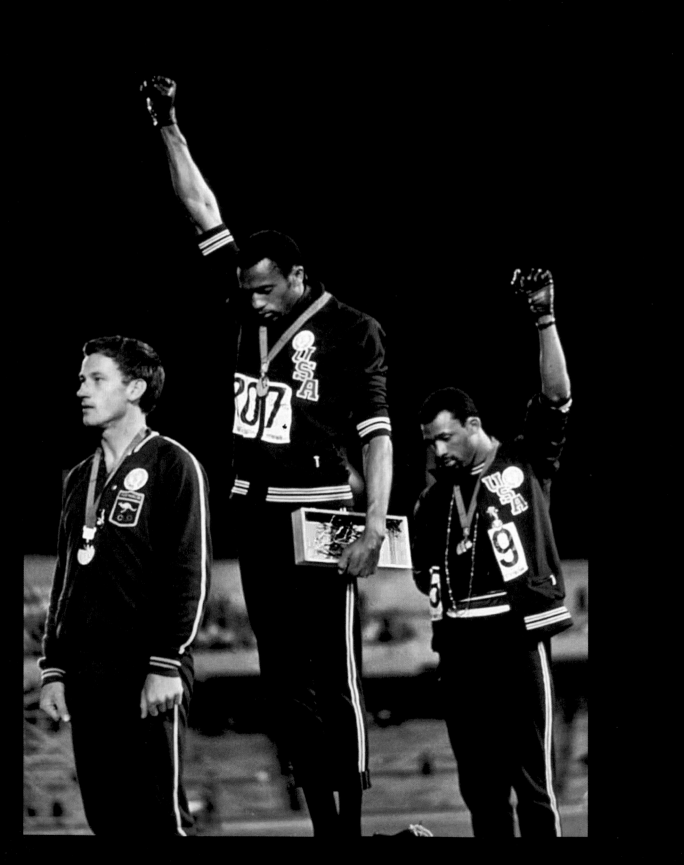

The 1968 Summer Olympics took place in Mexico City, Mexico, during worldwide social unrest, from the Vietnam War protests in the US to student-led uprisings in France in response to the brutal Tlatelolco massacre in Mexico City just ten days before the opening ceremony.

The Games strictly forbid political statements, gestures, or messaging of any kind. Nevertheless, when US track athletes Tommie Smith and John Carlos received their medals for the 200-meter race, they used the opportunity to make a statement about racial and economic injustice in America and show pride in Black America. They removed their shoes to protest poverty; beads and scarves hung around their necks to symbolize the horror of lynchings. Carlos's unzipped jacket revealed a black T-shirt concealing the "USA" on his uniform. Silver medal winner Peter Norman, a white Australian, also stood with them in solidarity. All three men wore the badges of the Olympic Project for Human Rights.

At first, the audience was silent; then they began to boo. Smith and Carlos were expelled from the Olympic Games. Back in America, both men and their families received death threats. Norman was severely punished by Australian conservatives and blackballed from the 1972 Summer Olympics.

In 2008, Smith and Carlos each received an Arthur Ashe Courage Award. A commemorative statue stands proud on the campus of their alma mater San Jose State University and their protest is remembered as one of the most iconic moments in Olympic history.

©Associated Press Photo

Black Power salute by gold medalist Tommie Smith and bronze medalist John Carlos after the 200m race, during the playing of the national anthem at the 1968 Olympics, Mexico City, Mexico.

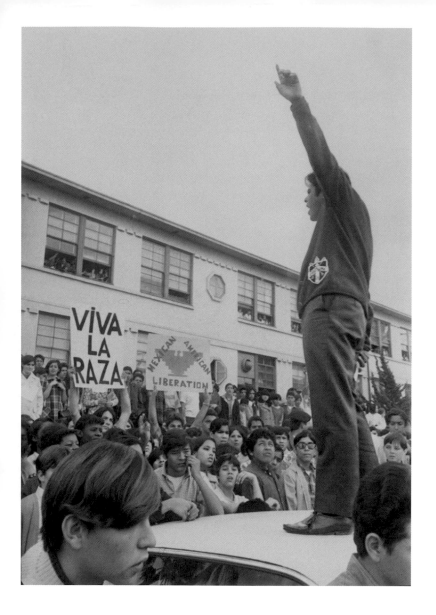

In the 1960s, only one in every four Latinx students completed public high school in California. Most Latinx schools were underfunded, and students faced frequent discrimination, including being physically punished for speaking Spanish.

A group of Mexican-American high school students in East Los Angeles led "blow-outs"—walkouts that lasted several weeks. By the end of the first week, over fifteen thousand students walked out of sixteen high schools, demanding *justicia y educación*.

The walkouts changed the trajectory of public education for California's Latinx population. A year later, UCLA's enrollment of Mexican Americans shot up from 100 to 1,900, and a number of the student leaders went on to become organizers, educators, and public officials.

©Hal Schutz/*Los Angeles Times* Photographic Archive. Library Special Collections, Charles E. Young Research Library, UCLA

Freddie Resendez rallies students at the Abraham Lincoln High School walkout, Los Angeles, California, 1968.

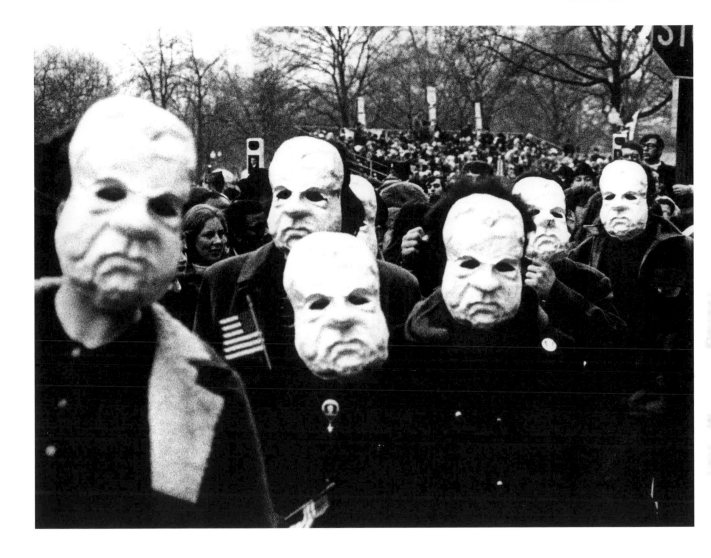

©Howard Epstein/Liberation News Service

Nixon inauguration protest, New York City, 1969.

Richard M. Nixon was elected president in November 1968. Despite protest efforts, the conflict in Vietnam raged on. Senator Robert Kennedy and Dr. King had been assassinated. Riots erupted in the wake of Dr. King's death; Oakland police killed seventeen-year-old Black Panther Bobby Hutton; the Democratic National Convention turned Chicago into a bloody police state. Anti-war candidate Senator Eugene McCarthy lost the nomination to Vice President Hubert Humphrey.

Dismayed, discouraged, and outraged, activists descended on Washington, DC, to stage a multiday "counter-inaugural." Actions included the "in-hog-uration" of a live pig, the throwing of horse manure at Vice President Agnew's guests, white rubber Nixon masks, and burning rubber dolls while chanting "Kill for Peace." Women crashed a formal reception and gave an impromptu "women's lib" speech in front of Nixon's daughter Tricia. The Women's International Terrorist Conspiracy from Hell (W.I.T.C.H.) cast spells and sang.

The Black Panther Party (BPP), originally the Black Panther Party for Self-Defense, was established in Oakland, California, by Huey P. Newton and Bobby Seale in 1966, and later branched out to cities and neighborhoods across the country. The Panthers' slogan, "We serve the people," is exemplified in their Ten-Point Program, which promotes equality, education, freedom, employment, and self-determination. They demanded an end to police brutality and the murder of Black people and encouraged Black people to join their effort to protect, defend, and nurture their communities. The BPP focused on social services, including health clinics, services for the elderly, education, and the free breakfast program that fed over twenty thousand children nationwide. They grew quickly to have headquarters in sixty-eight cities and their newspaper reached 150,000 readers.

The Panthers quickly became known for their distinctive look—Afros, berets, and black leather jackets—and their militancy. In response to the Oakland police's continued brutality, they began carrying guns in 1967, championing Malcolm X's creed to defend their communities "by any means necessary." Oakland's Republican assemblyman Don Mulford proposed and passed a gun control bill that prohibited open carry and is still in force today.

The BPP influenced other groups, like the Puerto Rican militant group the Young Lords, the American Indian Movement (AIM), and the Gay Liberation Front (GLF). Activist groups all over the globe have adopted BPP's Ten-Point Program and strategies, such as the Yellow Panthers (a part of the Vietnamese National Liberation Front), the Vanguard Party in the Bahamas, and the Dalits in India.

©David Fenton

Black Panther demonstration at the New York City Courthouse under a portion of an Abraham Lincoln quote which reads, "The Ultimate Justice of the People," New York City, 1969.

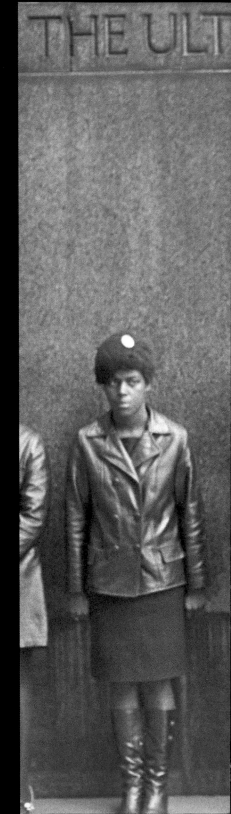

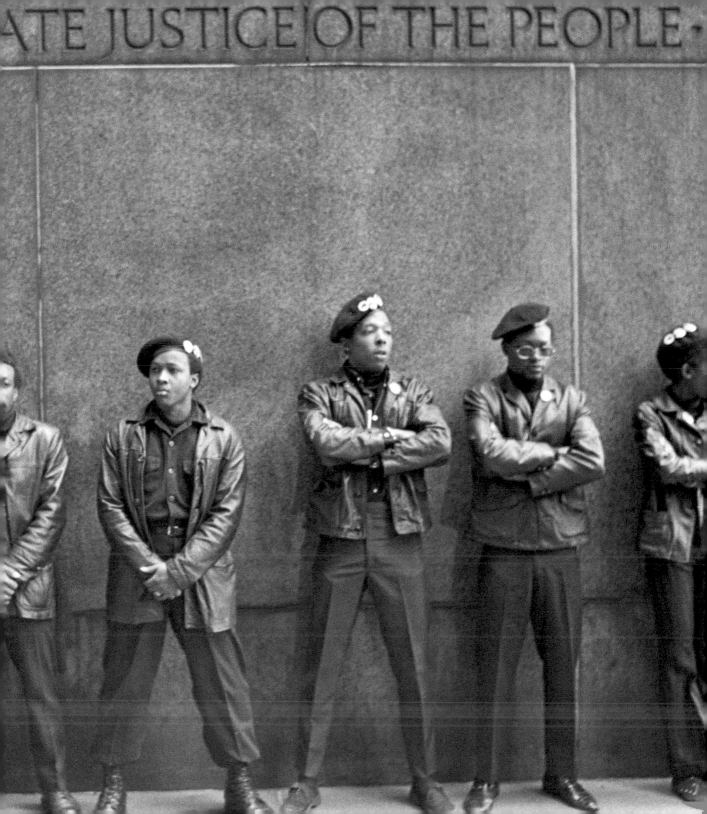

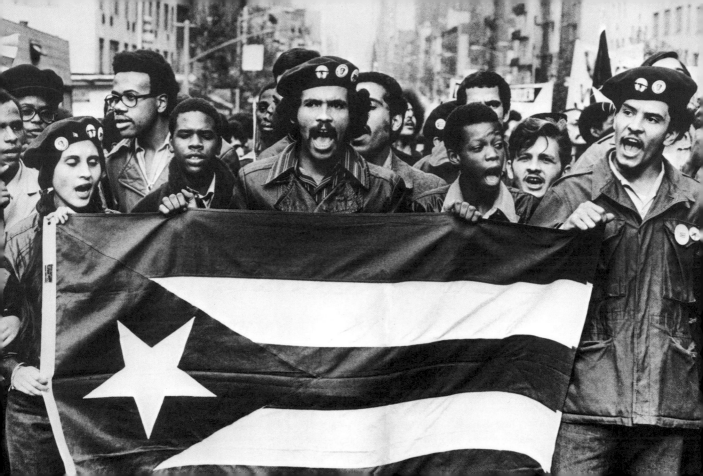

The Young Lords, a revolutionary group of Latinx activists, emerged in 1968 from the streets of Chicago and grew into a powerful change agent, especially for New York City's Puerto Rican communities. Heavily inspired by the Black Panthers, the Young Lords fought for neighborhood empowerment and the right to self-determination for Puerto Ricans, Latinxs, and "colonized" people. Members were mainly Puerto Rican, but also included Cuban, Dominican, and Black Americans.

The Young Lords also had a multi-point program, with thirteen demands, one being the immediate withdrawal of US troops from the occupied island of Puerto Rico. Young Lords members wore uniforms with purple berets and created social programs for their communities, such as free breakfast for children, day care, clothing drives, and cultural education. The many female members effectively advocated for greater respect within the organization and inclusion of women's rights, and denounced oppressive machismo in the party platform.

Young Lords were known for their provocative, effective actions, most famously the "garbage offensive." Garbage trucks often refused to serve New York's Puerto Rican neighborhoods, so the Young Lords piled the garbage in the middle of busy streets, blocking traffic and publicly shaming the city. They hijacked a portable x-ray machine to diagnose tuberculosis, took over an unused NYC hospital building, and occupied a Methodist church in Harlem to provide social services. Their creative, scrappy efforts helped the Puerto Rican community develop a sense of self-determination.

The FBI's covert counterintelligence program (COINTELPRO), which targeted political organizations and activists, infiltrated the Young Lords, creating internal stresses that ultimately destabilized the group.

©Michael Abramson
The Young Lords, New York City, 1970.

57

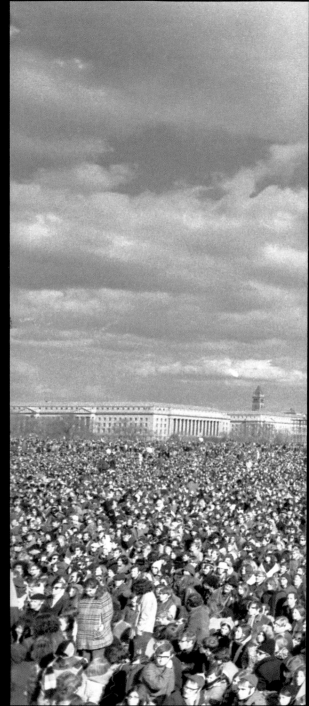

By the time Richard Nixon took office in January 1969, approximately thirty-four thousand American soldiers had been killed in Vietnam, with many more injured and psychologically traumatized. Despite Nixon's talk of peace, over ten thousand more soldiers had died by the end of his first year in office.

To keep the pressure on the administration, anti-war organizers planned the Moratorium to End the War, a huge demonstration intended to bring together as many people as possible. To show that the anti-war movement wasn't just comprised of disaffected college students, wacky hippies, and militant leftists, they created a broad coalition that included civil rights leaders, faith groups, labor activists, women's groups, and more.

Two days before the main event, forty thousand people participated in "The March of Death," a silent procession that lasted for over twenty-four hours as individual protesters marched down Pennsylvania Avenue bearing placards with the names of soldiers killed in Vietnam.

On the day of the Moratorium, over half a million people streamed into Washington, and organizers asked schools, seminaries, and locals to house the demonstrators. People wore black armbands to pay tribute to American soldiers who had died in the war. Pete Seeger led the crowd in John Lennon's "Give Peace a Chance" for over ten minutes.

The Moratorium frightened Nixon and his cabinet, but they could not think of

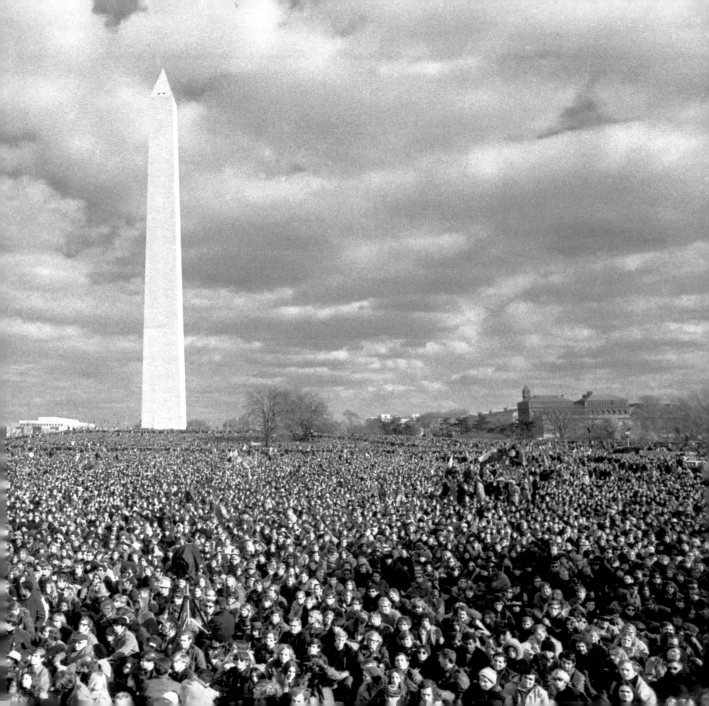

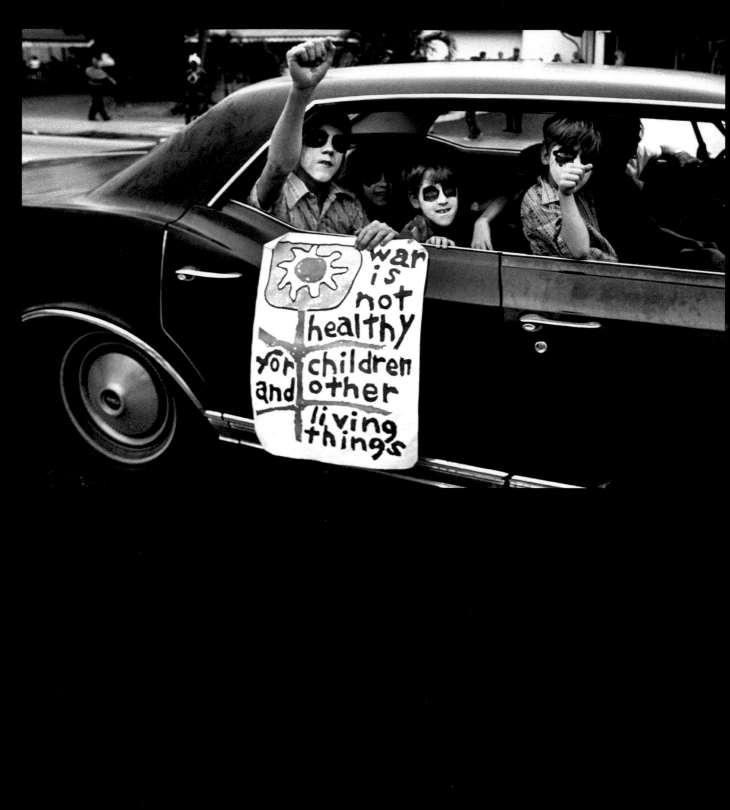

This famous poster was created by Lorraine Art Schneider in 1966 as an entry for an art exhibition calling for small art works. She wanted to create her own personal picket sign and titled the piece "Primer" because the premise felt so fundamental.

Schneider's deep concern over the threat of nuclear proliferation and the injustice she saw around her was impacted by her life experiences: she'd been horrified by the forced imprisonment of her Japanese American friends, worked as an occupational therapist with traumatized and injured veterans in college, and was the mother of four children.

In 1967, a group of fifteen women planned a peace action for Mother's Day. They wanted to send a thousand cards to politicians in Washington, DC, asking for an end to war for Mother's Day instead of candy and flowers. Schneider let them use her image for the face of the card, and a thousand cards quickly turned to two hundred thousand. Those fifteen women became Another Mother for Peace, a leading grassroots anti-war organization, and Schneider's iconic illustration is still seen on posters, cards, jewelry, and stickers. Its slogan and sunflower imagery are regarded as one of the most powerful anti-war tools of all time, inspiring mothers to unite over many other issues, such as drunk driving and gun violence.

©Ken Light/Contact Press Images

"War is not healthy for children and other living things," anti-war protest, Washington, DC, 1969.

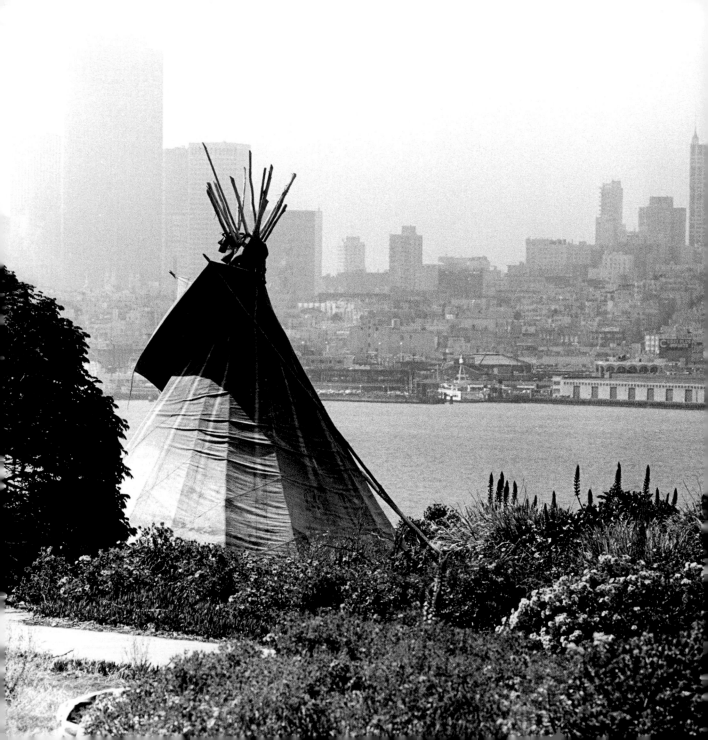

A group of eighty-nine Native American college students sailed out to Alcatraz, the abandoned prison on an island in the middle of the San Francisco Bay, and claimed the island in the name of "Indians of all tribes" in November 1969. They wrote a manifesto, citing the 1868 Treaty of Fort Laramie, which stated that out-of-use federal land should be returned to Native tribes.

Over the next nineteen months, the eighty-nine students—most of whom had been part of the Third World Liberation Front and the movement to establish Ethnic Studies programs on college campuses—were joined by thousands of fellow Native Americans and allies. They established a functioning community complete with sleeping quarters, a cafeteria, schools, and healthcare. They negotiated with the federal government, published a newspaper, and broadcasted a radio program. Until the federal government forcibly removed them, the students and their supporters held Alcatraz as Native land and celebrated the traditions and heritage that a century of racist federal policy had attempted to destroy.

The occupation unified activists and is considered the beginning of the modern Native American civil rights movement. It inspired over two hundred acts of resistance, notably in 1973, when members of AIM occupied the town of Wounded Knee in South Dakota on the Pine Ridge Reservation for seventy-one days. Congress was pushed to establish the Self-Determination and Education Assistance Act of 1975. Most importantly, it gave Native Americans a new sense of cultural identity and pride and reignited the desire for autonomy and

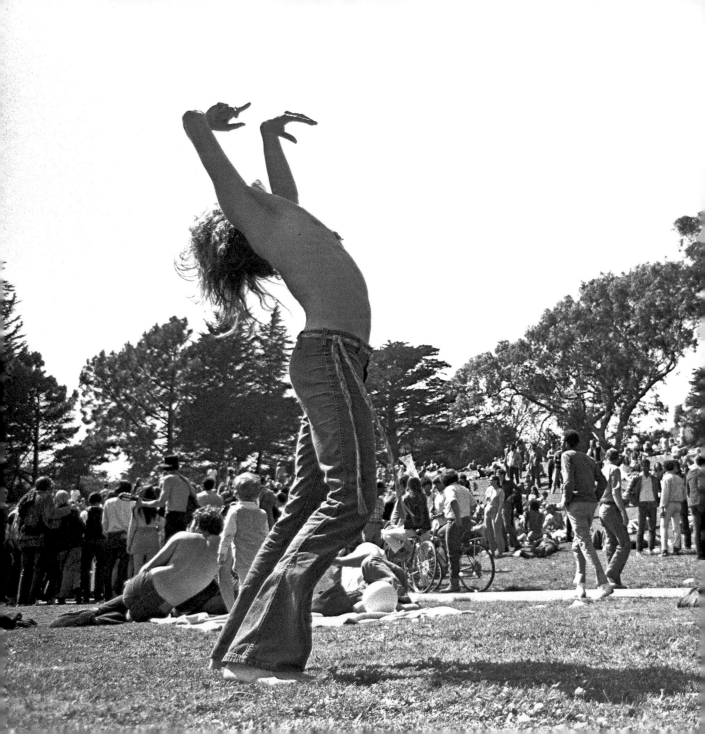

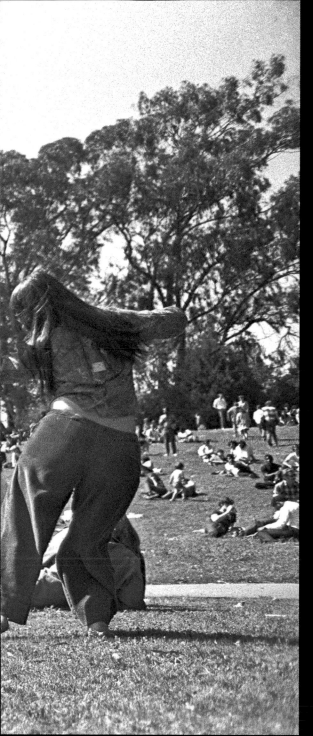

The San Francisco Bay Area was a prime incubator for ideas and vision during the civil rights movement and the nexus for the hippie movement. In this free-spirit environment, artist Michael Bowen developed the Human Be-In event, celebrating humanist values and a social melding of the various political movements. On January 14, 1967, over twenty-thousand young people flocked to San Francisco's Golden Gate Park, located at the edge of the Haight-Ashbury neighborhood, for the first Human Be-In. It was part rally and part concert, with local bands like the Grateful Dead, Jefferson Airplane, and Big Brother and the Holding Company. One speaker was Harvard professor-turned-psychedelic drug-pioneer Timothy Leary, who told the crowd to "turn on, tune in, and drop out."

The event inspired a number of community leaders to plan a summer of similar gatherings—the Summer of Love. Thousands of young people came from all over the country for the uncensored, anti-establishment scene, with free concerts, readings, peace rallies, and parties that drew people into the hippie ethos.

Hippies rejected the mainstream American culture as shallow, repressed, materialistic, and deeply unhappy. They looked to Asian belief systems, like Buddhism and Hinduism, that sought inner peace. Seeking freedom from rules and regulations, they embraced the altered states of mind that meditation and psychedelics cultivated. Their ambitious and very loose approach invited playfulness and experimentation with social norms. Ideas and practices once considered unconventional—such as yoga, meditation, organic living, and

The city of San Francisco began to emerge as a mecca for gay culture around the late forties. In the years following World War II, the Black Cat bar became known for its gay and bohemian clientele. In 1951, the California State Supreme Court ruled that bars could not be shut down just for catering to homosexuals. This opened the door for the establishment of more gay bars and night clubs.

In 1955, Del Martin and Phyllis Lyons founded the Daughters of Bilitis, an underground lesbian social club in San Francisco. In 1961, Jose Sarria, a local drag queen, ran for the city's board of supervisors, becoming the first openly gay candidate to run for office in the US. In 1962, a coalition of gay bar owners formed the Tavern Guild, becoming the first gay business association in the US. By 1964, *LIFE* magazine declared San Francisco the gay capital of the country. By 1969, there were over fifty gay organizations in San Francisco.

The "free love" ethos of the hippie scene encouraged gay people to come out in public and supported the development of the Gay Rights movement. Despite these developments, being openly gay—or transgender—was still not always safe. Gay and trans youth who were rejected by their families often ended up on the streets of San Francisco, where they endured harassment from police and residents alike; the 1966 Compton's Cafeteria riot was a precursor of the events at New York City's Stonewall Inn in 1969.

©Harold Adler

"Gay," Golden Gate Park, San Francisco, California, 1969.

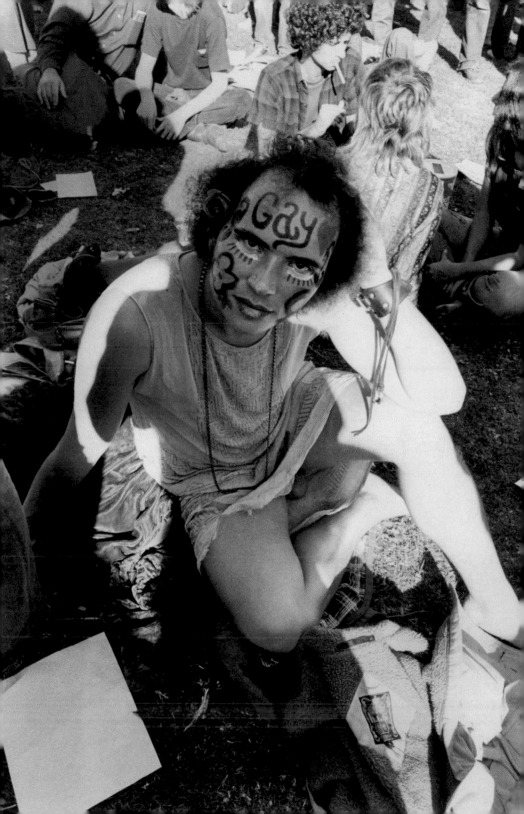

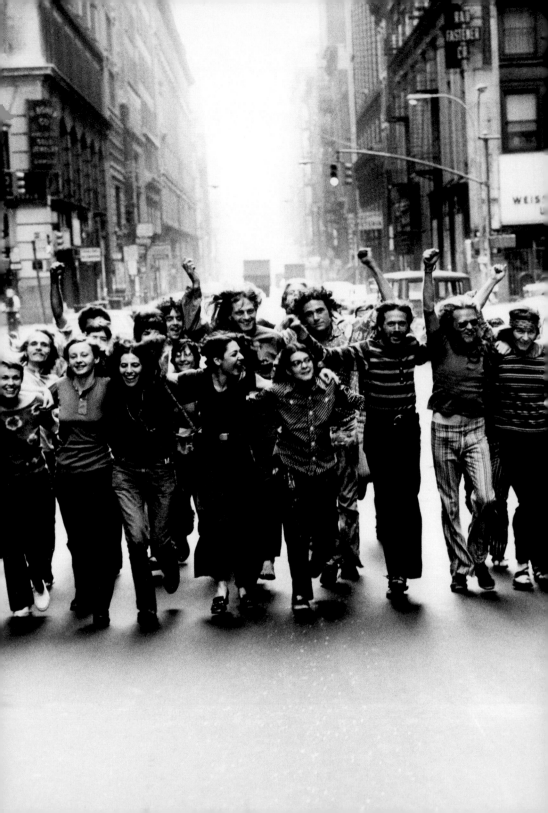

The Gay Liberation Front (GLF) was one of numerous LGBTQ+ rights organizations that formed in the wake of the June 1969 raid on the Stonewall Inn in New York City. The raid was nothing new for a gay bar like Stonewall, a frequent target of the NYPD. What was new was the way the crowd—white, Black, and Latinx gay men, drag queens, trans women, and lesbians—fought back that night, refusing to submit to police intimidation.

The uprising lasted for six days, shocking the public and the police, and transforming the LGBTQ+ community. While LGBTQ+ activists had been involved in organized and spontaneous demonstrations for over a decade, Stonewall got the country's attention and galvanized the movement.

The GLF consisted of a younger, more militant group of gay activists. They intentionally used the word "gay," which many organizations had previously avoided, preferring coded language like "Mattachine," "Bilitis," and "Janus." In the post-Stonewall moment, GLF activists like Michael Brown, Martha Shelley, Lois Hart, Bob Martin, and Karla Jay resisted silence and assimilation and urged people to be out, loud, and proud. They aligned themselves with organizations like the Black Panthers, who expressed solidarity with their struggle, and planned marches, fund-raising dances, consciousness-raising groups, and radical study groups.

Gay Liberation Front poster image, New York City, 1970.

On January 28, 1969, a massive blowout on an oil rig off the coast of Santa Barbara, California, caused what was then the nation's worst-ever oil spill. For an entire month, a thousand gallons of crude oil per hour spilled into the Pacific Ocean. Images of the devastation were shocking. California's pristine coast was a mess of filthy black beaches with thousands of oil-soaked birds and dead dolphins.

Wisconsin Senator Gaylord Nelson was one of many politicians who came to tour the spill. On his flight home, he read an article about the teach-ins being held on college campuses. A longtime advocate for the environment, Nelson was inspired by this model and had the idea for the first Earth Day.

He recruited grassroots activists, professors, scientists, students, and Republican Congressman Paul McCloskey (CA) to coordinate the effort. A staff of eighty-five people planned coast-to-coast events for Earth Day and brought together twenty million Americans in parks, auditoriums, classrooms, and the streets to advocate for a healthy, sustainable environment. Other countries took up the cause and altogether over two hundred million people in forty-one different countries showed their reverence for Mother Earth.

Thousands of colleges organized events, and groups that had long been fighting separate but related battles against pollution, power plants, and pesticides and for wilderness conservation and clean water united under the umbrella of environmental activism. Congress later passed some of its most robust environmental legislation, including the Clean Air Act of 1970, the Clean Water Act of 1972, and the Endangered Species Act of 1973.

©Associated Press Photo

A Pace College student in a gas mask "smells" a magnolia blossom in City Hall Park, New York City, on Earth Day, April 22, 1970.

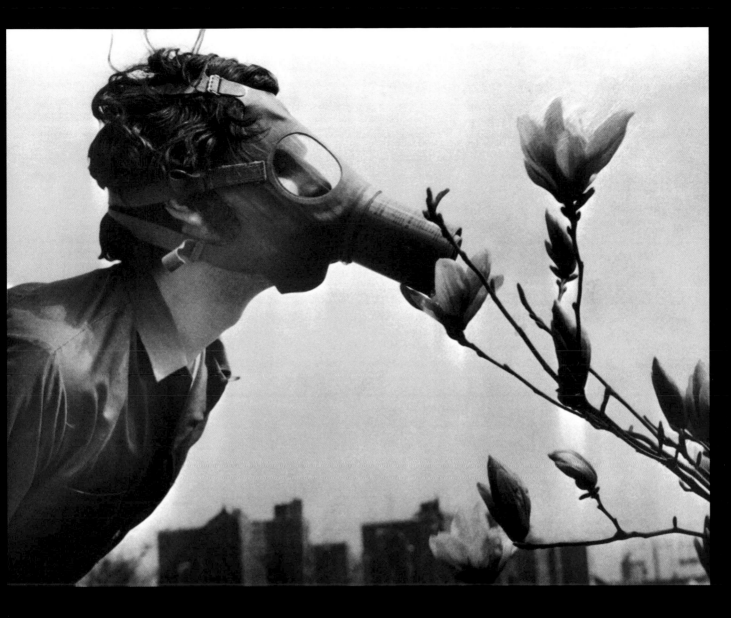

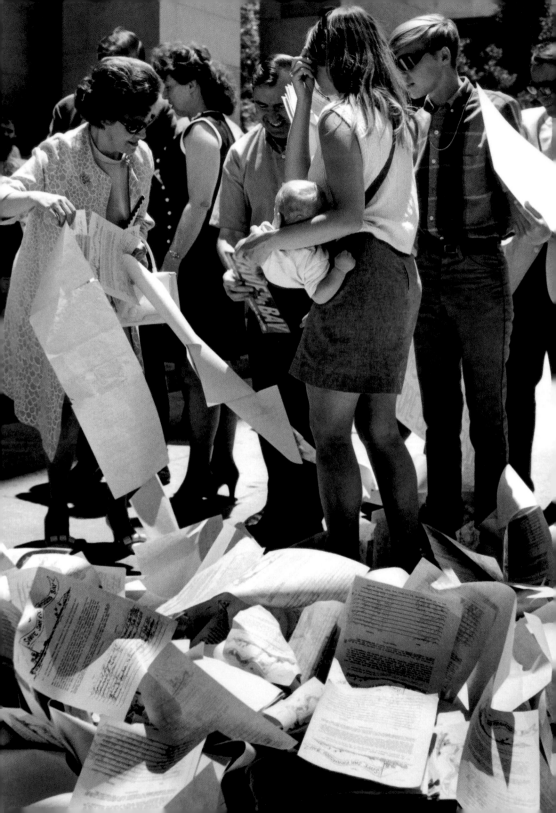

The San Francisco Bay is the largest Pacific estuary in the Americas. Once home to the native Ohlone people, it is now surrounded by some of America's most populous cities, including San Francisco, Berkeley, Oakland, and San Jose. Its wetlands are home to countless species of flora and fauna, and it almost certainly wouldn't be the same without Sylvia McLaughlin, Kay Kerr, and Esther Gulick, the three women who founded Save the Bay in 1961.

In the fifties, San Francisco Bay was heavily polluted. Toxic sewage and trash were regularly dumped into its waters. In 1959, the Army Corps of Engineers released a study showing that 70 percent of San Francisco Bay could be filled and turned into usable land. The city of Berkeley, where McLaughlin, Kerr, and Gulick lived, was considering doubling its size by extending three miles into the bay.

Outraged and concerned, the three women reached out to conservationists, but no one was willing to help, so they started their own organization. Save the Bay quickly proved to be a force: their grassroots efforts led to a moratorium on landfill in the Bay, convinced the state legislature to make a permanent conservation agency to regulate development along the shoreline, and helped establish the Don Edwards San Francisco Bay National Wildlife Refuge, the first and largest urban wildlife refuge in the country.

©Susan Landor

200,000 petition signatures for the Save the Bay Campaign sprawled over the Capitol Plaza, Sacramento, California, 1969.

73

In 1970, President Nixon appeared on TV to announce that the US was going to invade Cambodia to disrupt North Vietnamese supply lines. Shortly after, it was leaked that the US had been secretly bombing Cambodia for some time. The millions of citizens who were already opposed to the war were outraged—especially because Nixon had previously announced a drawdown of troops in Vietnam.

Students staged strikes and demonstrations on nearly four hundred colleges

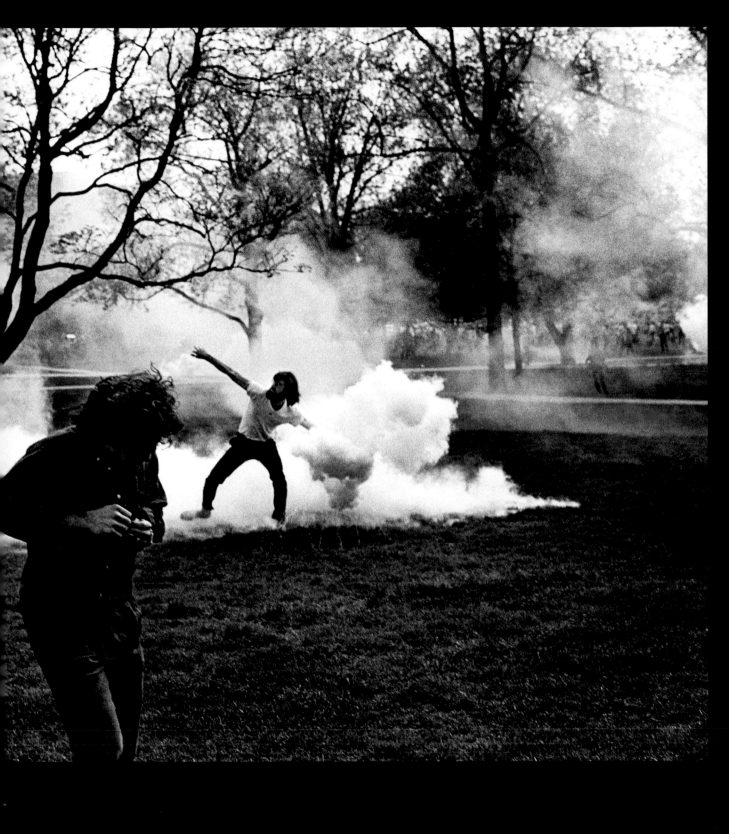

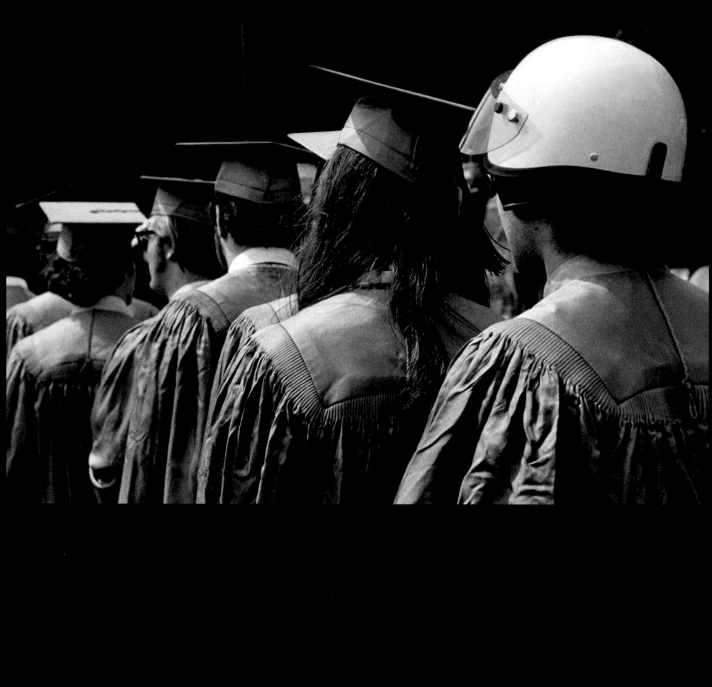

By the end of the school year in 1970, campus protests were increasing in size and volatility. The protests occurred at over 441 campuses and were so intense that many universities cancelled classes. A number cancelled commencement ceremonies entirely, including UC Berkeley, Boston University, and Kent State, which shut down for months immediately after the massacre.

Many colleges and universities that did hold commencement ceremonies in the spring of 1970 incorporated the anti-war movement into the events, holding moments of silence or including special readings reflecting on the national strife. Students at Rutgers carried a large blue flag with a peace symbol. New York University renamed their commencement ceremony "A Convocation for Peace" and included a reading from the Gettysburg Address.

At Columbia University, the site of a major student uprising in 1968, this graduate made an undeniably powerful statement by donning a riot helmet—the headwear of choice for campus police and National Guardsmen—in lieu of the traditional graduation cap.

Commencement at Columbia University, New York City, 1970.

In the midst of the social movements of the late 1960s, the women's movement began to pick up steam. Despite all the radical change of the 1960s, leadership within most movements and organizations, from unions to anti-war to SNCC and SCLC and SDS, was exclusively male. Many male leaders saw their female contemporaries not as equals but as secretaries and sex objects. To call out and reject this misogyny, women began to organize on their own terms and in their own spaces.

Fifty thousand women marched down New York City's Fifth Avenue for the Women's Strike for Peace and Equality, the largest-ever march focused on the rights and demands of women, organized by the National Organization for Women (NOW), founded in 1966 by a coalition of feminists including Pauli Murray, Betty Friedan, Aileen Hernandez, and Kathryn Clarenbach. The march emphasized three core demands: free abortion on demand, equal opportunity in employment and education, and the establishment of full-time childcare centers.

The Women's Strike for Peace and Equality commemorated the fiftieth anniversary of the passage of the Nineteenth Amendment, which prohibited states from denying the right to vote on account of sex. The march's timing highlighted how far women still had to go when it came to equal rights and treatment.

©Ken Light/Contact Press Images

Women's Strike for Peace and Equality march, Fifth Avenue, New York City, August 26, 1970.

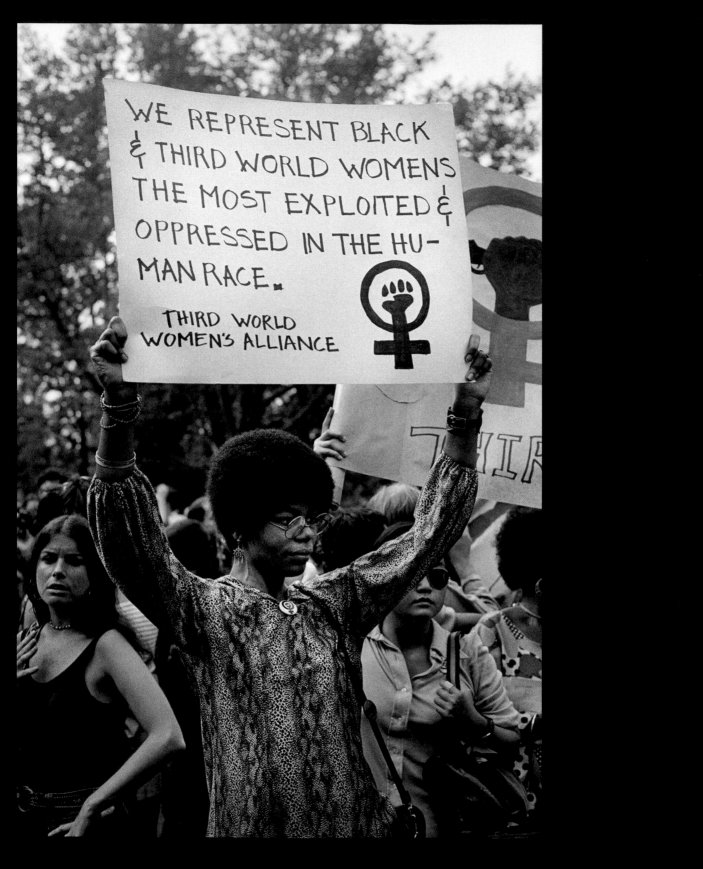

Third World Women's Alliance, Women's Strike
for Equality march, Fifth Avenue, New York City,
August 26, 1970.

The Third World Women's Alliance (TWWA) operated in various forms from
1968 to 1980 and was a key part of the emergence of Black feminist thought and
organizing. TWWA originated within SNCC as the Black Women's Liberation
Committee, with the purpose of addressing misogyny in the civil rights move-
ment. This group separated from SNCC and became the Black Women's Alliance;
in 1970 they aligned themselves with Puerto Rican women activists and became
the TWWA.

While rooted in Black feminist thought, the TWWA advocated for a global
approach to dismantling systems of oppression beyond US borders. They sought
to "take an active part in creating a socialist society where we can live as decent
human beings, free from the pressures of racism, economic exploitation, and
sexual oppression."

In addition to standing up to the patriarchy, TWWA also combated the lack of
intersectionality in feminism and the dominating internalized biases that white
feminists brought to the discussion. This need for inclusivity of all races, classes,
sexualities, and abilities continues to be an issue for movement organizers.

The La Marcha de la Reconquista was a three-month-long march that began at the US-Mexico border in southern California, and extended eight hundred miles north to Sacramento. It began on May 5, to coincide with the Mexican holiday of Cinco de Mayo, which commemorates the Mexican army's victory over French troops at the Battle of Puebla, and concluded in August with a large rally at the state capitol building.

The march was organized by a coalition of Chicano movement activists, including members of the anti-war Chicano Moratorium, the Black Panther–inspired Brown Berets, and the burgeoning La Raza Unida political party. These activists tried to unite the very geographically mixed people of Latin heritage by choosing the new identifier of *Chicano/a* as the umbrella under which to bond as a group.

The activists aimed to bring visibility to the myriad demands of their community, including justice for farmworkers; an end to police harassment and brutality; equal public education facilities; and an end to the draft, which disproportionately impacted young Chicano men, who were less likely to be eligible for student deferment.

©Jeffrey Blankfort

A Chicana Brown Beret raises her fist at La Marcha de la Reconquista, Sacramento, California, 1971.

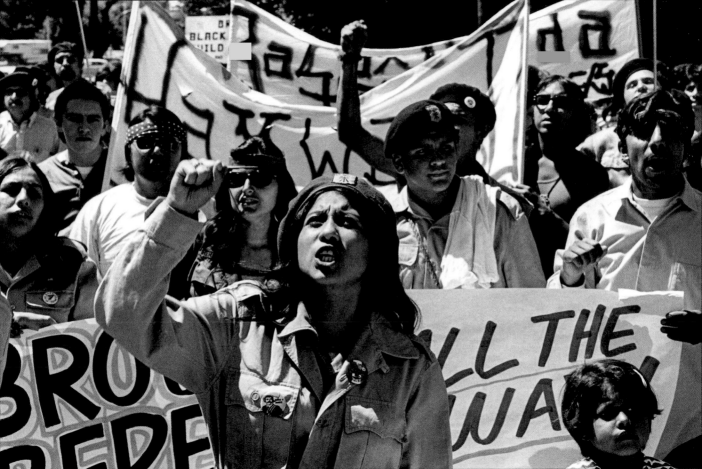

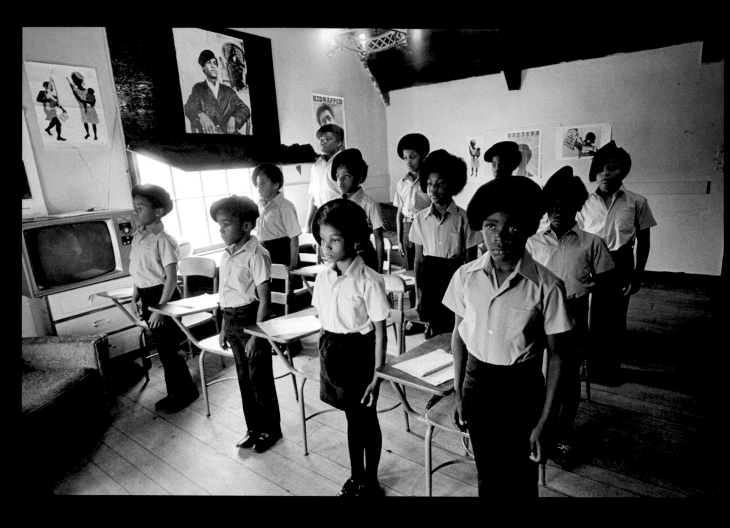

The fifth point of the Black Panthers' Ten-Point Program reads: "We want education that teaches us our true history and our role in the present-day society." Members of the Oakland-based BPP saw a pressing need for this: in 1971, the Oakland Unified School District had a 60-percent nonwhite student population and was one of the country's lowest-scoring districts. Despite the top national ranking of California schools overall during this era, resources were not reaching the poorer neighborhoods.

That year, the BPP opened its first liberation school in Oakland. The Intercommunal Youth Institute offered a private school experience, initially for twenty-eight enrollees, most from Panther families. The core curriculum was enriched with poetry, foreign languages, Black history and culture, yoga, meditation, and martial arts. Students did community service and developed writing skills by penning letters to political prisoners. Black teachers were hired to create a supportive learning environment without the internalized bias white teachers could have against Black students. Students also met Black role models like Maya Angelou, James Baldwin, and Richard Pryor.

By 1973, the school was ready to serve a population beyond the Panther community and had a long waitlist. Director Ericka Huggins moved the school to East Oakland, renaming it the Oakland Community School (OCS). The first class graduated in 1974. OCS students scored higher than Oakland Unified School District on standardized tests and, in 1976, California governor Jerry Brown and the state legislature commended OCS for "having set the standard for the highest level of elementary education in the state."

©Stephen Shames/Polaris

Children in a classroom at the Intercommunal Youth Institute, the Black Panther school in Oakland, California, 1971.

Many of the draftees who were sent to fight in Vietnam were also against the war. Consequently, there was a great deal of insubordination and anti-war resistance in the battlefield. The troops suffered from the lowest morale of any US war.

In combat, soldiers wore black armbands in solidarity with students; some deserted and some formed an underground culture of resistance within the ranks. Discharged soldiers became anti-war protesters back on US soil and formed Vietnam Veterans Against the War (VVAW). They organized a week of anti-war demonstrations in Washington, DC, called "Operation Dewey Canyon III," a reference to a series of small-scale military incursions into Laos and Cambodia.

At one point, a group of soldiers marched to the US capitol building to return their awards and medals to Congress, which had erected a fence to keep them out. Undeterred, the veterans stood before the crowd and stated their name, rank, regiment, and the award they received from their service in Vietnam. Then they turned around and threw their medals over the fence. Many marched with upside-down American flags, the universal sign for distress, or to indicate a state of war.

Several months earlier, the VVAW convened the "Winter Soldier Investigation," a three-day forum in Detroit, Michigan. Discharged servicemen from each service branch, including future US Senator John Kerry, testified about war crimes and atrocities they had committed or witnessed in Vietnam. Their accounts revealed that the US had also invaded Laos. This event was largely overlooked by the media at the time, but the material was picked up by Congress.

©George Butler/Contact Press Images

Vietnam Veterans Against the War raise the American flag upside down in protest, Operation Dewey Canyon III, Washington, DC, April 19–23, 1971.

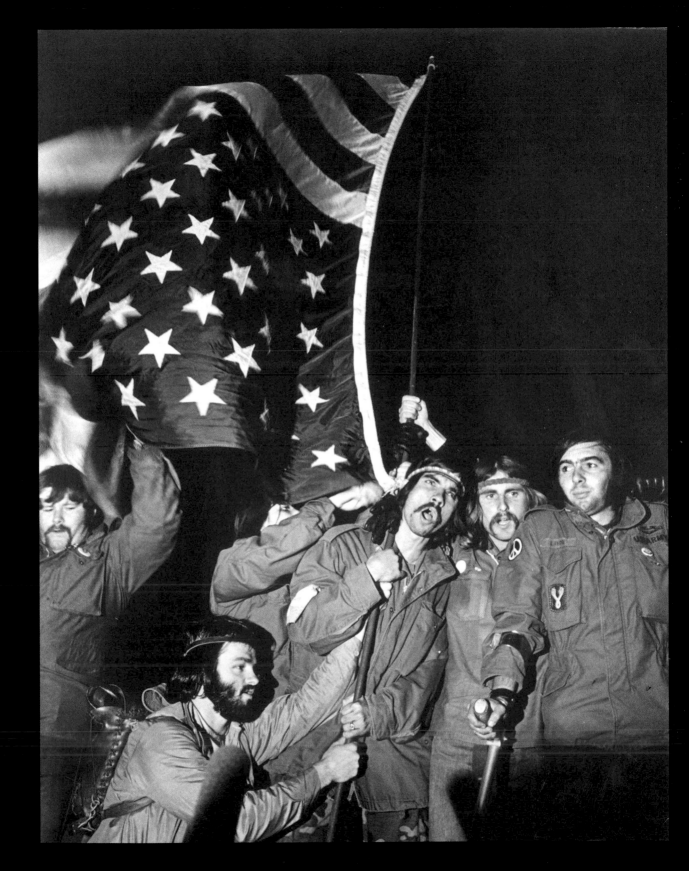

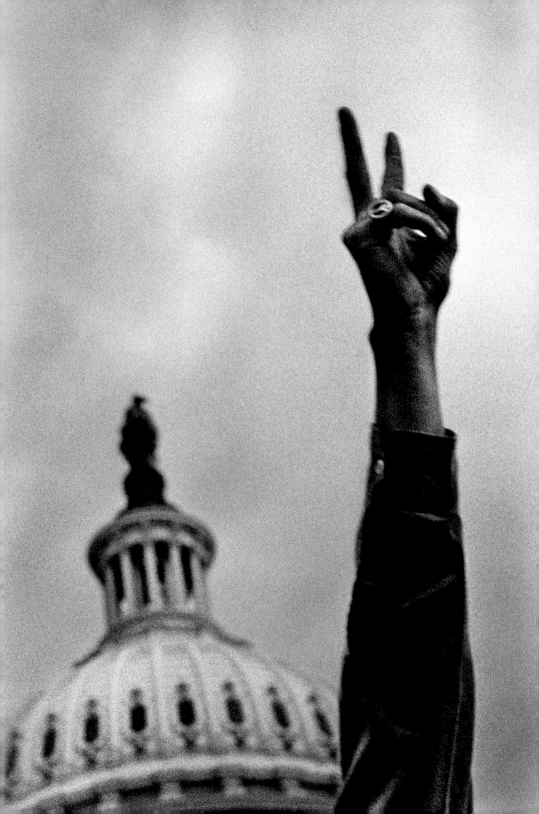

Hearings on Vietnam were started in 1966 by the US Senate Foreign Relations Committee and accelerated when Democratic Senator J. William Fulbright of Arkansas became the chair in 1971. The shocking testimony of the "Winter Soldier Investigation," which revealed that the US had secretly invaded Laos, caught the eye of Republican Senator Hatfield of Oregon, who asked that the transcripts be read into the Congressional Record and an investigation ensue as part of the Fulbright Hearings. Twenty-two hearings were held between April 20 and May 27.

Anti-war protesters again flocked to DC. An estimated five hundred thousand gathered on April 24. And a small militant activist group, the Mayday Tribe, was planning something new: to shut down the government completely through nonviolent action, starting on May 1 with their slogan and plan: "If the government won't stop the war, we'll stop the government."

Their tactical manual identified twenty-one strategic locations where protesters would block traffic, preventing government workers from getting to work. It was distributed across their national network prior to the protest, but unfortunately fell into the government's hands. On May 1st, protesters camped out in West Potomac Park; on May 2nd, the police broke up the encampment; and by May 3rd, police were waiting at the sites. While blockage of some roads, bridges, and buildings was successful and traffic was snarled, more than seven thousand people were locked up that day, and over twelve thousand by the end of the week, in what remains the largest mass arrest in US history. The May Day demonstration was the last major anti-war protest on a national scale. Though it didn't go as planned, it introduced new methods for disruptive protest tactics.

©Ken Light/Contact Press Images

May Day demonstration, Washington, DC, 1971.

In 1933, journalist and social activist Dorothy Day founded the Catholic Worker Movement (CWM) after an intense conversion to Catholicism. Her goal was to give direct aid to those in need. Day advocated "distributism," which she considered a hybrid of capitalism and socialism. She organized volunteers to provide food, clothing, and shelter in impoverished urban areas. CWM supports labor unions, human rights, cooperatives, and the expansion of nonviolent culture. Its communities continue to be self-governed, and there has never been a central leader, save Day. As such, it is a Christian anarchist movement and has served as a model of a nonviolent but revolutionary culture.

While the CWM supported many farmworkers across the country, their alliance with Cesar Chavez, himself a Catholic, was the most dynamic. He reached out to CWM early on, and it was integral to the UFW struggle. At the height of their activism, the seventy-six-year-old Day traveled to California to assist Cesar Chavez and the UFW, specifically to get arrested. At the time, the UFW was in a tense battle with the Teamsters Union. After their arrests, the protesters refused to post bail. Day kept a daily diary of her time in jail, writing about racist prison guards, staying up all night to pray for Chavez while he negotiated with the Teamsters, and recounting a visit from folk singer Joan Baez, who she says "sang to [them] and the other prisoners in the yard" with a voice so "remarkable . . . it tore at your heart."

Dorothy Day faces sheriff deputies at Giumarra orchard picket with the United Farm Workers Union, AFL-CIO, Lamont, California, 1973.

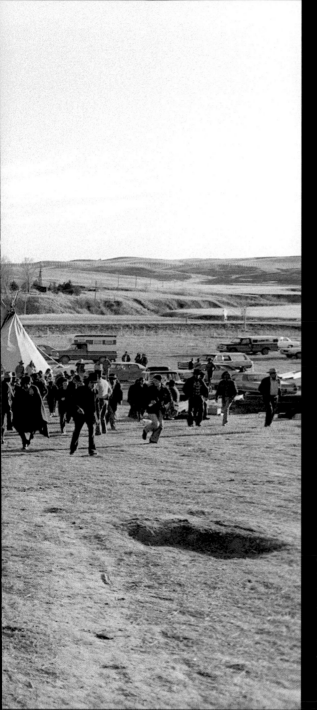

This tiny town has had a long and painful history with the US government. In 1890, the United States Army killed several hundred Lakota Indian men, women, and children on the Pine Ridge Reservation in South Dakota, after a failed attempt to disarm the camp. This became known as the Wounded Knee Massacre and the premier example of the abuse laid upon the American Indian Nations at the hands of the US government.

In 1973, the Oglala Lakota had become unhappy with Dick Wilson, their corrupt tribal chairman, and with the government's ongoing failure to honor treaties. They appealed to Amerian Indian Movement (AIM) leaders for help and soon organized two hundred people to occupy Wounded Knee, a location they chose for its powerful history. They seized the town and demanded that the government honor its nineteenth- and twentieth-century treaties. The effort was similar to the occupation of Alcatraz, but more militant and brutal.

Federal marshals and the National Guard quickly surrounded the town, exchanging intermittent gunfire with the AIM activists. Eventually the Guard cut off electricity and water to the town. When a sympathetic pilot dropped food and supplies on the fiftieth day, occupiers ran out from the cover of their buildings to retrieve the drop. The government agents opened fire, killing a Cherokee activist, the first to be killed during the occupation. After seventy-one days, negotiations

The San Francisco Mime Troupe was founded in 1959 by R. G. Davis. Despite the word "mime" in their name, these performers were boisterous, musical, and far from silent. Mime Troupe shows were always topical, critiquing war, sexism, racism, and capitalism. Because of this, they often clashed with the police—R. G. Davis was notoriously arrested during a performance in 1965, in front of an audience of a thousand people.

The Troupe started out doing avant-garde performances in bohemian lofts and basements. Later they were inspired by the comic, farcical Italian Renaissance tradition of *commedia dell'arte*. They moved on to performing free shows in public spaces in San Francisco, especially Golden Gate Park, and eventually began touring. In 1971, they went to Washington, DC, to take part in a large series of the anti-war May Day protests organized by the Mayday Tribe.

The San Francisco Mime Troupe was part of a tradition of experimental political street theater, including the Living Theatre, founded on anarchist principles in 1947; Bread and Puppet Theater, founded in Vermont in 1962 and known for their massive puppet effigies; and El Teatro Campesino, founded in 1965 as part of the UFW. El Teatro Campesino presents political theater from the Latinx point of view; in the early years they joined workers on picket lines and marches.

©Ken Light/Contact Press Images

San Francisco Mime Troupe, May Day Demonstration, Washington, DC, 1971.

In June 1972, five men were arrested for breaking into and illegally wiretapping the Democratic National Committee headquarters, housed in the Watergate apartment complex in Washington, DC. During the sentencing process, it was revealed that the White House was involved with the break-in. *Washington Post* journalists Carl Bernstein and Bob Woodward were assigned to the story and eventually exposed the extent of the conspiracy.

An investigation ensued, and by July of 1974, the House Judiciary Committee passed three articles of impeachment. Transcripts of the infamous Watergate tapes were finally released, implicating Nixon in a complex web of lies, corruption, and political cover-up.

In early August, Nixon opted to resign, and Vice President Gerald Ford was immediately sworn in as president. Richard Nixon was the first American president to resign from office. There were many additional convictions, and as a result, Congress instituted campaign finance reform.

This marked a new divide in politics and in worldviews between conservatives and liberals. For those in the anti-war movement, Nixon's resignation was a bittersweet victory. They were glad to see him go and felt vindicated by the incontrovertible proof of core governmental corruption. Conservatives and the Republican segment of Congress learned to be more antagonistic toward and mistrustful of investigative journalism, but everyone recognized the need for vigilant scrutiny of government.

©Ken Light/Contact Press Images
Nixon resigns, Oakland, California, August 9, 1974.

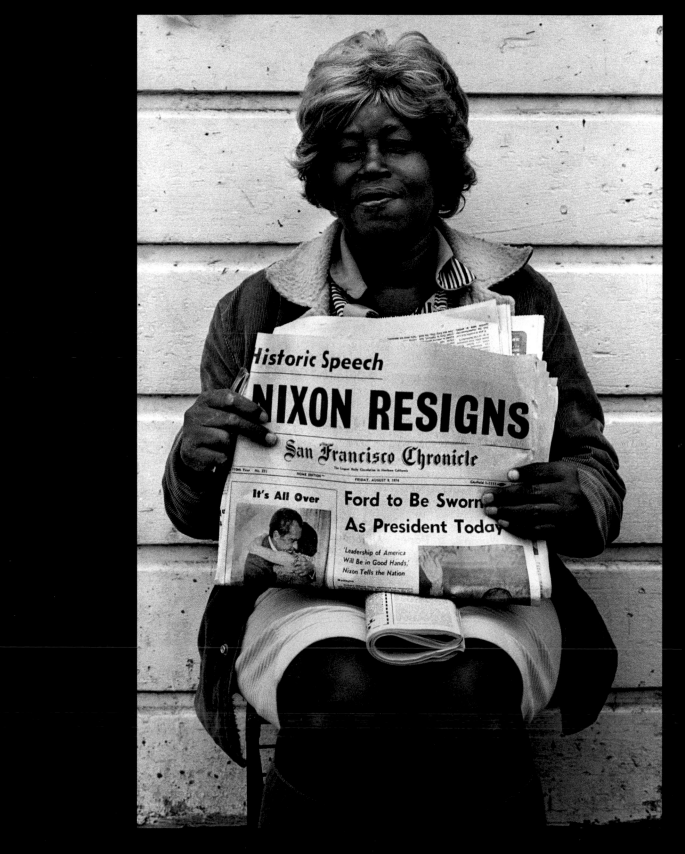

A nuclear power plant on an earthquake fault?

PG&E is making the mistake of our lives.

STOP DIABLO CANYON

Rally and Energy Fair April 7 S.F. Civic Center 12 Noon

Musicians: Bonnie Raitt Danny O'Keefe Mimi Fariña Tim Hardin Norton Buffalo and Bill White Kate Wolf
Honey Creek John Hall Speakers: Ralph Nader Dennis Banks Carol Ruth Silver Harry Britt

Support Alternative Energy

Abalone Alliance and Citizens for a Better Environment For more information call: 781-5342 Childcare and disabled access.

EXHAUSTION AND BACKLASH

By Nixon's resignation, the idealism and energy of the sixties had given way to exhaustion, frustration, and cynicism. In 1976, writer and cultural critic Tom Wolfe deemed the seventies the "me decade," arguing that white middle- and upper-class Americans had abandoned the collective, community-based ethos for an individualized, self-absorbed mode.

The conservative movement, as expressed by the Religious Right and the New Right, mounted a powerful backlash against the recent revolutionary social, cultural, and political upheavals. Jimmy Carter's campaign and presidency brought faith into mainstream politics; his highly visible, devout Christianity encouraged the rise of the conservative Christian right. To these evangelical Christian and conservative organizations, the great progress made by women, the LGBTQ+ community, and people of color threatened the status quo.

An insidious part of this backlash was the Southern Strategy of the Republican party, an electoral effort to realign the South by walking back civil rights through local laws. Harry Dent, chair of the South Carolina Republican party, used concepts like fiscal conservatism, cutting taxes, and balancing the budget as dog whistles for policies that would most hurt low-income African Americans.

The passage of *Roe v. Wade* in 1974 was a turning point in the feminist movement, but it was also a major moment for conservative activists, who began their ongoing crusade against abortion rights. Their activism, including protesting at women's health clinics and marching in Washington, DC, was answered by equally committed feminist activists who were committed to protecting a woman's right to choose.

Opposition to the Equal Rights Amendment (ERA) in the 1970s and early 1980s further evidenced this fierce cultural divide. The ERA stipulated that "equality of rights under the law shall not be denied or abridged by the United States or by any State on account of sex." Some of its fiercest opponents were conservative women like Phyllis Schlafly, who relied on racist, misogynist arguments. This organized effort laid the groundwork for conservative movements in the following decades.

The 1980 election of Ronald Reagan further threatened the progressive vision. Reagan's trickle-down economic theory—combined with large-scale deregulation of industry, rollbacks of labor and union protections, and the racist War on Drugs devastated the poor working-class and urban communities of color. Deinstitutionalization of state mental hospital patients, released without resources to handle their care, made homelessness a highly visible problem. The Dickensian answer to social ills was prison and bigger police forces.

This era may have lacked the mass mobilization and intense radicalism of the late sixties and early seventies, but many committed, passionate Americans still refused to accept militarism and dangerous American foreign and domestic policies through new movements and protests that spanned the spectrum.

©Public Media Center, 1979

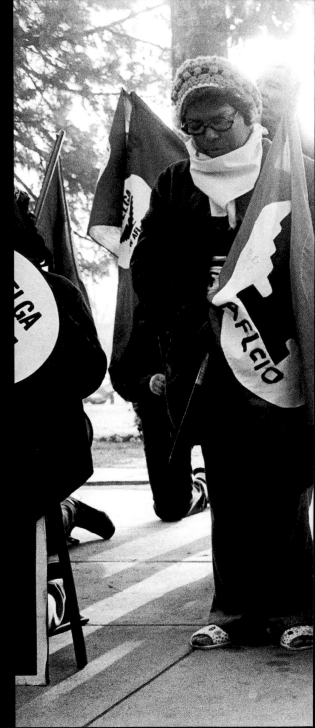

The Fair Labor Standards Act of 1938 exempted agricultural workers from any of the standards in an effort to appease segregationist southern Democrats, who still could not abide giving African Americans an equal footing with whites in the workplace. Meaningful progress was nonexistent until Cesar Chavez, Dolores Huerta, and the United Farm Workers (UFW) put this issue on the national stage by striking and refusing to work for winemakers and grape and lettuce growers. In 1970, after five years of striking, the UFW won better pay, more benefits and some workplace protections. But the struggle for fair work conditions in the fields was not over.

During the summer of 1973, the nation's largest winemaker, Gallo, decided not to renew its contract with the farm workers, signing instead with the International Brotherhood of Teamsters. Gallo produced one out of every three bottles of wine sold in the United States, and the loss of the Gallo contract infuriated the UFW leadership, who argued that the Teamsters' contract gave the workers less protection from pesticides and a diminished voice in the fields.

In response, Cesar Chavez and the UFW called for a boycott of all Gallo wines. In March of 1975, thousands of farm workers and their supporters set out from San Francisco for a weeklong, 110-mile march to Gallo headquarters in Modesto,

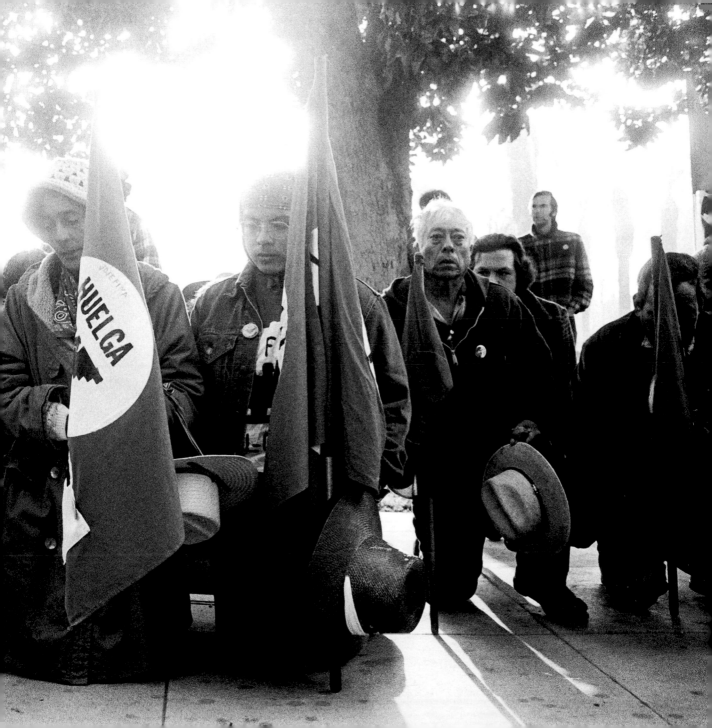

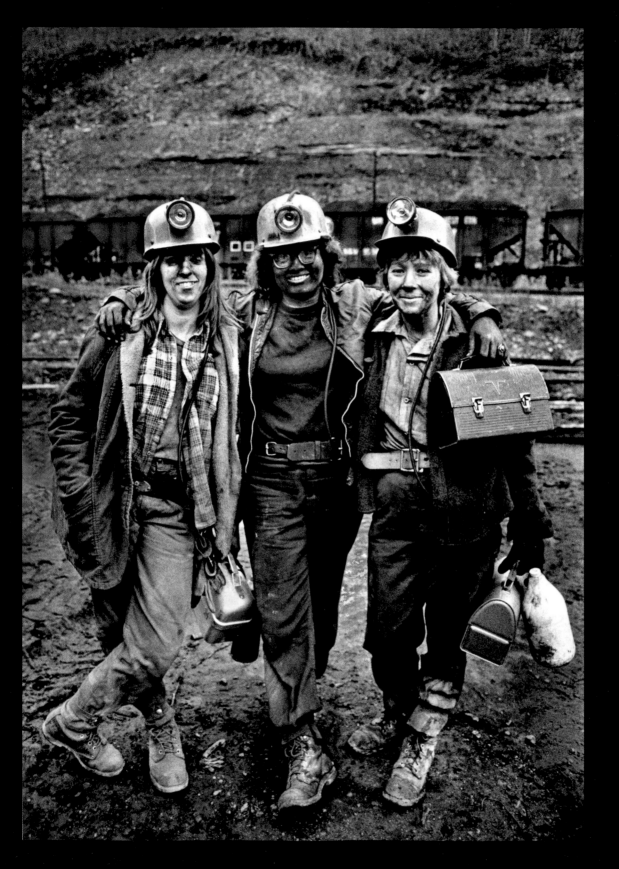

Coal mining has long been a dangerous and deadly job. For those who grew up in coal country, the work was lucrative and a source of cultural pride—and it was *not* for women. An old mining superstition warned it was bad luck for a woman to even enter a mine, let alone work in one. In coal country during the seventies, the only jobs with decent wages were in the mines. A woman could earn $2.50 per hour working in a bank or $7.90 or more digging for coal, so naturally they wanted those jobs.

A few women had always worked in the mines, but the feminist movement inspired more women to apply. By the mid-seventies, more women were seeking these jobs, but very few were getting hired. In 1977, a group of women formed the Coal Employment Project (CEP), a nonprofit group that advocated for the rights of women coal miners.

In 1978, CEP filed a complaint against 153 coal companies, charging that the companies were federal contractors and forbidden by law from discrimination. Their efforts led to $370,000 in back pay for jobs denied to women, an agreement that coal companies would bring women up to 37 percent of the mining workforce, and job training and placement programs for women. By the end of the seventies there were over three thousand women working in America's coal mines. Their work was a major breakthrough for women in all industrial workplaces, which often benefit from contracts with the government.

©1976, Earl Dotter

Women coal miners, Vansant, Virginia, 1976.

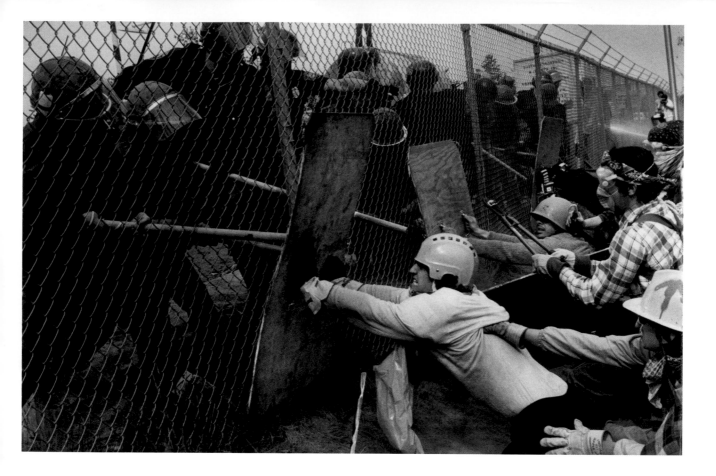

Antinuclear protests began in the US as early as 1946, after the United States launched "Operation Crossroads," a pair of nuclear weapons tests at Bikini Atoll in the Marshall Islands. The antinuclear movement grew during the fifties and sixties, with global resistance to the proliferation of nuclear weapons as well as the development of nuclear power.

After the oil embargo of 1973, President Nixon announced a plan to expand research into and application of nuclear energy, and to fund the development of new generations of nuclear plants. His goal was to have a thousand power plants in place by the year 2000. The antinuclear activists sprang into organized action.

Construction of the Seabrook Nuclear Power Plant began in a small town in New Hampshire in 1978. Years earlier, outraged local residents who had opposed the plant's construction formed the Clamshell Alliance. The Alliance organized several protests to block the construction, but the biggest was on June 25, when nearly twenty thousand protesters marched to the site. Members cut through barbed wire and camped on the property for three days. Fourteen hundred people were arrested for civil disobedience, and while they didn't stop the construction, they caused a significant delay, garnered international media attention, and inspired antinuclear activists to keep up the fight.

©Michael Maher, *The Lowell Sun*

Seabrook Nuclear Power Plant protest, Seabrook, New Hampshire, June 25, 1978.

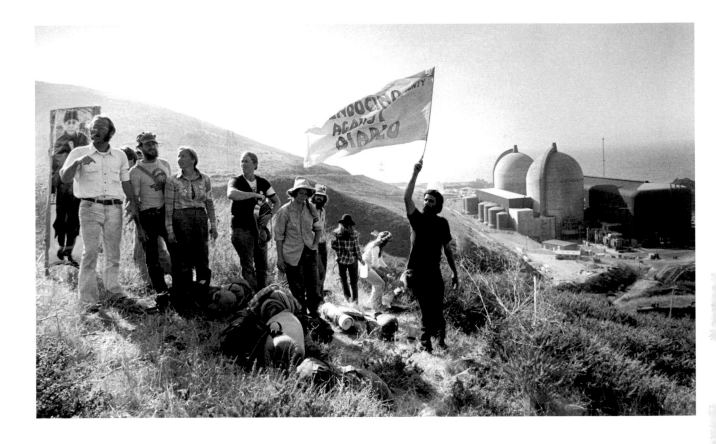

©Ken Chen/*San Luis Obispo County Tribune*

A group of antinuclear protesters wave a flag above the Diablo Canyon nuclear power plant as thousands were arrested during a blockade of the plant, Diablo Canyon, California, 1981.

Proponents of nuclear energy maintain that power plants are safe, cheaper than coal and solar, and emit very little greenhouse gas. Opponents of nuclear energy argue that there are numerous health, environmental, and security issues, but the primary concern is of a "nuclear meltdown." A meltdown would release deadly radioactive materials that can cause radioactive contamination, fallout, and poisoning.

In 1979, a power plant in Three Mile Island near Harrisburg, Pennsylvania, suffered a partial meltdown. Over a hundred thousand nearby residents were evacuated as a result of the most significant accident in US commercial nuclear power plant history. Public anxiety over nuclear power plants peaked and the antinuclear movement intensified its efforts.

In 1981, a coalition called the Abalone Alliance organized to block the construction of a power plant near San Luis Obispo, California, several miles from a major earthquake fault line. Inspired by the Clamshell Alliance protests at Seabrook, and bolstered by public support in the wake of the Three Mile Island debacle, thousands of protesters hiked to the Diablo Canyon Nuclear Power Plant. They practiced nonviolent civil disobedience by blocking the gates for nearly two weeks. In total, around thirty thousand people joined the blockade, and nearly two thousand protesters, including celebrities like singer Jackson Browne, were arrested.

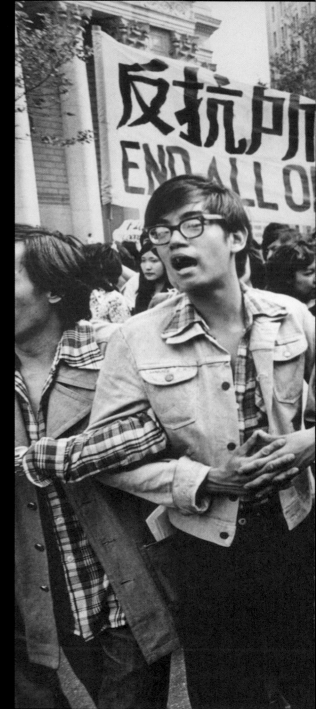

Two motorists got into a minor collision in New York City's Chinatown neighborhood on April 26, 1975. A heated argument ensued, and a crowd of onlookers collected around the accident. When police showed up and started to push the crowd back, they aggressively shoved a fifteen-year-old Chinese-American boy to the ground.

Peter Yew, a twenty-seven-year-old architectural engineer, witnessed the assault on the boy and yelled in protest. In response, a police officer beat and hauled him in to the police precinct. Yew was stripped, handcuffed, and beaten again by three officers. He suffered multiple injuries, including punctured eardrums. Yew was then charged with resisting arrest and assault on a police officer.

Yew's assault was the last straw for New York City's Chinatown community. For years, they had endured harassment, intimidation, and violence at the hands of the NYPD. Many older people were afraid to speak up, but the younger generation was ready to resist. The Asian Americans for Equal Opportunity (AAFEO) marched on City Hall to demand dismissal of all charges against Yew and the end of discrimination in the Chinese community. Fifteen thousand people took to the streets to protest Yew's beating, and nearly every business in Chinatown closed shop for the day. Signs in the windows read "Closed to Protest Police

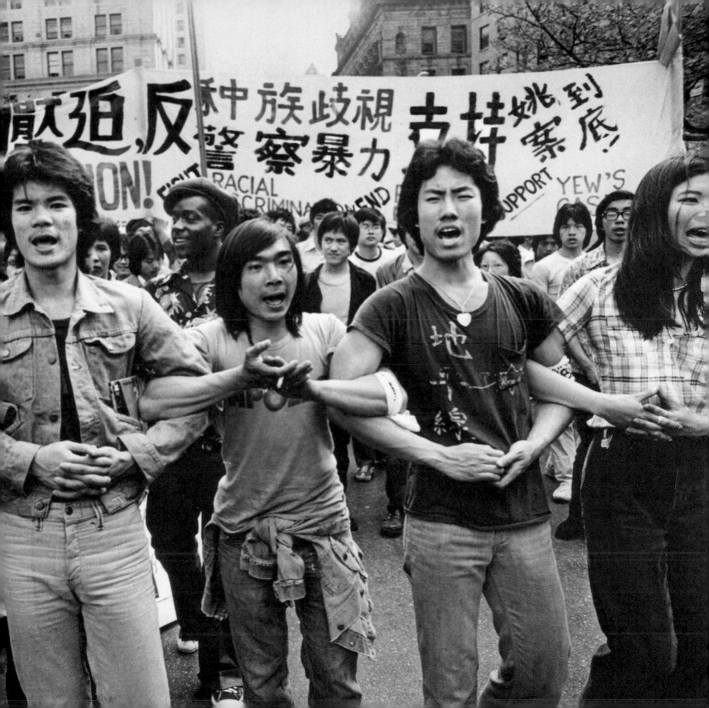

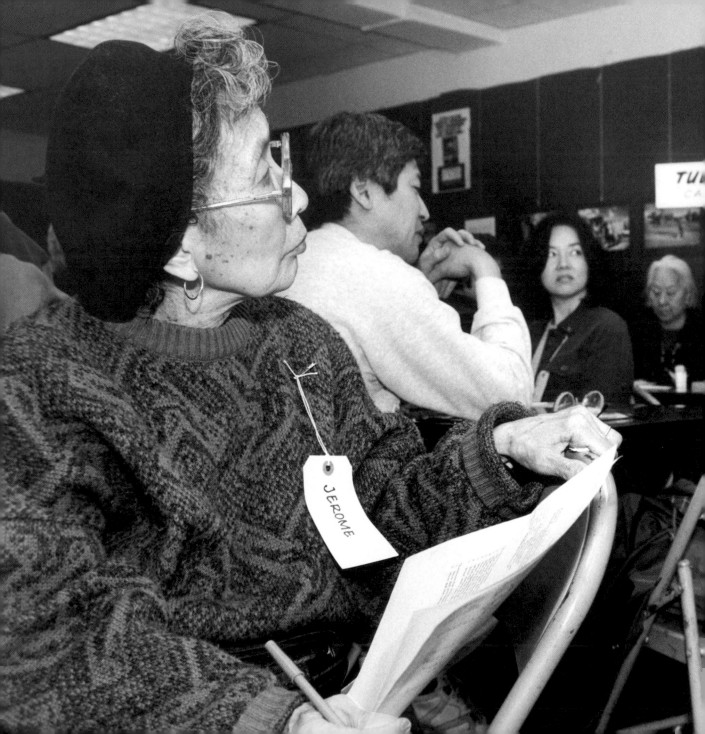

In 1942, ten weeks after the Japanese-led attack on Pearl Harbor, President Roosevelt issued Executive Order 9066 (EO 9066), authorizing the forced removal and incarceration of 120,000 American citizens of Japanese descent who were living on the West Coast. Men, women, and children of all ages were imprisoned in concentration camps for several years. Upon their release at the war's end, most returned to find their homes, businesses, and assets had been sold off.

The civil rights movement and ethnic pride movements of the sixties and seventies inspired Japanese-American activists, many of whom had been incarcerated as children or whose parents and grandparents had lived through the camps, to raise awareness of this mass incarceration and to seek redress. In 1976, after years of grassroots organizing and political lobbying, President Gerald Ford officially rescinded EO 9066. In 1978, the Japanese American Citizens League called for the government to pay a restitution of $25,000 per internee; it took years, but in 1993, former camp inmates or their heirs received reparations and a formal apology from Congress.

This photo was at the February 19 Day of Remembrance, an annual event started by Japanese American activists to commemorate the signing of EO 9066. Pictured in the foreground is Yuri Kochiyama, whose incarceration as a teenager

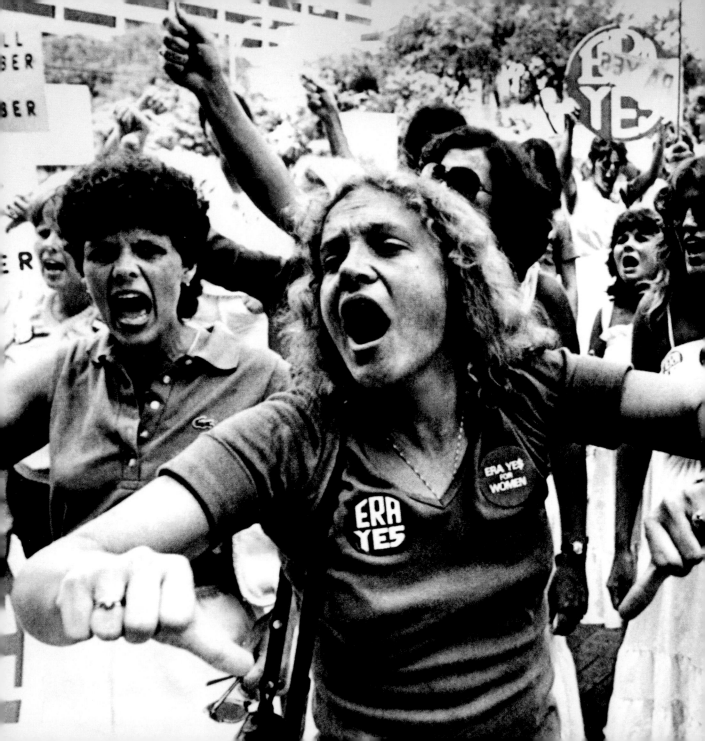

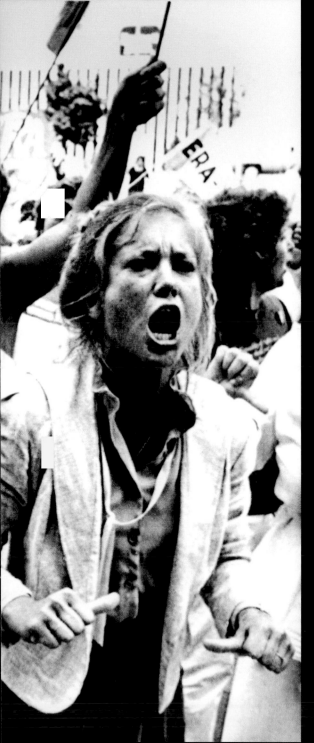

The Equal Rights Amendment (ERA), which would guarantee equal legal rights for all Americans regardless of sex, was introduced to Congress for the first time in 1923. Author and suffrage activist Alice Paul aimed to honor a guarantee that "Men and women shall have equal rights throughout the United States."

The ERA was introduced in every session of Congress from 1923 until it finally passed both houses of Congress in 1972, thanks to generations of women who lobbied and organized on its behalf. It then went to the states for ratification, requiring approval by three-fourths of the fifty states. By 1973, thirty state legislatures had ratified it.

During the next ten years, thousands of women across the country lobbied, marched, and rallied to convince eight more states to ratify the ERA. They faced mounting opposition, from conservative activists like Phyllis Schlafly, who became the face of the Stop ERA campaign. As the final votes came in 1982, thousands of pro-ERA activists swarmed statehouses—like the one in Florida, where the state legislature narrowly voted down the ERA—chanting, "Vote them out!" In January 2020, Virginia became the thirty-eighth state to vote in favor of the ERA, but the Trump administration has stated that the ratification

By the end of the 1970s, New York City, like many other American cities, was struggling with urban decline, poverty, and a burgeoning homeless population. The financial crisis of 1975 had cleaned out the city tax funds for maintaining or building new low-income housing, and Reagan-era policies eliminated federal housing development monies and cut funding for programs that served and supported low-income communities.

Particularly impacted were low-income communities of color, whose neighborhood buildings, services, and facilities had become increasingly underserved by the city. These long-standing, vibrant communities became vulnerable to developers and real estate speculators eager to move in and buy up abandoned or foreclosed properties and resell them to wealthier, whiter populations. Stable community networks were disrupted and people were pushed out into the unknown.

Community and housing activists across the city rallied to stop gentrification. While often described euphemistically as "revitalization" or "urban renewal," gentrification is ultimately a power play by people with means who respond to an inadequate housing stock by buying cheaper housing, effectively expropriating working-class housing for themselves. This was the case in East Harlem, also known as "El Barrio," a predominantly Puerto Rican community in the early eighties. The members of the Committee to Save East Harlem rallied in their community, determined to raise awareness of the threats to their lives, businesses, and homes.

©Joe Rodriguez

The Committee to Save East Harlem
anti-gentrification demonstration, East Harlem,
New York City, 1984.

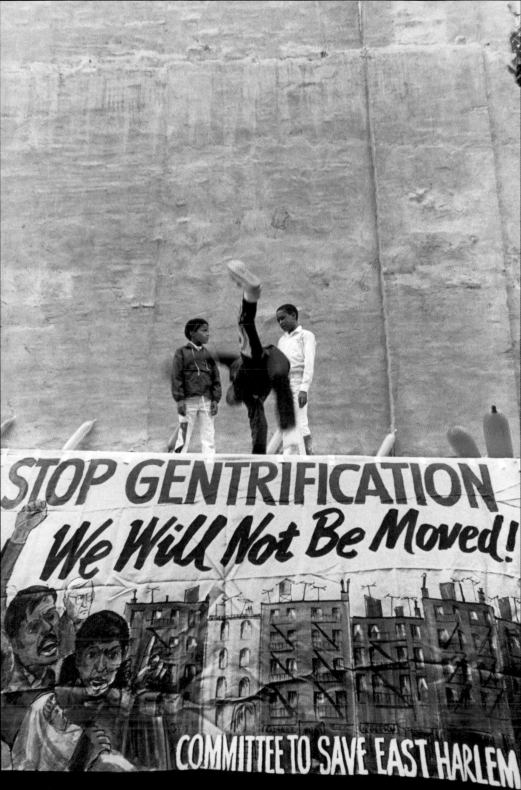

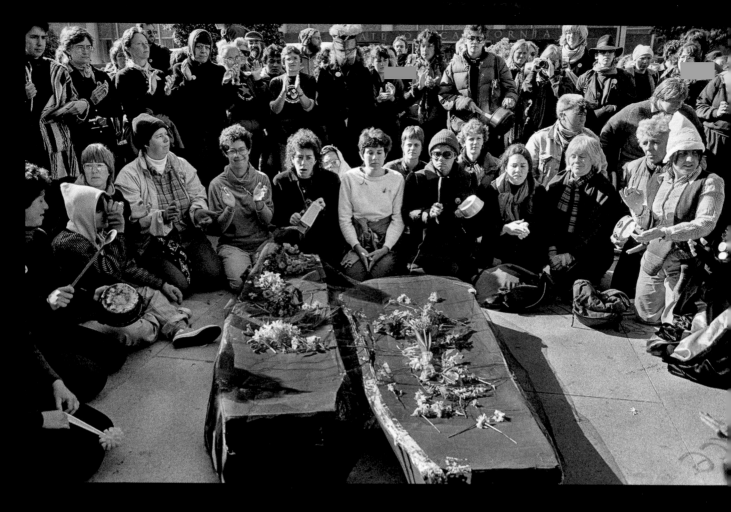

The Reagan administration aimed to preserve the conservative and oppressive governments in Central America by sending arms to these countries. In 1983, Congress prohibited federal funding of the Nicaraguan right-wing rebel Contras, a group that sought to destabilize the left-wing Sandinista government. Reagan continued to support them secretly by selling arms to Iran and passing the proceeds to the Contras, which once revealed, became known as the Iran-Contra affair. The US also supported government death squads in El Salvador that murdered thousands of civilians. After the White House ordered troops to invade Grenada in October 1983, many people feared that countries like Nicaragua or El Salvador could be next.

The Central American solidarity movement quickly emerged. Protests erupted across the country as groups staged street theater actions, protests, and marches against US foreign policy in Central America. Vietnam was still a vivid memory for many, and the public was strongly opposed to more unnecessary foreign intervention.

Anti–Vietnam War activists resumed their organizing, and a coalition of religious leaders, feminists, labor union activists, veterans associations, and civic groups built a strong grassroots lobby in Washington, DC. People took pledges of resistance, promising to engage in mass civil disobedience if the US invaded Nicaragua or El Salvador, and many cities created rapid-response networks to ensure that protesters could mobilize immediately in the event of further military action.

©Janet Delaney

Coffins in front of Federal Building during the Emergency Response Network protest mobilizing against Reagan's War in Central America, San Francisco, California, 1985.

In 1983, over twelve thousand women lived communally protesting American militarism and nuclear proliferation, and trained in nonviolent resistance near the Seneca Army Depot where they could draw attention to the ballistic missiles there. President Reagan was widely suspected of wanting to deploy them to NATO bases for future wars.

The site was symbolic. Romulus was an Underground Railroad stop and home to suffrage activist Elizabeth Cady Stanton. Nearby is Seneca Falls, where the women's rights movement emerged during the 1848 anti-slavery convention.

The Women's Encampment became a living expression of women's potential and empowerment and a school for making connections between militarism, patriarchy, racism, unemployment, and global poverty. Posters invited women to join them for "a day...a week...a month." It continued to be a space for women's organizing and activism until 2006. It influenced other peace groups, like the Window Peace Project in New York City.

©Mima Cataldo

"Hang It Up," at the Women's Encampment for a Future of Peace and Justice, Romulus, New York, 1983.

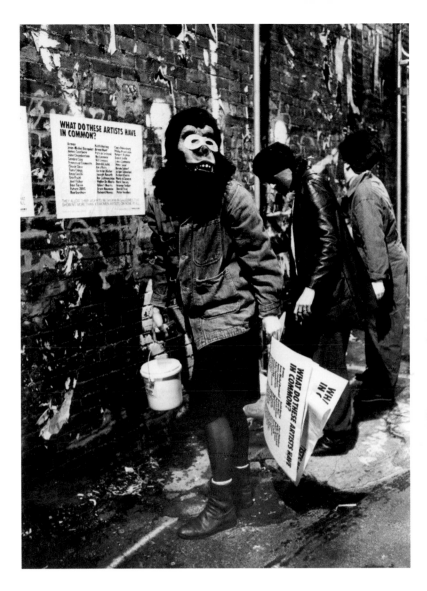

The Guerilla Girls are an anonymous group of feminist activist artists who use facts, humor, and provocative stunts to protest the patriarchy and draw attention to the lack of gender and racial parity in the art world. Their efforts began in 1985, when the Museum of Modern Art in New York showed only thirteen, all-white women out of 165 artists from seventeen countries.

They created posters pointing out art world sexism and racism, then wheat-pasted them all over the SoHo and Chelsea neighborhoods. As their infamy grew, they protected their identities by wearing gorilla masks and using the names of dead women artists like Anaïs Nin, Frida Kahlo, and Käthe Kollwitz.

The Guerilla Girls' drove the art world and the media mad with curiosity. This helped spread their message to the wider public. They expanded their message to cover abortion, rape, cosmetic surgery, education, and the Clarence Thomas hearing where Anita Hill appeared, among others issues. They continue their work today and have become an important part of art history.

Guerrilla Girls wheat-paste posters throughout Manhattan after midnight, New York City, 1985.

The first cases of acquired immunodeficiency syndrome (AIDS/HIV) were clinically reported in 1981. The significant number of people living with and dying from AIDS were gay and bisexual men. Because of this, action to address and stop the epidemic by the medical and political establishments was devastatingly slow. In fact, President Reagan didn't say the word "AIDS" until 1986.

The LGBTQ+ community became a juggernaut that worked on many fronts, confronting an unresponsive medical and governmental system and fighting to educate, promote research and treatments, change laws, and demand solutions to this terrifying epidemic. Over twenty-four thousand people had died by 1986, including actor Rock Hudson and designer Perry Ellis. In the midst of this, several men came together in New York City to form one of the most effective groups ever, calling themselves AIDS Coalition to Unleash Power (ACT UP).

Just as many straight people saw AIDS as a "gay disease," some in the Black community saw it as a "white man's disease." Neither was true, and raising awareness about this was a critical part of early AIDS activism. In 1985, the *New York Times* published new findings from a prominent epidemiologist: Black people, who made up just 12.5 percent of the US population, accounted for 25 percent of the fourteen thousand reported AIDS cases. "AIDS," the article stated, "is color-blind."

Gay Pride march, San Francisco, California, 1985.

1986–1993

SILENCE=DEATH

Why is Reagan silent about AIDS? What is really going on at the Center for Disease Control, the Federal Drug Administration, and the Vatican?

Gays and lesbians are not expendable...Use your power...Vote...Boycott...Defend yourselves...Turn anger, fear, grief into action.

IT'S ALL ABOUT THE ECONOMY

Economic forces increasingly shaped activism in the US. By 1986, Americans had endured back-to-back recessions; wages continued to stagnate, while college costs and student loan debt soared. In 1987, the stock market took its biggest dip since 1929 and the Dow didn't recover for two years.

Nevertheless, progressive activists continued their fights on numerous fronts, including AIDS activism, LGBTQ+ and reproductive rights, and resistance to aggressive American foreign policy. One successful effort was the anti-apartheid movement, which was picked up—and largely led—by college students who pressured school administrations to divest from South Africa and to condemn the apartheid laws. American corporations did divest and the US joined the global anti-apartheid movement. Apartheid ended in 1994.

The continuing larger theme connecting individual movements was protest of military intervention in other countries, this time focused on nuclear capacity. The Reagan doctrine essentially established a new cold war to dismantle Soviet-backed, pro-communist governments in Africa, Asia, and Latin America by providing overt and covert aid to anti-communist guerrillas and resistance movements. Reagan's "Star Wars" missile defense system dominated the media. Activists worked in coalition groups to stop military intervention and to halt the nuclear weapons buildup with the Nuclear Freeze campaign.

The right-wing Republican reign did not end when Reagan left office. In 1988, Vice President George H. W. Bush defeated Walter Mondale, campaigning on a promise to continue Reagan's economic, social, and foreign policies. He attacked Mondale as an elitist "Massachusetts liberal" and employed dog-whistle tactics to appeal to white voters with his infamous Willie Horton ad that blatantly relied on racist stereotypes about Black men and sexual violence.

The antinuclear and antimilitarism activism of the eighties came together in 1991 when thousands of people marched to resist the Gulf War in the Middle East. The massive outpouring of demonstrators into the streets was a powerful signal to the US government.

Conservatives and evangelicals came into their own during the eighties and nineties. When conservative Pat Robertson ran for president in 1988, the Christian Right felt empowered and formed groups to execute their strategy to dominate the government. Abortion laws became a flashpoint, with NARAL Pro Choice America and Operation Rescue facing off at events, a divisive struggle emblematic of the entrenched partisan politics under which we still labor.

Racial tensions boiled over again nearly three decades after the Civil Rights Act was passed, this time in Los Angeles. During the sixties, black-and-white photographs delivered the truth about police brutalization of Black communities to white America. In 1992, a video camera captured the beating of Rodney King. The riots which broke out after his attackers were acquitted paralyzed Los Angeles and reminded America we were far from realizing Dr. King's vision of racial harmony.

©The Gran Fury Collective, 1987

The Bay Area Peace Navy was a unique part of the diverse resistance to US military intervention in Central America. Founded in 1983 by members of the American Friends Service Committee, a Quaker social justice group, the Peace Navy attempted to block shipments of arms in and out of San Francisco Bay and to bring attention to US Naval intervention abroad.

Their actions were inspired by the San Francisco Mime Troupe and the environmental activist organization Greenpeace. They blockaded arms shipments and also flew banners, mounted mini-theatrical moments, and spray-painted political messages on the sides of battleships.

Their mission extended beyond the Bay. They also brought medical supplies to Nicaragua after a particularly destructive hurricane, and two of their members were part of a delegation to promote peace there. They had water-based demonstrations and actions in Haiti, South Africa, Grenada, Panama, and Iraq.

At their peak, they had access to a fleet of over one hundred privately owned boats used for actions through 2008. The Peace Navy still exists, waiting for the next opportunity to speak out for water-based social justice issues. They are infamous for their presence every year at San Francisco's Fleet Week, which celebrates the US Navy and the Marines. Huge crowds always turn out to watch the Navy's Blue Angels fighter jets streak overhead and warships cruise under the Golden Gate Bridge. The Peace Navy sends their own flotilla of small flag-bearing rafts into the parade of behemoth aircraft carriers and warships.

©Janet Delaney
Peace Navy obstructs USS Missouri on the San Francisco Bay during Fleet Week, San Francisco, California, 1986.

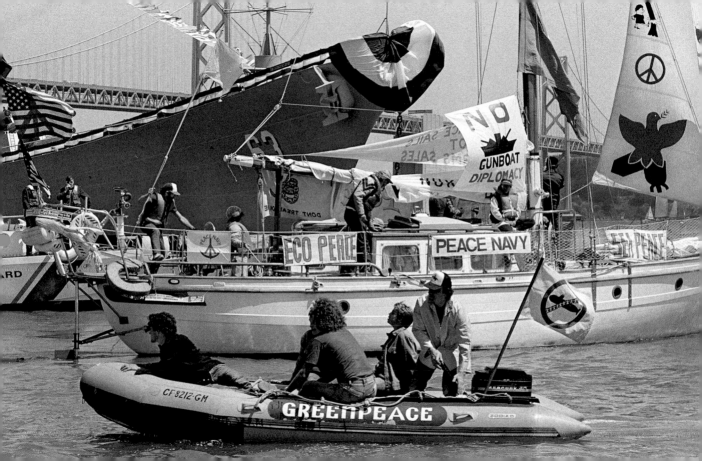

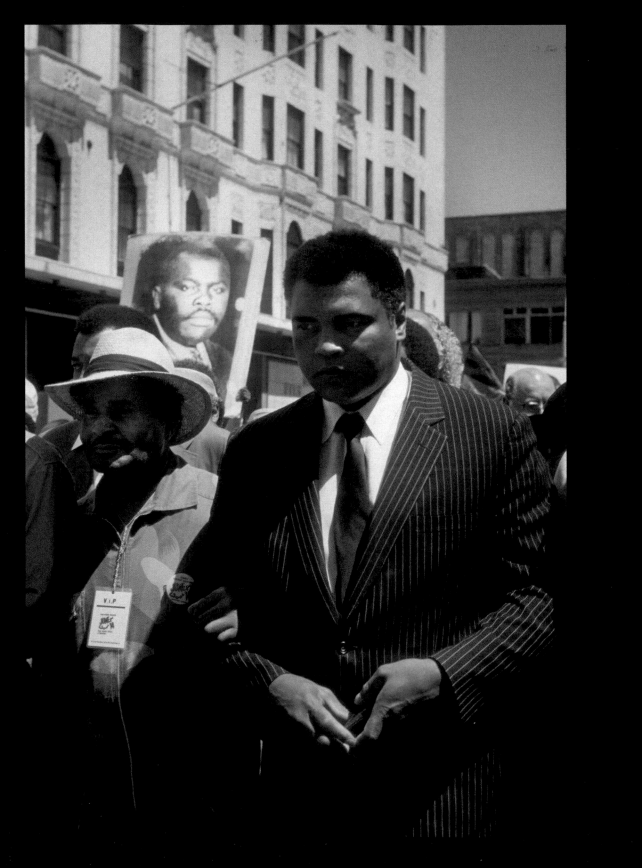

Apartheid—"separateness" in the South African–Dutch language of Afrikaans—was the system of institutionalized racial segregation established in South Africa in 1948. Strategies for resisting apartheid, in both South Africa and the global community, varied over the decades; by the eighties, the anti-apartheid movement reached a peak, with millions engaging in boycotts, divestment campaigns, direct action, and marches.

One of many anti-apartheid actions in the US was the global march in June 1986 to commemorate the tenth anniversary of the 1976 Soweto uprising, when thousands of Black South African youth demonstrated against apartheid and the forced instruction of Afrikaans and English in schools. The peaceful march was met with gunfire from soldiers, which killed hundreds of youth.

The anti-apartheid movement drew support from many high-profile celebrities, including Muhammad Ali, who joined the demonstration in New York that June. Born Cassius Clay, Ali was a heavyweight boxer who converted to Islam, changed his name, and began speaking out about politics in 1966, when he refused to be drafted into the military, citing his religious beliefs as a Muslim. He was convicted of violating selective service and sentenced to five years in prison. Though that conviction was overturned, he was stripped of his heavyweight boxing crown, becoming indigent and a pariah in the boxing world. To make money, he became a public speaker against the war and in favor of civil rights, and became an activist hero. Ali has repeatedly been cited as the inspiration for many activist athletes to take the risk of taking a stand.

©Frank Fournier/Contact Press Images

Muhammad Ali participates in an anti-apartheid march in Harlem, New York City, June, 1986.

For decades, the wearing of fur was seen as a status symbol. Fur coats and hats, mink stoles, fur-lined gloves, and other accessories made from the fur of animals served the functional purpose of keeping the wearer warm, but they were also coveted luxury items.

The animal rights movement formed in the 1970s, as more people explored vegetarianism and connected the welfare of animals to growing environmental awareness. By 1989, there were over one hundred animal rights groups in the US, with over ten million Americans donating money to help protect and defend nonhuman creatures.

At the same time, mink production was reaching a peak, and animal rights groups trained their sights on New York City, the capital of the $2 billion fur industry. Tactics ranged from public protests and shaming of fur-clad pedestrians to militant underground networks like the Animal Liberation Front, which raided fur farms and damaged fur-selling stores. Organizations like People for the Ethical Treatment of Animals (PETA) became known for throwing red paint onto women wearing fur coats, and displaying graphic photos of trapped animals.

The anti-fur campaigns were ultimately successful. While fur farming and production weren't completely eliminated in the US, there has been a significant cultural shift away from the use of fur as a luxury good and toward faux fur. The work of animal rights activists continues, now buttressed by current research findings that animals have feelings, language, and culture.

©Gabe Kirchheimer

Anti-fur protest on Fifth Avenue, across the street from Trump Tower, New York City, 1989.

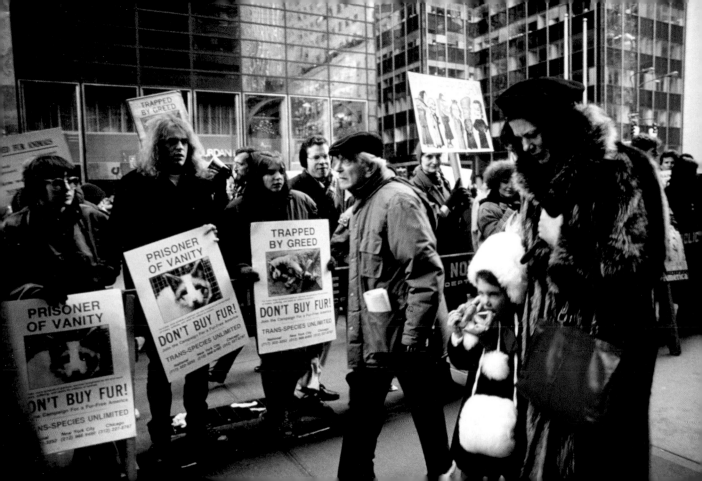

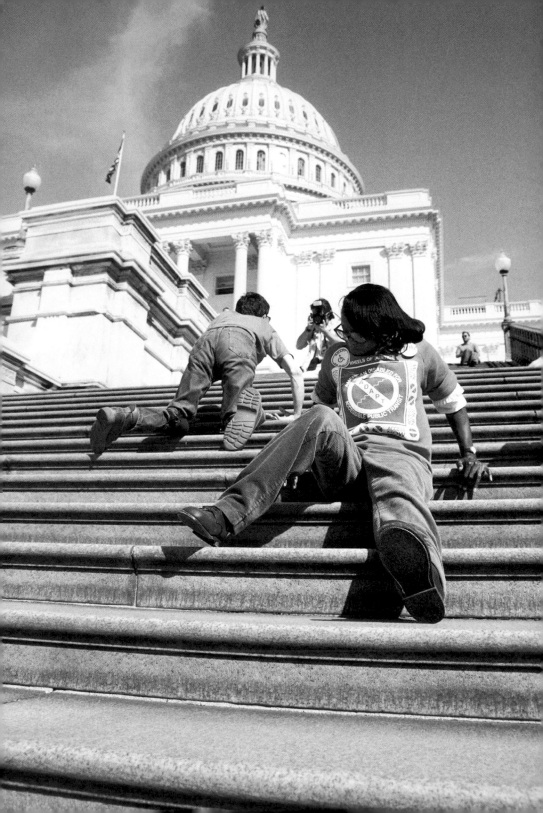

The disability rights movement developed alongside the free speech and civil rights movements in the sixties, particularly at UC Berkeley, where quadriplegic Ed Roberts and other students with disabilities began to organize for access and independence. They founded the first Independent Living Center, a resource for the community, staffed entirely by people with disabilities.

During the seventies, disability rights advocacy focused on passing comprehensive civil rights–inspired legislation guaranteeing equal access and opportunity. Activists lobbied, organized, and engaged in mass civil disobedience, notably during the 504 Sit-in of 1977, in which 150 activists with disabilities and their aides and allies occupied a San Francisco federal building, demanding implementation of Section 504 of the Rehabilitation Act of 1973.

By the eighties, they aimed to persuade Congress to pass the ADA to ensure equal rights for people with disabilities: equal opportunity, full participation, independent living, and economic self-sufficiency. By March 1990 the ADA had passed the Senate with bipartisan support. When the bill stalled in a House committee, activists rallied.

Over one thousand protesters from thirty states demanded that Congress finally pass the Americans with Disabilities Act (ADA). To dramatize the barriers that people with disabilities face, more than sixty, including an eight-year-old girl with multiple sclerosis, abandoned their wheelchairs for the "Capitol Crawl" up the seventy-eight steps to the capitol building. At the top, they delivered messages to Speaker Tom Foley and House Minority Leader Robert Michel, demanding immediate passage of the ADA. When the bill passed four months later, a number of lawmakers credited their support to this action.

Tom Malone, from Owensboro, Kentucky (left) and Shaila Jackson, from Atlanta, Georgia (right) crawl up the steps of the Capitol when the ADA was stalled in Congress, Washington, DC, 1990.

In 1990, the Iraqi army, under the direction of Saddam Hussein, invaded and annexed the small neighboring state of oil-rich Kuwait, hoping to control the extensive oil reserves there. Had he succeeded, he would have controlled over 20 percent of the world's oil reserves, thereby becoming the world's biggest oil broker. The invasion created a geopolitical oil crisis, and a US-led coalition of thirty-five nations, under the leadership of President George H. W. Bush, launched "Operation Desert Storm." They sent hundreds of thousands of troops to the region, and in January 1991 launched an intensive aerial and ground attack.

President Bush and Secretary of Defense Dick Cheney claimed that Hussein, a former ally of the US, was a dictator who would try to take over the entire Middle East if the US did not assume our moral responsibility to stop the domino effect for "the cause of peace." Cable news channel CNN broadcast live images of exploding bombs and soaring missiles, deepening the impact of these actions. Americans, and people all around the world, saw the devastation of war in real time. Protesters responded on an international level to this brutal bloodbath with strikes, blockades, demonstrations, and civil disobedience.

©Ken Light/Contact Press Images
Gulf War protest, San Francisco, California, 1991.

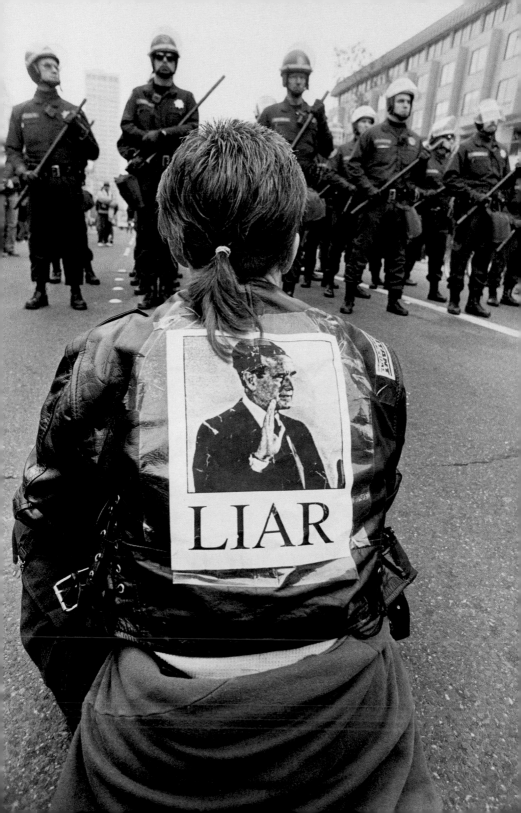

LIAR

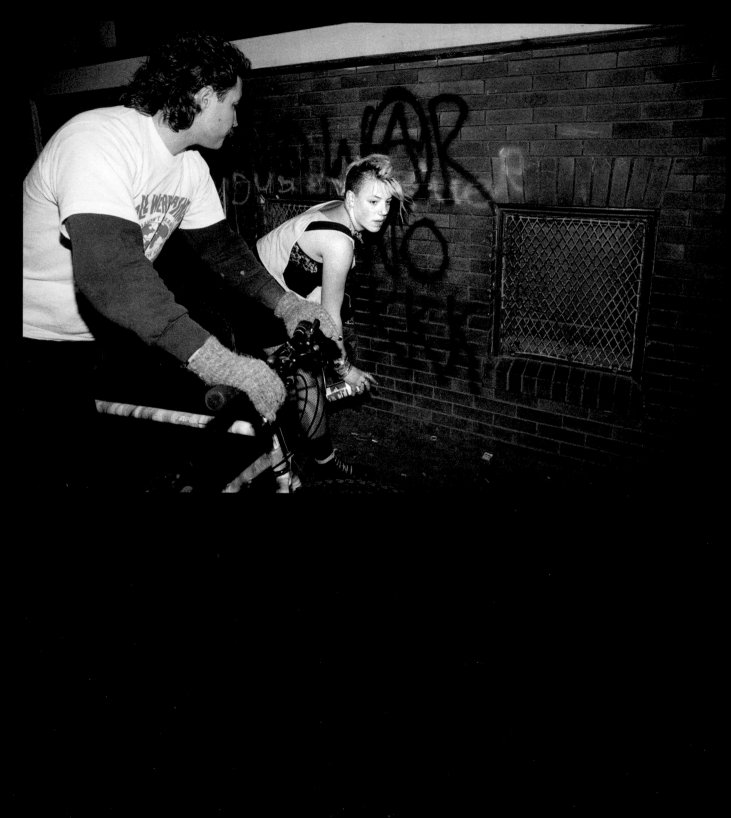

Ten days before the US-led bombing began, 4,100 protesters in Santa Fe, New Mexico, blocked a four-lane highway for an hour, demanding "no war." Residents said the action far exceeded any Vietnam-era protests. College students across the country demonstrated against the war, and on the eve of the bombing, six thousand protesters marched in Ann Arbor, Michigan, while five thousand gathered in San Francisco to form a human chain around the Federal Building.

Four days after the bombing, seventy-five thousand anti-war activists rallied near the White House, and spontaneous demonstrations popped up all over. Activists in San Francisco blocked the Golden Gate and Oakland Bay Bridges, and the world headquarters of Chevron Oil in San Ramon, California was blockaded, with US and Chevron flags going up in flames. Protests erupted at the BP Oil headquarters in London, and even ACT UP staged a "Day of Desperation" in New York City, shouting "Fight AIDS, not Arabs."

Hundreds of thousands of people were killed in that war, which ended after a mere forty-two days. About 250,000 of the 700,000 Desert Storm soldiers suffer from illnesses related to exposure to chemical warfare compounds. This intractable display of global hegemony and spurning of public opinion increased the enmity of activists.

Gulf War resisters putting up graffiti,
San Francisco, California, 1991.

In the nineteenth century, male doctors sought to secure their profession by driving out traditional female healers and midwives who had supported women's control of their fertility. Feeling threatened by women's increasing independence, men latched onto the issue of reproductive rights. By 1880, every state banned abortion, allowing only therapeutic medical abortions. Wealthier women still had access to safe abortions, while poor or low-income women were forced to seek illegal abortions.

Despite the 1973 *Roe v. Wade* decision protecting a woman's privacy and right to an abortion, by the early nineties abortion had become one of the most prominent, controversial, and polarizing issues in American life and politics. Threats loomed on many fronts. The right-wing Operation Rescue harassed and shut down women's clinics, community family planning clinics closed, and Supreme Court decisions put women's health in jeopardy.

Women's Health Action and Mobilization (WHAM) was established in response to the 1989 Supreme Court ruling in *Webster vs. Reproductive Health Services*, which granted states more power to restrict access by barring the use of public money and facilities for abortions.

While national organizations like NOW and Planned Parenthood worked on the legislative and legal fronts, WHAM focused on direct action. They often worked in collaboration with ACT UP, the grassroots AIDS group, going for high-visibility, media-centered actions like "gagging" the Statue of Liberty to protest the so-called "gag rule" of 1991 which prevented federally funded health clinics from discussing and providing abortion, and dropping banners over the statue's pedestal and face.

Activists from Women's Health Action and Mobilization (WHAM) and ACT UP dropped a pair of banners from the Statue of Liberty, New York City, 1991.

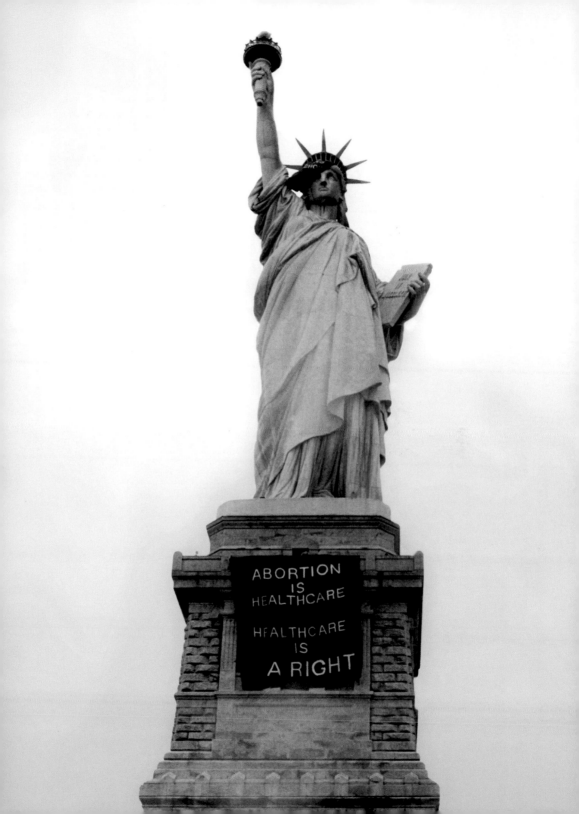

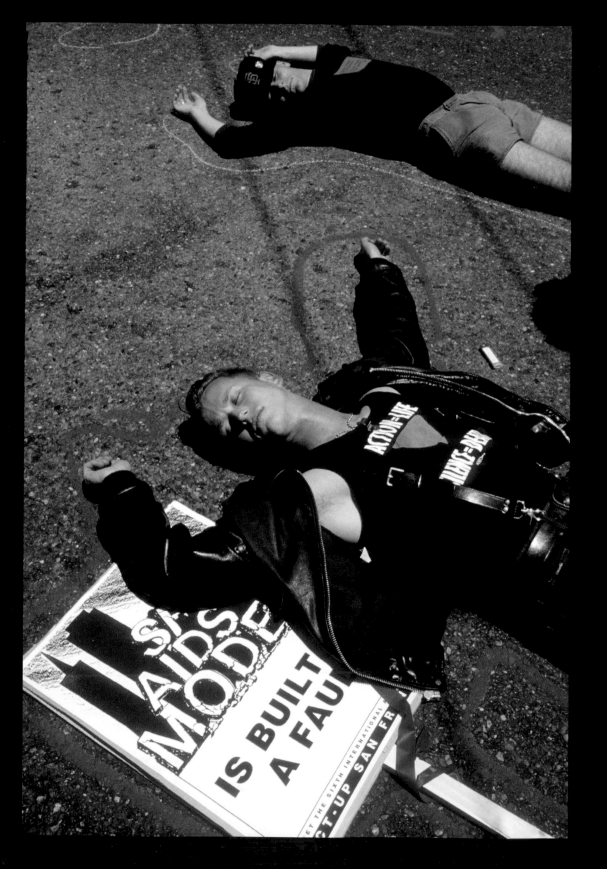

The Sixth International AIDS Conference was held in San Francisco, drawing many of the world's leading HIV/AIDS doctors for a week of meetings, lectures, and discussions. It also attracted thousands of AIDS activists and their bold, powerful tactics.

The activist group ACT UP, founded in 1987 by Larry Kramer, was ready to force people to listen. After nearly a decade of grief and trauma in the face of the AIDS epidemic, the LGBTQ+ community was full of rage about the lack of responsiveness throughout the country. Specifically, they were protesting the conference for the lack of inclusion of people with HIV/AIDS; insufficient programming for the infection and treatment of women, people of color, and IV drug users; and the recent drastic law forbidding HIV-positive people from entering the country.

Activists channeled that rage through actions that were at different times serious, raucous, and festive. They chanted, performed street theater, and staged die-ins. At the sound of a siren, protesters would drop to the ground, while others drew chalk outlines around them. The outlines remained, haunting reminders of those who had died of AIDS. When activists wearing T-shirts declaring their HIV+ status attempted to hop barricades and enter the conference, they were pushed down by police.

After a week of intense protest and outrage, the conference protests culminated with an impromptu street party in San Francisco's Castro District—this event, known as "Pink Saturday," continues today on the eve of San Francisco's Pride Parade.

©Alon Reininger/Contact Press Images

Members of ACT UP at a "die-in" during the Sixth Annual AIDS Conference, San Francisco, California, 1990.

In 1912, the African National Congress (ANC) began the fight to unite its people and combat racism and apartheid. Their international call to condemn the South African system of racial segregation and oppression, formalized in 1948, birthed anti-apartheid organizations in virtually every country around the world—the biggest social movement ever. Pressures like international sanctions failed because South Africa had one-third of the world's gold reserves. But the South African economy needed the US banking system. US protesters pushed Congress to pass the Comprehensive Anti-Apartheid Act in 1986, requiring US banks to divest. This effectively forced the country to dismantle apartheid laws and practices.

Nelson Mandela devoted his life as a South African revolutionary and ANC leader to overthrow apartheid. Arrested in 1962, he continued his activism from behind bars, delivering statements of support for the anti-apartheid battle, and became a beloved global icon of freedom.

Upon Mandela's release in 1990, he embarked on a US tour to show gratitude for American activism and ensure continued support for the new government. In New York City, 750,000 people lined the streets for a celebratory ticker-tape parade.

The tour visited Oakland because the Bay Area was a leading force in the anti-apartheid movement: longshoremen at the Port of Oakland refused to unload South African cargo; UC Berkeley divested $1.7 billion in assets after relentless student protests; and Congressman Ronald Dellums sponsored anti-apartheid measures in Congress for two decades. Mandela thanked a sold-out crowd at the Oakland Coliseum, asking them to redouble their efforts in the fight to end apartheid.

©Ken Light/Contact Press Images

Nelson Mandela Freedom Tour, Oakland, California, 1990.

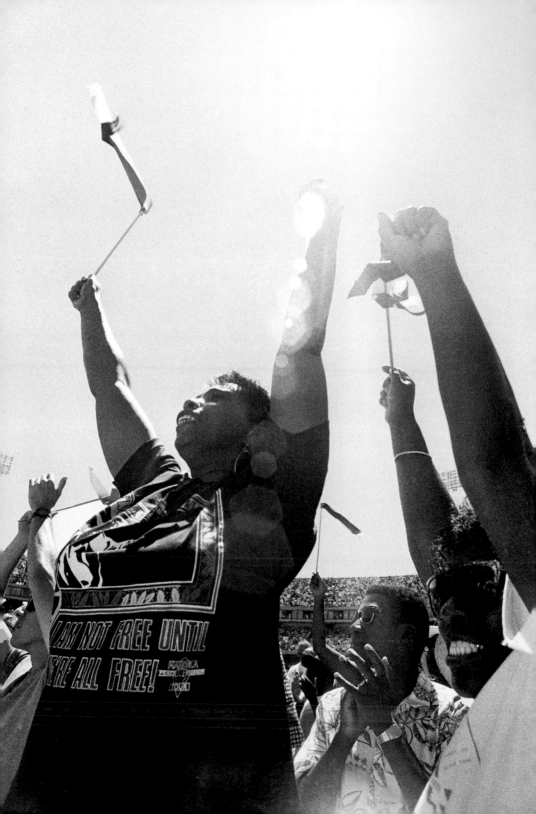

Confirmation of federal circuit judge Clarence Thomas to succeed Supreme Court Justice Thurgood Marshall in 1991 appeared assured until tapes of an FBI interview with law professor Anita Hill were leaked. Hill, who worked under Thomas in two different federal departments, accused him of sexually harassing her there. Called to testify publicly before the all-male, all-white Senate Judiciary Committee, Hill endured their often intrusive, dismissive, and patronizing comments and questions for three days. She was even subjected to a polygraph test, but throughout provided her testimony with steady calm.

Four female witnesses were set to corroborate her testimony but were never called due to a private deal between Senate Republicans and Judiciary Chair Senator Joe Biden. Hill's reputation suffered immensely. Politicians and media figures cast her as a liar and a liberal tool.

The Senate confirmed Justice Thomas, but Hill's testimony had a lasting impact. Single-handedly, she had brought the issue of sexual harassment to public attention. Over the next five years, workplace sexual harassment cases doubled and awards to complainants nearly quadrupled. The Senate's abhorrent treatment of Hill inspired women to run for office; in 1992 a record-breaking five women won seats in the Senate and twenty-four in the House.

Anita Hill pauses during her testimony at the Senate Judiciary hearing on Supreme Court nominee Clarence Thomas, Washington, DC, 1991.

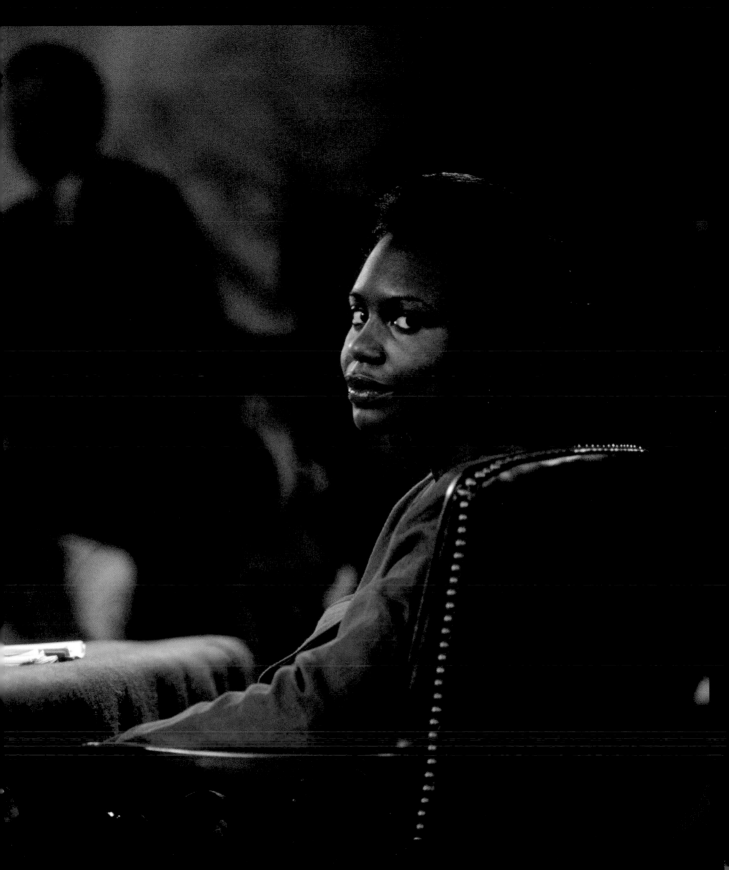

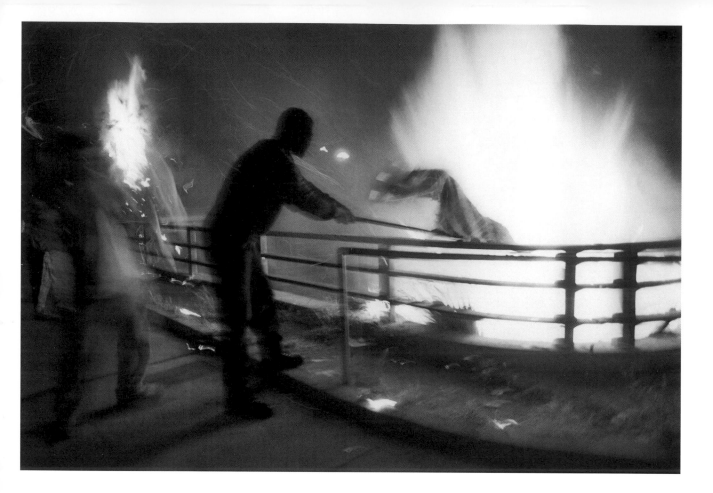

In March 1991, a Black man named Rodney King led police on a high-speed chase through Los Angeles streets. King was pulled from his car and brutally beaten by four police officers for fifteen minutes, while more than a dozen officers watched. King suffered skull fractures, broken bones and teeth, and permanent brain damage.

George Holliday videotaped the entire incident from his terrace and released the tape to a local TV station. It was broadcast worldwide, and viewers were stunned to see the police brutality that the Black community experience. Decades of complaints about racist, unnecessarily violent police could no longer be denied. Holliday received a Peabody Award and launched the age of citizen journalism.

The four officers were charged with excessive use of force, but acquitted one year later. Within hours, unrest began in South Central LA, a majority-Black community with a long history of police brutality. Outraged residents set fires, attacked motorists, and looted and destroyed liquor stores, retail shops, and restaurants with a ferocity that could not be contained for days.

The mayor called in the National Guard and set dawn-to-dusk curfews. The city was paralyzed: mail delivery stopped, school was cancelled, and armed troops patrolled the streets. Sixty-three people died in the riots, including ten shot by police. Over 2,500 people were injured, with damage of nearly $1 billion.

©Ted Soqui

A protester burns an American flag over the 101 freeway downtown during the riots after the Rodney King verdict, Los Angeles, California, 1992.

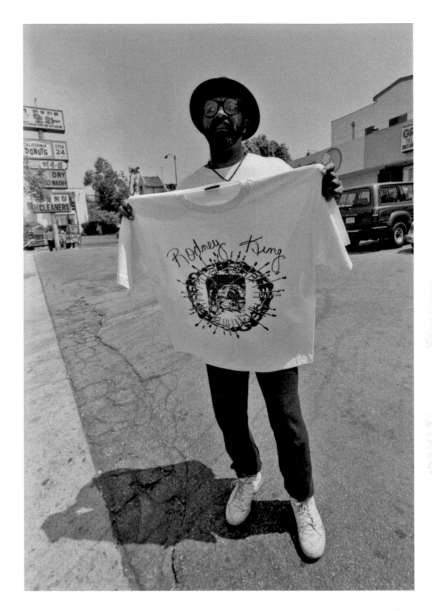

The King trial occured when South Central Los Angeles was at a boiling point due to maximum stress. Drug addiction and unemployment were high, gang activity was rampant, and police brutality was at its worst. Residents saw the police as an antagonistic, occupying force. In addition, there was racial tension between Black and Korean neighbors. Only a month before King was beaten, a Korean store owner had shot and killed Latasha Harlins, a fifteen-year-old Black teenager, accusing her of stealing juice. Harlins had the money for the juice in her hand. The store owner received probation and a $500 fine, but no jail time. During the riots, over two thousand Korean-owned businesses were destroyed.

The simple cry from Rodney King on the second day of the riots—"People, I just want to say, you know, can we all get along?"—voiced the deep despair in this community. People were deeply affected and inspired to push for reform in police departments across the country.

©Ted Soqui

A man holds a homemade T-shirt with an image of Rodney King being beaten by the police following the riots in Koreatown, Los Angeles, California, 1992.

Though lesbians were involved in pushing for tolerance, acceptance, and equal rights in both the Gay Pride and feminist movements, they felt treated as second class citizens. The Gay Pride movement catered to cisgendered gay men, who could be misogynistic and dismissive of the needs of the lesbian community, and feminist leaders like Betty Friedan worried that lesbian inclusion could hurt the feminist movement. After she called lesbians a "lavender menace," a group of lesbian activists embraced the phrase and formed a new organization claiming lesbian identity as revolutionary.

This tactic of expropriating a pejorative and owning it with pride was not new. The LBGTQ+ community adopted the pink triangle, which the Nazis used to shame and label homosexuals, as their symbol and used it on the Silence=Death poster. Some lesbians reclaimed the slur "dyke" as a positive identifier.

A group called the Lesbian Avengers conceived a separate "Dyke March" after learning that, despite the word "lesbian" in the title, the 1993 March on Washington for Lesbian, Gay, and Bi Equal Rights would have no special section for lesbians. Sick of being excluded from the gay rights agenda, they decided to organize. They put out flyers for the march around New York City and spread the word to lesbian activist groups around the country. On the eve of the big march, twenty thousand women showed up at DuPont Circle in Washington, DC, and marched to the White House. More dyke marches followed, and it's now an annual event in many cities, taking place the day before pride parades.

©Darrow Montgomery
Dyke March, Washington, DC, 1993.

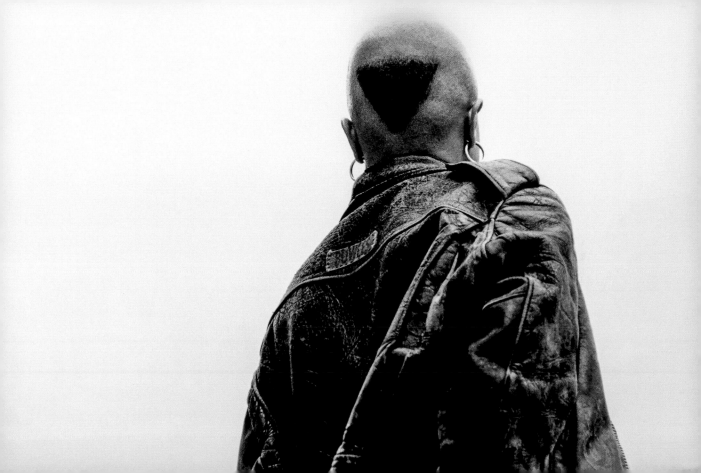

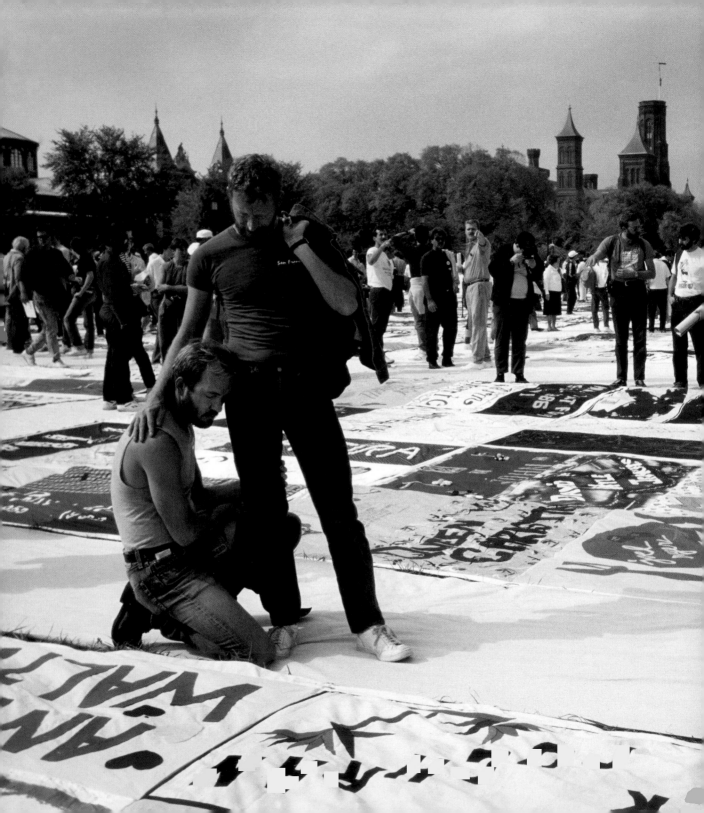

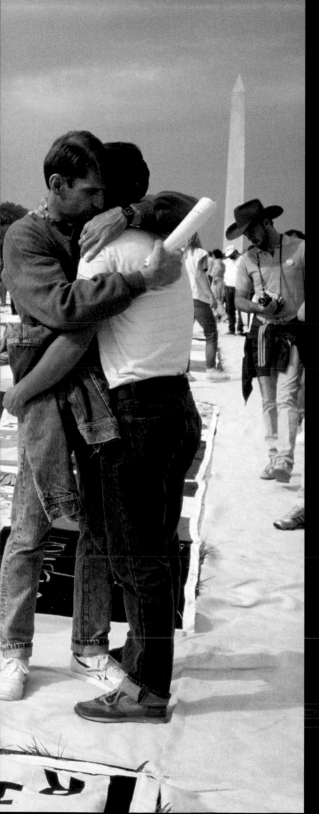

The Quilt debuted on the National Mall in 1987, but began in 1978 when gay rights organizer Cleve Jones held a candlelight vigil to commemorate the life of Harvey Milk, the first openly gay elected official in California history.

The annual vigil continued as the devastation of AIDS continued to mount. By 1985, the losses in Jones's San Francisco community were overwhelming, so at that year's vigil he asked the crowd to write the names of loved ones who'd died of AIDS on pieces of paper. They taped the papers on the walls of a downtown federal building. It made Jones think of a quilt—and it gave him an idea.

Jones and his friends began sewing quilt panels for their departed friends. They spread the word, inviting anyone who'd lost loved ones to contribute. They intentionally set the size of the panel to be three by six feet—the dimensions of a grave.

Volunteers worked hard to stitch the panels together, and the AIDS Memorial Quilt made its debut at the National March on Washington for Lesbian and Gay Rights in October 1987. The 1,920 panels were viewed by over half a million people. Each panel was unique, many decorated with the personal belongings of the deceased.

The NAMES Project's AIDS Memorial Quilt now weighs 54 tons, complete with 49,000 panels on 5,956 blocks. It was nominated for the Nobel Peace Prize and has become one of the most powerful tools for educating the public about AIDS and HIV prevention and for telling the human stories behind the lives lost to the AIDS epidemic.

©Frank Fornier/Contact Press Images

AIDS Memorial Quilt displayed at the National Mall, Washington, DC, 1987.

1994–2010

OCCUPY

THE STREETS

OccupyTogether.org

A NEW ERA IN ACTIVISM

The years between 1994 and 2010 comprised an era of transformation and upheaval: Bill Clinton's impeachment; the contested Gore-Bush presidential election; Y2K, the terrorist attacks of September 11, 2001; the election of the first Black US president; the Great Recession; the digital revolution and shifting undercurrents.

Digital technology exploded, radically changing our culture, economy and modes of social change. We embraced most of it, launching a mad love affair with our smartphones and apps, unsuspecting of unintended negative consequences. The internet, camera phones, and social media platforms like Facebook and Twitter connected global activist communities in exciting new ways, enabling previously isolated populations to share their stories and needs. Camera phones, debuted in 2002, empowering the average citizen to capture a mass protest or a police shooting, then upload and share it to websites seen by millions around the world.

MoveOn.org launched in 1998. "Blog" was coined in the late nineties. The smartphone was first invented in 1992; the iPhone hit stores in 2007; and though Facebook seems to have been around forever, it has only existed since 2004.

Tech companies, chiefly the big four of Apple, Amazon, Google, and Facebook, monetized the digital space. This accelerated globalization. The aftermath of the Great Recession and the scalability of apps led to the gig economy. Tech companies profited hugely from users' private information which they harvested and sold without explicit permission. We had not yet discovered that "free" is not free.

The 2008 election of President Barack Obama was surprising after the relative centrism of the Clinton era and the chaos and controversy of George W. Bush's two terms. The first Black president ushered in a new era of hope for millions of Americans. His first major piece of legislation was the landmark Affordable Care Act.

The Great Recession, which began under President Bush, was the worst downturn since the Great Depression. It exacerbated and illuminated the wealth gap between the super-rich, the merely rich and the rest of America. Many white voters affected by the Great Recession felt unseen and were angry that Obama focused on helping large corporations recover without addressing people who lost their homes. They became a new constituency initially overlooked by the Democrats.

Conservatives angered by Obama's election formed the Tea Party movement to roll back the Affordable Care Act, reduce the deficit, cut taxes, and limit government. This lured many white working-class voters from the Democratic Party. The Republican Party took control of Congress in the 2010 election.

The Occupy Wall Street movement erupted in New York City but became a global cry and the world erupted in protest. Time declared "The Protestor" person of the year in 2011, stating "From the Arab spring to Athens, from Occupy Wall Street to Moscow, the word protest has appeared in newspapers and online exponentially more this past year than at any other time in history."

©Eric Drooker, 2011

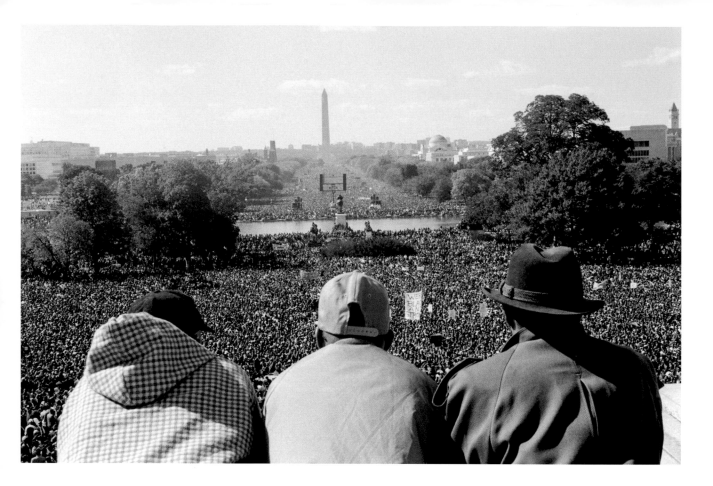

In October 1995, the Million Man March assembled over eight hundred thousand Black men in Washington, DC, to embrace dignity, brotherhood, and self-reliance, and to refute prevailing racist stereotypes about Black men. Called for by Nation of Islam leader Louis Farrakhan and organized by a coalition of groups including local NAACP chapters, the march infused the Black community with new energy, focus, and strategies to continue the work of Dr. Martin Luther King, Jr.

Hard-nosed policies of the eighties, specifically cuts to social safety nets, had devastating consequences. By 1995, rates of incarceration, violent crime, and joblessness were high among Black men, and the Black family was endangered.

The Million Man March did not demand change from the government, but encouraged change from within. Farrakhan, Jesse Jackson, Rosa Parks, and Dick Gregory spoke, asking Black men to pledge to support their families, eschew violence, abstain from drugs and alcohol, build up Black businesses and culture, and register to vote.

Celebratory and empowering, the March became a powerful touchstone for Black men and their families. Over 1.5 million Black men registered to vote for the first time in 1996; the number of Black families adopting children soared; Black men became involved in empowering their communities; among other similar actions inspired by the March.

©Eli Reed/Magnum Photos

Million Man March, Washington, DC, 1995.

©Andrew Lichtenstein

A child of striking auto workers
takes a nap on the UAW General Motors plant
picket line, Flint, Michigan, 1998.

In 1998, United Auto Workers (UAW) at General Motors' (GM) Flint Metal Center walked off the job to protest safety and staffing concerns. Soon after, 5,800 union employees at Delphi Flint East joined them. They were on strike for fifty-three days, stopping production at nearly thirty more plants and leaving over two hundred thousand employees jobless. This was the longest strike against GM since 1970; it cost the company more than $2 billion in profits.

The strike resulted in better pay for the workers and significantly improved communication between the UAW and GM. However, it also marked a serious decline in American auto manufacturing. GM was in a state of turmoil before the strike and had downsized its workforce considerably. After the strike, some GM plants were closed and moved overseas, leaving the greater Detroit area in shambles.

GM returned to profitability but never reinstated its workers' former wages or benefits. The violation of the contract between the owners and workers led to unrest in the Great Recession, when the government propped up GM but not the workers and persuaded many to vote for Donald Trump later in 2016.

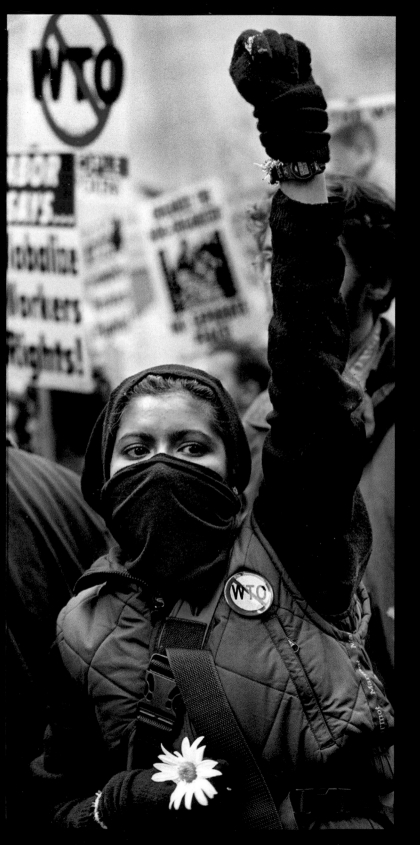

The World Trade Organization (WTO) is an international intergovernmental body that regulates trade among nations to create a more socially just world through treaties and policies that help countries produce wealth while supporting higher living standards, encouraging good governance, giving the weak a stronger voice, and promoting peace and stability.

In 1999, the WTO's Ministerial Conference in Seattle, Washington, assembled five thousand delegates from 150 countries to shape their agenda for the new millennium and the global economy.

While the WTO promoted itself as a steward of global equality and democracy, activists saw them favoring unfettered capitalism, striking down measures that would have helped the world's poor, protected the environment, and safeguarded health. They organized online and descended on downtown Seattle.

Fifty-thousand protesters—environmentalists, labor unions, indigenous groups, international NGOs, students, faith groups, anarchists—blocked delegates from entering the convention. When Seattle police used tear gas and rubber bullets to break them up, anarchist groups smashed windows and destroyed cars. The "Battle of Seattle" wasn't the first time that activists addressed globalization, but it helped introduce the anti-globalization movement to the American public and demonstrated the evolution of activist tactics, from using the internet for large-scale organizing to the activist journalists providing real-time broadcasting from the streets.

©Karie Hamilton

World Trade Organization Protests,
Seattle, Washington, 1999.

The George W. Bush administration worked for three years to build a case for invading Iraq, claiming Saddam Hussein's regime was harboring "weapons of mass destruction" (WMDs), threatening the global community. Bush and UK Prime Minister Tony Blair argued the only way to prevent the WMDs' deployment was to invade Iraq and end Saddam Hussein's dictatorship.

Secretary of State Colin Powell testified before the UN Security Council that Iraq had WMDs. Ten days later, between six and eleven million people turned out in at least 650 cities worldwide to protest the United States' push to invade Iraq. It was the world's largest anti-war protest and remains the largest one-day global protest.

The day's largest protests were in Europe—an estimated three million people turned out in Rome, landing it in *Guinness World Records*. One estimate holds that between January 3 and April 12, 2003, thirty-six million people participated in almost three thousand protests against the Iraq war.

These protesters have copied bits of Pablo Picasso's *Guernica*, painted during the Spanish Civil War immediately after the Nazis destroyed the Basque town of Guernica. It has become an international call for peace and a condemnation of the senseless tragedy of war.

125,000 people march down Broadway to demonstrate against the war in Iraq, New York City, 2003.

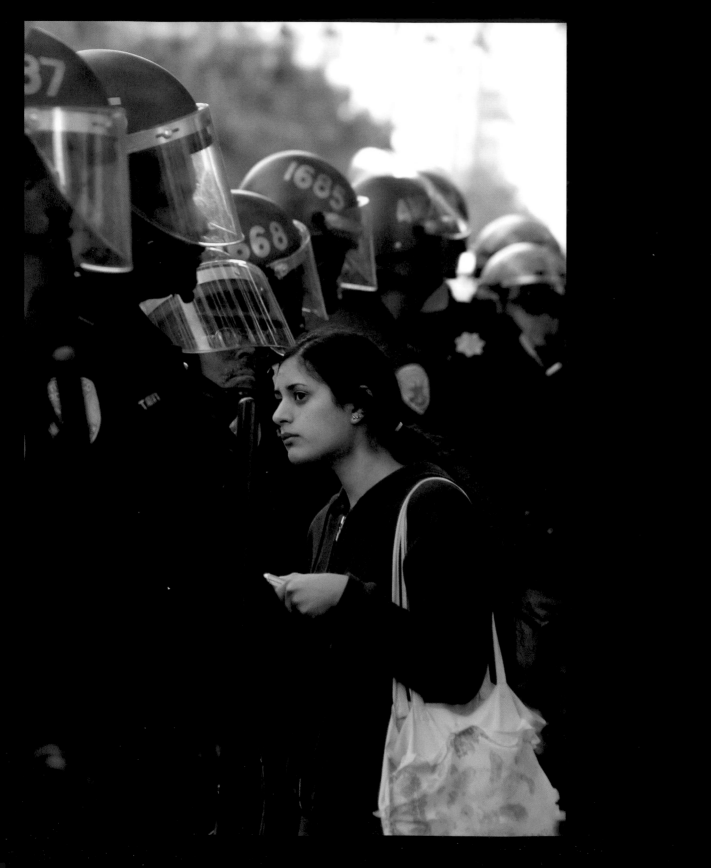

Since 1976, an unofficial forum for leaders of the seven richest industrialized countries—Canada, France, Germany, Italy, Japan, the UK, and the US—have met to address development and global challenges calling themselves the G7. From 1997 to 2014, Russia's inclusion made it the G8. Guests from some other countries are invited to weigh in on the topics.

Once a relatively quiet, private event, in the early 2000s it became a stage for widespread debate as anti-globalization sentiments increased. The 2001 G8 summit in Genoa, Italy, saw massive protests—over two hundred thousand demonstrated against what they considered an unfair concentration of power: a few of the richest countries setting the terms for everyone else. The police crackdown was brutal. Hundreds of protesters were injured and several killed by police.

In 2004, the G8 took place in Sea Island, Georgia. A protest was planned there. Solidarity demonstrations occurred in other cities, including San Francisco. Fearing a repeat of 2001, Georgia governor Sonny Perdue ordered overwhelming numbers of police, troops, and FBI agents. The turnout was nowhere near the numbers seen in Genoa; an estimated third of demonstrators were actually undercover FBI agents. The police and National Guard effectively shut down the march, seen by some as an exercise in martial law.

©Geoffrey W. King

Demonstration against the G8 Summit, San Francisco, California, 2004.

Throughout 2006, millions protested proposed changes to US immigration policy. The protesters, many of them Latinx, were outraged by anti-immigrant legislation either passed or pending. They wanted comprehensive, fair immigration reform— not policies that criminalize immigrants and endanger America's twelve million undocumented immigrants. Demonstrations took place in more than 140 cities in thirty-nine states.

Just before International Workers' Day, the US Senate passed the Immigration Reform Act of 2006, on the heels of the House-passed Border Protection, Antiterrorism and Illegal Immigration Control Acts. These bills formed a vise, clamping down on undocumented people working here. Organizers held "Day Without Immigrants" on May 1: more than five hundred thousand rallied in Los Angeles demanding a path to citizenship. Organizers asked immigrants and their supporters to stay home from work and school. Across the country, thousands of mostly Latinx immigrant workers refused to pick crops, work in factories, serve meals, clean houses, and do the labor that many Americans depend on and take for granted.

The protests reminded people of the important roles immigrants play in an American society that deems them good enough to work, but not good enough to be recognized as full citizens—and marked the emergence of a powerful Latinx political voice.

National Immigration demonstration on May Day, Fresno, California, 2006.

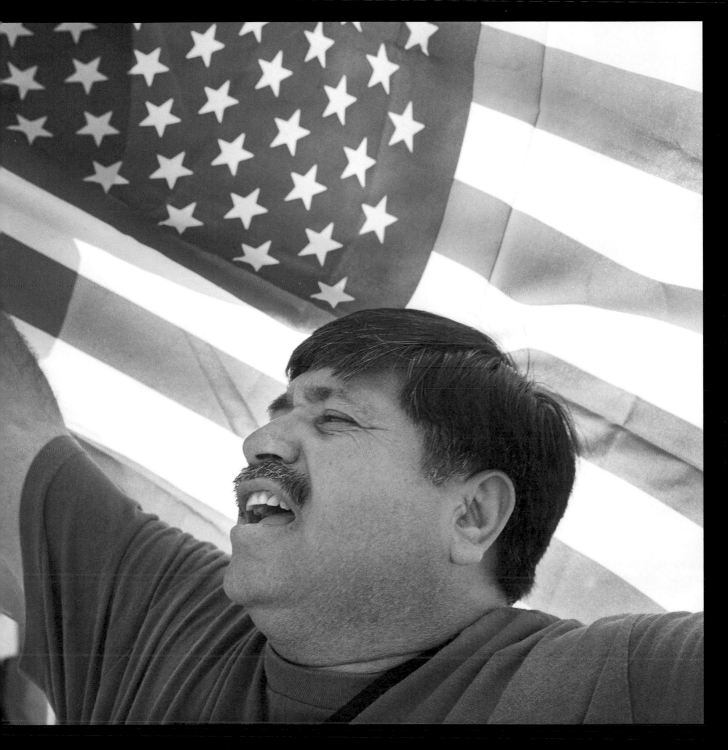

Del Martin and Phyllis Lyon began their lives together in 1952 as young women living in San Francisco. Together they founded the Daughters of Bilitis, which began as an underground social club for lesbians and became America's first lesbian rights organization. They were the first lesbians to join NOW, and they worked for decades to decriminalize homosexuality and promote acceptance of LGBTQ+ people in churches, the workplace, and other public spaces.

This couple of fifty-five years became the first same-sex newlyweds in San Francisco under a new right granted by the California Supreme Court in 2008. But it wasn't their first marriage. Four years earlier, on February 12, 2004, they were issued a marriage license after San Francisco mayor Gavin Newsom ordered that marriage licenses be given to same-sex couples.

Thousands of same-sex couples were married, only to have their licenses voided by the California Supreme Court on August 12, 2004. But when the state Supreme Court found that same-sex couples' access to marriage is a fundamental right under the California Constitution, Mayor Newsom held a private marriage ceremony for eighty-four-year-old Lyons and eighty-eight-year-old Martin. They were honored as pioneers of gay and lesbian rights and finally had their lifelong partnership recognized by the state.

©Marcio Jose Sanchez/Associated Press Photo

Del Martin and Phyllis Lyon are married by San Francisco mayor Gavin Newsom, San Francisco, California, 2008.

The path to marriage equality has been long and tumultuous, but thanks to the steadfast commitment of thousands of same-sex couples, the LGBTQ+ community, their allies, and politicians standing up for equality, same-sex marriage has gained public and political support.

While the struggle for gay rights has been ongoing for decades, the changes around same-sex marriage happened relatively quickly. Individual states began to recognize same-sex marriages, beginning with Hawaii in 1993. More legal battles ensued, but in 2015, the US Supreme Court ruled on *Obergefell v. Hodges*, a landmark civil rights case, that the fundamental right to marry is guaranteed to same-sex couples by both the Due Process Clause and the Equal Protection Clause of the Fourteenth Amendment to the US Constitution.

Now LGBTQ+ people can have a completely different future. Same-sex couples share the same legal rights as other married couples: assumption of a spouse's pension, bereavement, sick or parental leave; immigration rights; sharing insurance coverage; medical decision-making on behalf of a spouse; veteran's discounts and widow's benefits; spousal visitation in a hospital or prison; inheritance rights; burial rights; child custody; crime victim's recovery benefits; divorce protections; IRS tax laws for spouses; adoption and foster care; and all rights due to married people.

©Darcy Padilla

Frank Capley and Joe Alfano kiss at the end of their marriage ceremony in the Rotunda, City Hall, San Francisco, California, 2008.

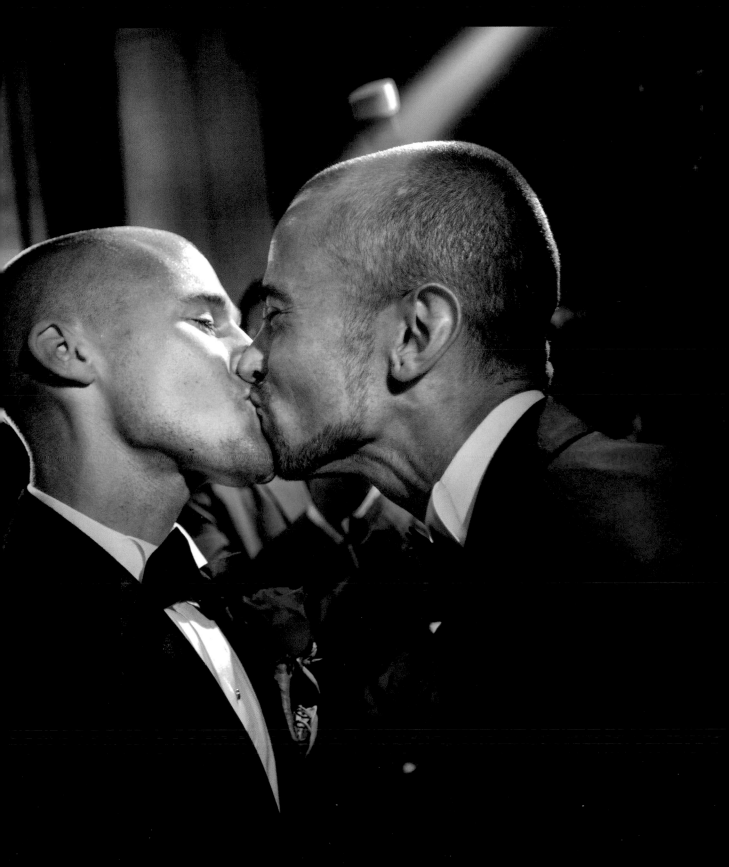

The conflict between the peoples of Israel and Palestine is long-running, controversial, and deeply complex. Two self-determination movements—the Jewish Zionist project and the Palestinian nationalist project—claim the same territory.

The sides have clashed for centuries; the modern conflict arose after World War II. In 1947, the UN General Assembly partitioned Palestine into two states: Israel and Palestine. The city of Jerusalem, of deep religious and cultural significance for both Arabs and Jews, was placed under UN control. Neither side liked the plan, and the conflict continued.

The most contested area is the Gaza Strip, a 140-square-mile area along the Mediterranean coast between Egypt and Israel, which has endured decades of protest, military operations, and violence as Israel and the Palestinian Authority both assert the right to control it.

In 2008, a fragile six-month truce between Hamas (the Palestinian resistance movement) and Israel expired. Without a new truce, cross-fire ensued. Israel invaded the Gaza Strip in January 2009 and war raged for three weeks. An estimation of around 1,300 Palestinians were killed, many of them civilians; thirteen Israelis died (four from friendly fire). Protests broke out all over the world, with millions decrying the assault on Gaza and the Palestinian people.

©Geoffrey W. King

Protest against Israel in Gaza, San Francisco, California, 2009.

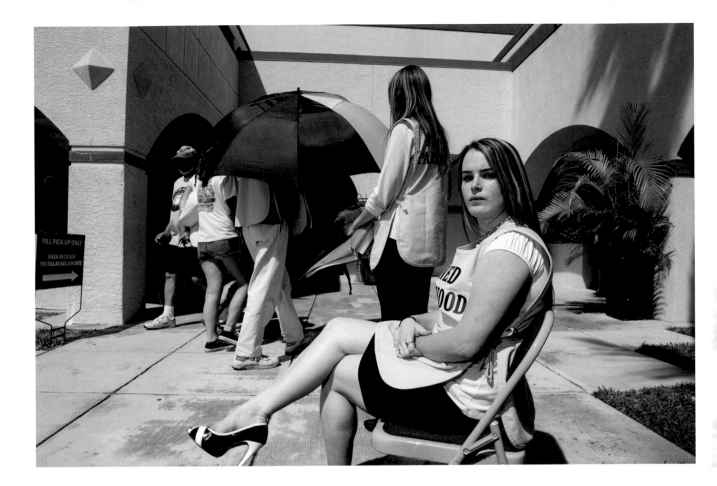

Casey Smith, a volunteer clinic escort, watches the entryway of the Collier County Planned Parenthood clinic. An umbrella shields the identity of an arriving patient from protestors. Naples, Florida, 2010.

Every woman's right to have an abortion was upheld by the US Supreme Court's landmark *Roe v. Wade* decision in 1973. Since then, the right-wing assault on abortion rights and women's reproductive health and bodily autonomy has raged. While conservative politicians, aided by anti-choice lobbying groups, chip away at the laws protecting women, groups like Operation Rescue and the Pro-Life Action League harass women's health clinics that provide abortion: picketing, waving gruesome signs, and dispensing false information. Some resort to arson, violence, and murder.

By 1994, Congress passed the Freedom of Access to Clinic Entrances Act, but harassment continues. In 2009, Dr. George Tiller, a physician who performed late-term abortions, was murdered while attending church in Kansas—one of more than eleven clinic employees murdered since 1977. There have been seventeen attempts, 383 death threats, and forty-one bombings. Arguably, this activity is domestic terrorism.

Women's health clinics like Planned Parenthood provide many health services, including Pap smears, cancer screenings, breast exams, pregnancy testings, and STI screenings. Many patients are uninsured. At risk to themselves, volunteer escorts outside clinic entrances shield patients from harassment, intimidation, and violence, enabling them to access care—an act of bravery to protect women's legal rights.

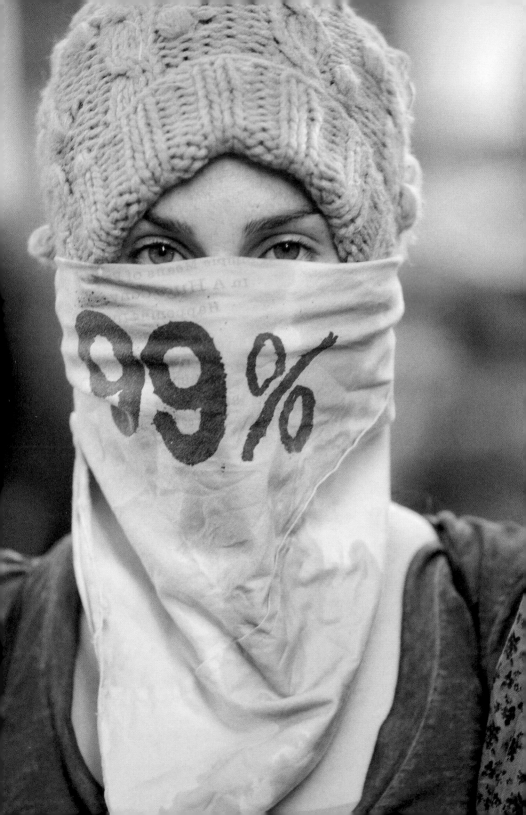

Sarah Mason, Occupy Wall Street protester just
before her arrest, Los Angeles, California, 2011.

By 2011, global protests were boiling over, from Greece to Tunisia to Iceland to
Spain. They may have had different priorities but a shared desire to end govern-
ment corruption and increase economic justice. Not only the impoverished and
disenfranchised, but millions of educated, employed, and middle class people felt
the system is rigged to benefit the wealthy on the backs of everyone else. *Time*
magazine named "The Protester" as their "Person of the Year" for 2011, using this
image of Sarah Mason to represent her.

The Occupy Wall Street movement began in early 2011, when the editors of the
Canadian *Adbusters* magazine announced a public protest on Wall Street with
an image of a ballerina posed on top of the *Charging Bull* statue in New York's
Financial District. The invitation: #OCCUPYWALLSTREET. SEPTEMBER
17TH. BRING TENT.

The image, the idea, and #OccupyWallStreet went viral. A coalition of about two
hundred planned the logistics. Their rallying cry—"We are the 99 percent!"—refers
to the income/wealth disparity in the US in which the wealthiest 1 percent own
roughly 40 percent of the country's wealth. Protesters argued, too, that the 99 per-
cent are paying for the excesses of the tiny minority ruling elite. Occupy protests
sprang up around the globe.

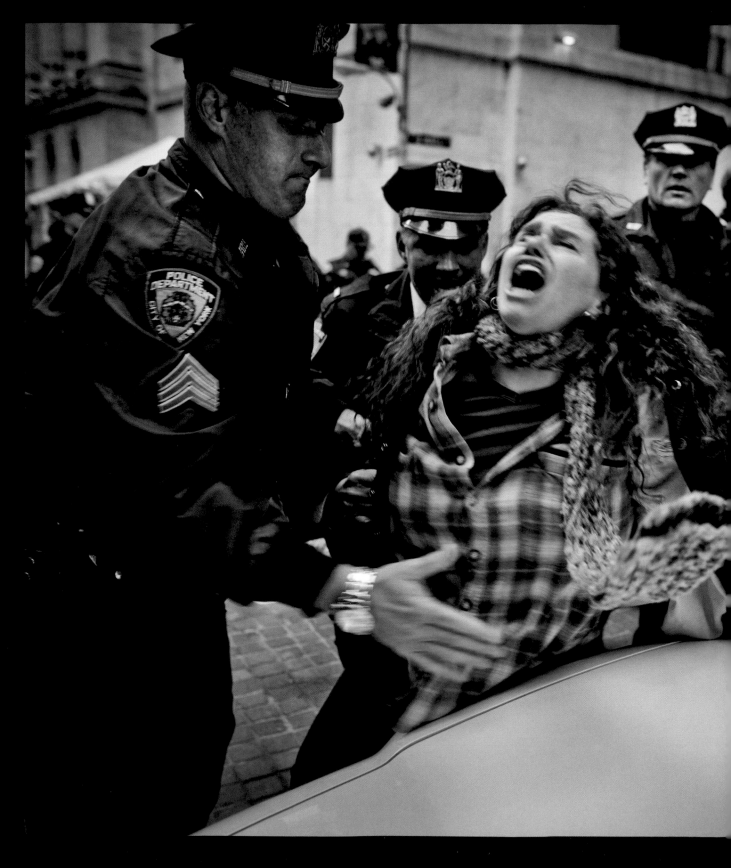

The Occupy movement that grew out of the Occupy Wall Street event had no formal leader and no single demand, but quickly grew into a worldwide phenomenon, with camps and protests in over eighty countries. Their goal was to draw attention to the critical problems of the twenty-first century: income inequality, corporate power, and the growing disparity between the rich and the poor.

The Zuccotti Park camp grew to include thousands of people; it included a working kitchen, a children's area, and a library. Public meetings known as "general assemblies" were held regularly, and all decisions were made by consensus. Many people used Twitter and other online platforms to share footage of meetings and protests in real time; this was especially popular during police crackdowns and tense moments, when livestream videos could be broadcast around the world.

In 2012, Occupy Wall Street called for a general strike and day of action on May Day. The protest drew ten thousand people and included a march to Bank of America, which had been implicated in the predatory lending practices that led to the financial crisis of 2008.

An Occupy Wall Street protester is arrested at the corner of Wall St. and Nassau, New York City, 2012.

Beginning with the *Adbusters* poster of the ballerina on a bull, art and imagery were central elements of the Occupy movement and remained a major messaging vehicle. At Occupy camps worldwide, thousands created posters, screen prints, banners, signs, and T-shirts for marches, online sales, and social media posts. Many camps held open mics, inviting poets and performers to express themselves through spoken word and song.

As the Occupy movement grew, artists of all kinds became inspired and began offshoots for their own communities. An Occupy Writers statement—"We, the undersigned writers and all who will join us, support Occupy Wall Street and the Occupy Movement around the world"—quickly garnered support from thousands of writers, including Margaret Atwood, Alice Walker, and Salman Rushdie.

Visual artists started Occupy museums and demonstrated at New York City's most prestigious art institutions to draw attention to the commodification of art. Ironically, at the same time major museums and organizations from the Smithsonian Institution to the New York Historical Society began collecting Occupy movement materials. Representatives for the Smithsonian's American History collection gathered buttons, signs, posters, and documents, recognizing Occupy and its imagery as a major moment in American history.

©Ted Soqui

Occupy Wall Street artists silkscreen posters, Los Angeles, California, 2011.

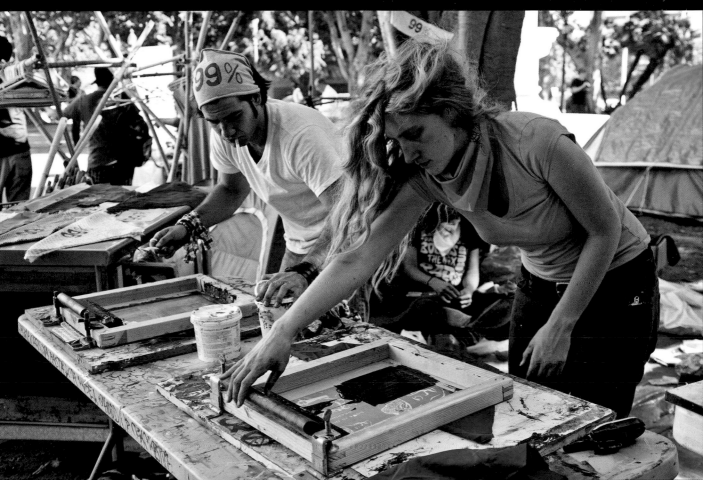

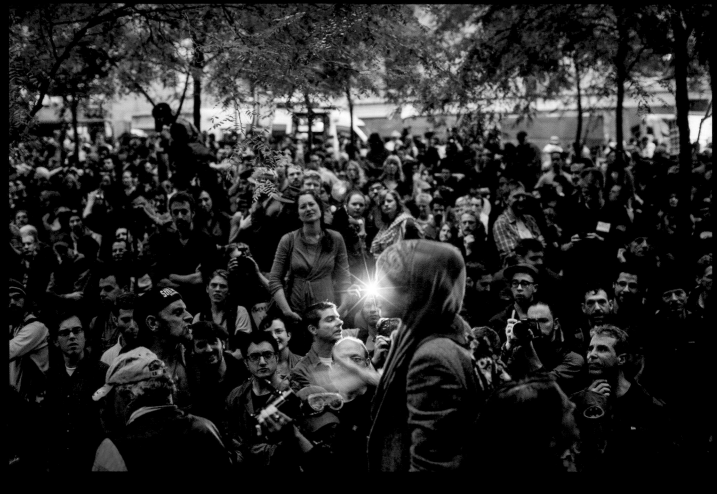

Faced with eviction from Zuccotti Park, thousands of Occupy Wall Street supporters gather in lower Manhattan at sunrise for a people's assembly to determine the next course of action, New York City, 2011.

As the Occupy Wall Street camp at Zuccotti Park grew, New York City began threatening to evict the protesters, citing public safety concerns and sending in the police force. But a volunteer lawyer did research and found a legal loophole. Zuccotti is a public park privately owned by a real estate company. But unlike other city parks, Zuccotti is legally open twenty-four hours a day, and people have the right to gather there.

On the West Coast, a raid on the Occupy Oakland encampment became headline news after hundreds of riot gear–clad police attempted a 5 a.m. eviction. Occupiers resisted, and violence ensued: police and protesters clashed for several days, and an Iraq war veteran sustained serious injury non-lethal projectile shot by police. Viral images from the melee even reached Egypt, where activists held a solidarity march in Tahrir Square.

But the camp crackdowns continued, with police and city officials citing lack of permits and public health and safety threats. Many camps did suffer from internal issues, including assault and harassment. Then winter came, making outdoor living unsustainable in many cities. Weather closed some camps; many others, including Zuccotti Park, were eventually cleared by police.

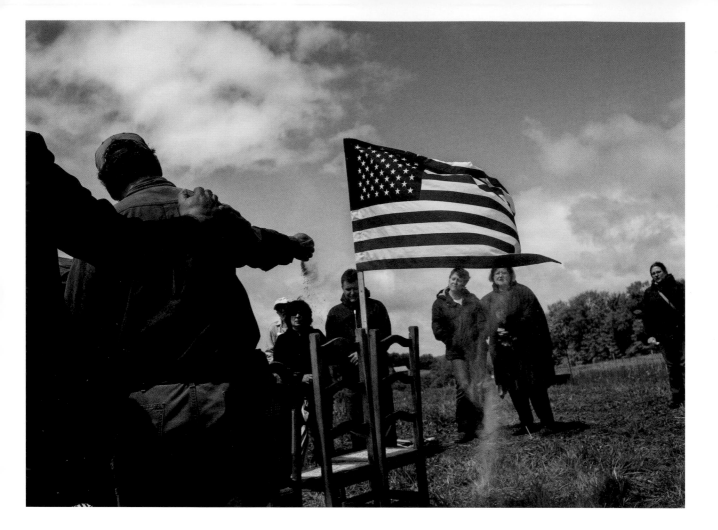

Extraction by hydraulic fracturing, or fracking, has gained popularity among oil and gas companies, despite protests from environmentalists. What was an experimental technique in 1948 has become a widespread and highly controversial practice.

Drilling into the earth, then injecting a high-pressure mixture of water, sand, and chemicals into the rock, releases natural gas. Concerns include the huge amounts of water required; potential for releasing carcinogenic chemicals that can contaminate groundwater; and destabilization of existing fault lines, which can trigger significant seismic activity in areas otherwise not prone to earthquakes. Over thirteen million people live within a mile of a fracking drill.

Fracking has impacted many communities, including the small organic Pennsylvania farm of Dr. Stephen Cleghorn and Lucinda Hart Gonzalez. Beneath it is the Marcellus Shale, a vast formation of sedentary rock underlying Ohio, Pennsylvania, West Virginia, and New York. After learning that a big corporation eager to extract enormous amounts of natural gas was developing a well 3,500 feet from their house, taking nearly ten acres of their property and sending toxins into the earth, Dr. Cleghorn and Gonzalez became anti-fracking activists. Though bans have been passed, the anti-fracking fight continues.

©Nina Berman/NOOR

Dr. Stephen Cleghorn declares his organic farm frack-free in a memorial tribute to his wife, Lucinda Hart Gonzalez, who died of breast cancer. Environmental activists from across the region attended to honor her and participate in releasing her ashes, Reynoldsville, Pennsylvania, 2012.

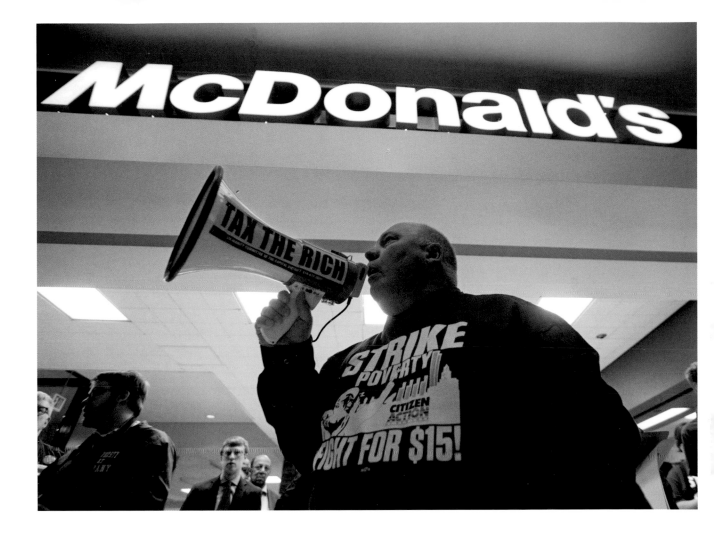

©Mike Groll /Associated Press Photo

Mark Emanatian, of Citizen Action of New York, speaks during a rally for a $15 an hour wage at the Empire State Plaza Concourse in Albany, New York, 2015.

One stunning activist victory is the Fight for $15 movement, founded by fast-food workers in New York City in 2012. Low-wage and non-regular workers have no regular shifts, little chance of upward mobility, and few or no benefits. Lacking union support, they are vulnerable to job loss if they strike or speak up. The federal minimum wage of $7.25, set in 2009, has no inflation adjustment mechanism. Minimum wage workers have 17 percent less buying power in 2019 than they might have in 2009 and 31 percent less than a minimum wage worker in 1968.

Workers walked off the job at popular chains, and diverse workers and allies joined the nationwide Fight for $15 protests, in what organizers called the biggest ever mobilization of US workers.

Between 2012 and 2019, Fight for $15 won $62 billion in raises for twenty-two million low wage workers and changed the national dialogue about minimum wage. After Seattle adopted a $15 minimum wage, other local and state governments followed, but the Republican-controlled Senate resists raising the federal minimum.

Fight for $15 has revitalized the labor movement and is working to bring back unions. $15 is now seen as the benchmark for a livable working wage.

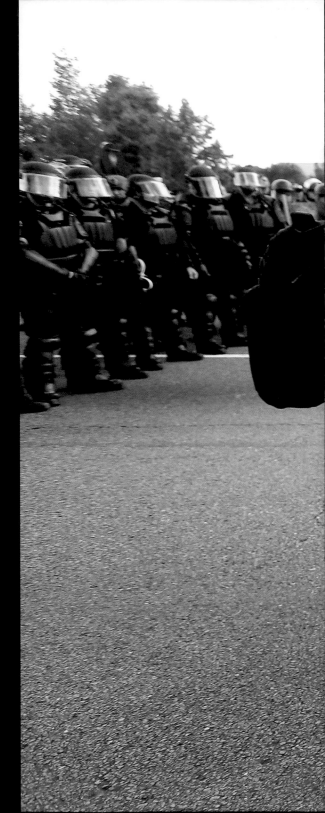

In summer 2016, two Black men were murdered by police within two days of each of each other; both killings were captured on video and viewed by millions. Philando Castile was shot in his car in St. Paul, Minnesota, after being pulled over for a broken taillight; his girlfriend used her phone to stream the deadly interaction live on Facebook. The following day, Alton Sterling was shot in Baton Rouge, Louisiana, after two police officers wrestled him to the ground.

The murders sparked fresh outrage and more of the racial justice protests that began in 2013, following many police shootings of unarmed Black men and women. While Black communities have long suffered at the hands of racist police, the high-profile police brutality against Black Americans like Trayvon Martin, Tamir Rice, Michael Brown, Sandra Bland, and Eric Garner caught the public's attention in new ways. Organizations like Black Lives Matter and bystanders' use of technology capture and broadcast the brutal truths of police brutality.

Ieshia Evans had traveled from New York City to Baton Rouge to protest the killing of Alton Sterling—her first protest. The photo, which recalls those of Jan Kasmir and of the young man facing down the tank in Tiananmen Square, is iconic.

©Jonathan Bachman/ Reuters

Ieshia Evans, while protesting the death of Alton Sterling, is detained by law enforcement officers near police headquarters in Baton Rouge, Louisiana, 2016.

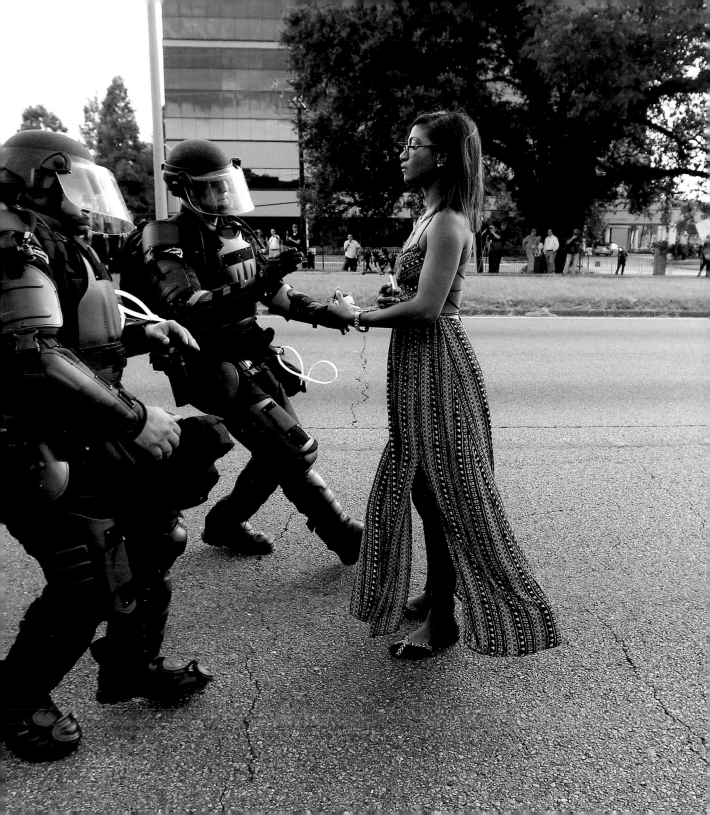

The Black Lives Matter (BLM) movement began in July 2013, after George Zimmerman, the man who shot and killed unarmed teenager Trayvon Martin, was acquitted. Three Black women—Alicia Garza, Opal Tometi, and Patrisse Cullors—made the phrase a hashtag to empower and support the grieving Black community. After another tragic police shooting of an unarmed Black man, BLM became a racial justice organization—and a powerful national and international movement.

In August 2014, yet another Black teenager, eighteen-year-old Michael Brown, was shot in the back by a police officer in Ferguson, Missouri. There was already tension between the majority-Black population and the majority-white police force. Community members held peaceful vigils, but anger overwhelmed some. Violence broke out, and the city cracked down hard, with curfews and military-style police equipment.

#BlackLivesMatter began trending like never before, and BLM organizers set up civil rights–inspired "freedom rides," bringing over six hundred activists to Ferguson to support the community. The unrest continued for several days and erupted again several months later, when a grand jury failed to indict the officer who shot Brown. Many BLM activists remained in Ferguson, training and empowering Black community leaders to sustain the fight for justice.

©Justin Sullivan/Getty Images

A protester stands in front of police vehicles with his hands up, after the grand jury announced officer Darren Wilson was not indicted in the murder of Michael Brown, Ferguson, Missouri, 2014.

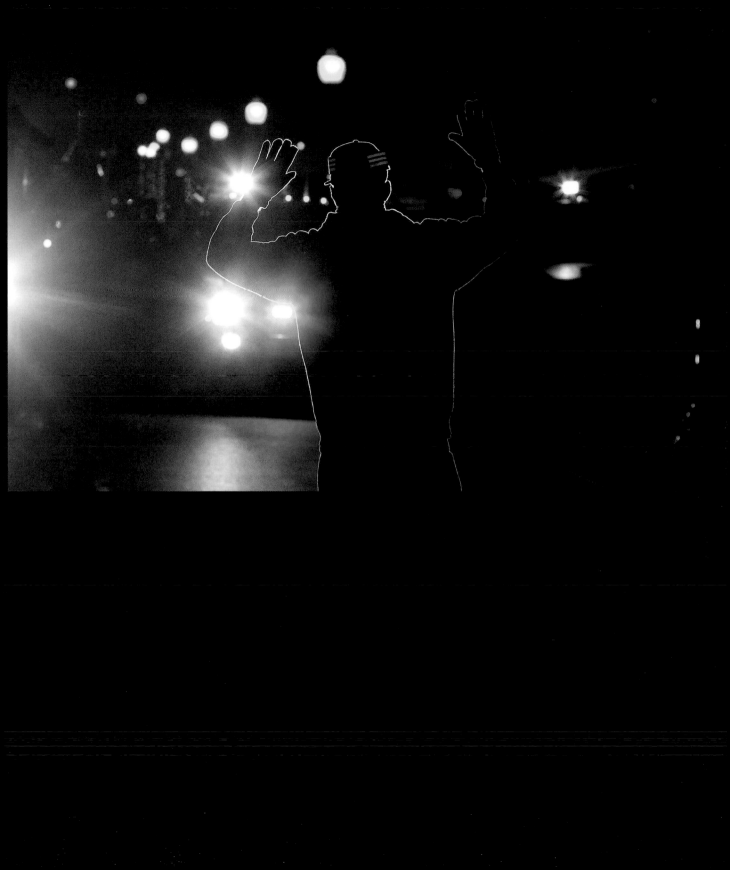

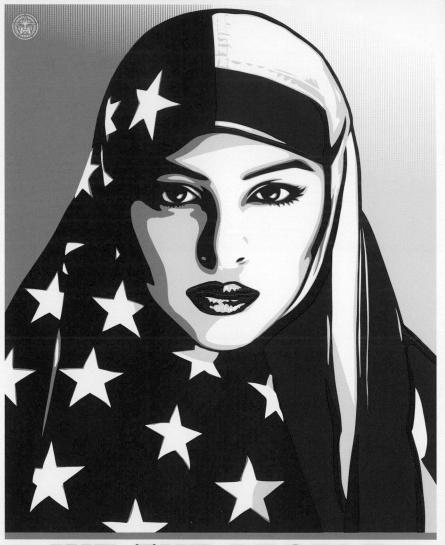

WE THE PEOPLE

ARE GREATER THAN FEAR

ACTIVISM IN A TIME OF REPRESSION & UPHEAVAL

Today, political, social, and ecological upheavals continue. The far right threatens democracies globally. Climate change is here. We can only adapt to it now. Progressives have expanded the concept of equality: while everyone merits equal rights, we are not all born equal and society must restructure to offset these differences. So, while radical conservatives dismantle social safety nets, progressives propose expansion—such as single-payer health care and free college—and several cities are trying small-scale basic income programs.

Donald Trump's 2016 election shocked and devastated millions; some of which had believed Hillary Clinton would be the first female president. Many were outraged by his overtly misogynist, xenophobic, racist campaign; long history of shady business dealings; and well-documented cases of sexual harassment and assault.

The election was followed by a spike in hate crimes against minority and marginalized groups, particularly in counties swept by Trump, second only to the uptick after September 11, 2001. Under his administration, the country's bitter ideological battles flared. Racist, sexist ideologies grew emboldened among radical right-wings after the 2019 impeachment, which the Senate voted down.

This span of years has seen the dark side of the digital revolution. Unregulated social media platforms have become a powerful recruiting tool for extremist and terrorist groups, which enabled Russia's interference in the 2016 election. Up to 36 percent of American workers take part in the gig economy because their primary job is inadequate. Many relying on it as primary income are struggling. Rideshare drivers have begun to actively organize, unionize, and challenge exploitation of gig workers, and legislators have responded.

After the 2016 election, Americans found a new activist consciousness, organizing some of the largest marches in decades. #Resist became the rallying cry, hashtag, and motto of a new activist coalition, including seasoned progressives and those with fresh political consciousness.

Many grassroots organizations committed to empowering citizen activists, holding the Trump administration accountable, defending those most vulnerable to Trump's policies, increasing voter registration and turnout, and empowering women and people of color to run for office. Indivisible, Swing Left, Run for Something, and Sister District, as well as reenergized organizations like EMILY's List, the ACLU, RAICES, and United We Dream have seen memberships, donations, and engagement skyrocket.

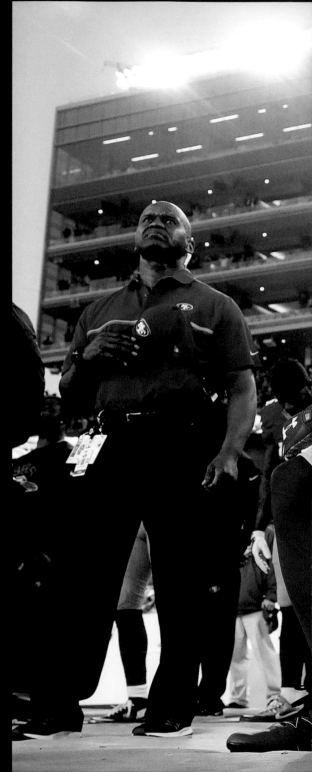

Moved by the rise of the #BlackLivesMatter movements, protests in Ferguson, and the deaths of Alton Sterling and Philando Castile, San Francisco 49ers back-up quarterback Colin Kaepernick decided to take a stand—by not standing—during a game in August of 2016. Despite the risk to his career, Kaepernick stayed seated during the pre-game national anthem. And again at the next game. After the third, he explained: "I am not going to stand up to show pride in a flag for a country that oppresses Black people and people of color." At a military veteran's suggestion, Kaepernick began taking a knee and bowing his head.

Many accused Kaepernick of being unpatriotic, and President Trump criticized him on Twitter. But his action was applauded by millions and inspired many other athletes, including fellow football players, to take a knee.

World Cup soccer champion Megan Rapinoe took a knee because as a lesbian she knew what it meant "to look at the flag and not have it protect all of your liberties." At the 2019 Pan American Games, Gwen Berry, gold medalist for the hammer throw, raised her fist. Many were punished by their leagues; some were forced to leave their sport. But soon high school and college athletes were taking a knee too. All of these athletes were inspired, in part, by Muhammad Ali.

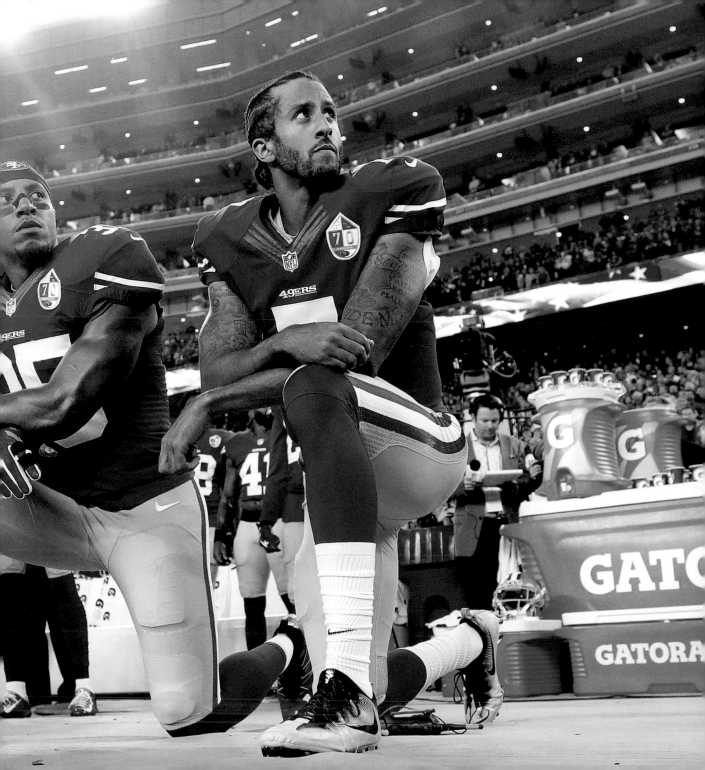

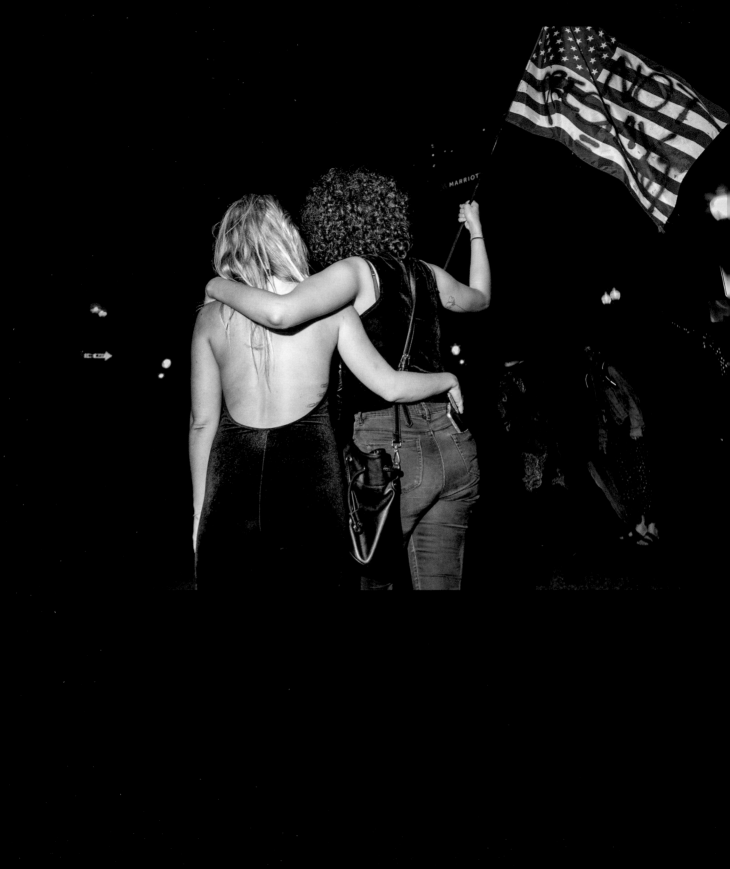

"Not My President" protesters on the night
Donald Trump won the presidential race,
Oakland, California, November 8, 2016.

Millions of Americans were shocked when Republican Donald J. Trump defeated
Democrat Hillary Clinton, who won the popular vote by an almost 2.9 million
margin but narrowly lost in the electoral college. She was the fifth candidate in
US history to win the popular but not the electoral vote.

That night, as Trump victories were announced in crucial "battleground" states
like Michigan, Ohio, Pennsylvania, and Florida, it became increasingly clear that
Trump would prevail. Many Americans, especially Democrats and female Clinton
supporters, felt a sense of dread. In cities, people took to the streets, outraged that
a blatantly sexist, racist, politically inexperienced businessman could defeat an
experienced woman who had endured misogyny on the campaign trail.

"Not My President" became the rallying cry, from Dallas to Portland to Chicago.
Protesters in New York City gathered at Trump Tower; in Los Angeles, thousands
shut down Highway 101. On college campuses, including UC Berkeley, thousands of
students left their dorms and marched toward Oakland, joining a crowd of seven
thousand who bashed Trump piñatas, marched through downtown, and, in a few
cases, smashed windows and set fires. Thus began open conflict between conserva-
tives and progressives and the most impassioned activism since the Vietnam War.

When Donald Trump became president, women responded swiftly and proactively all around the world. The idea for a women's march started in Hawaii with Teresa Shook's Facebook post. This invite, and more from others, went viral. Within a day, thousands of activists of all ages committed to come to Washington, DC, during Trump's inauguration. Dedicated volunteers toiled to coordinate what became the largest single-day protest in American history.

The day after Trump's inauguration, protesters streamed into Washington. Thousands of women, and some men, knitted and wore signature pink "pussy hats," named after the 2005 recording of Trump leaked during the campaign. Jayna Zweiman and Krista Suh of Los Angeles conceived the Pussyhat Project to protest the misogyny expressed by Trump and our culture at large.

The crowd of over a half million people—estimated to be triple the inauguration attendance—was awash in pink.

At sister marches all over the world, many wore their pussy hats. Women, nonbinary people, and their allies gathered for marches and rallies on all seven continents, including Antarctica, where thirty scientists and tourists held a rally on an expedition boat. Over 4.1 million people in the US participated. Worldwide participation was estimated to be as many as eight million people.

©Amanda Voisard for *The Washington Post*

Women's March on Washington, Washington, DC, January 21, 2017.

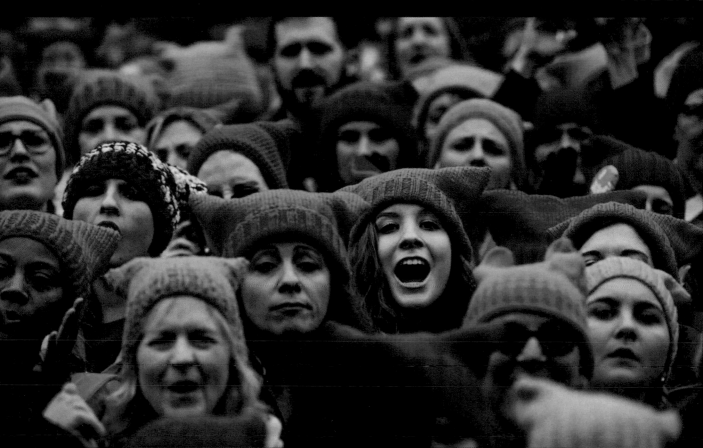

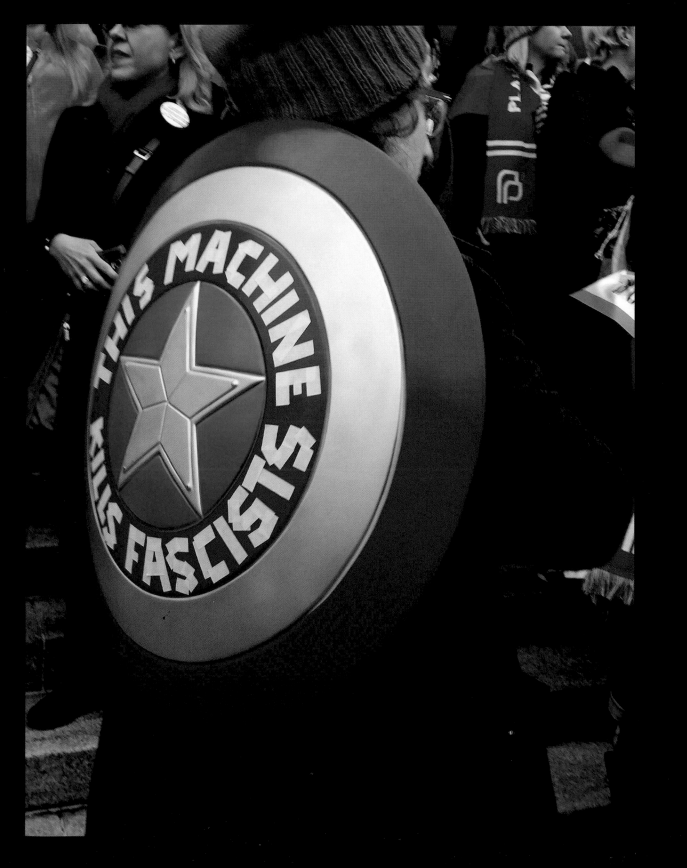

Creative signage has been part of many social and political movements, and the 2017 Women's March was no exception. This protester holds a shield similar to the one wielded by comic book hero Captain America. His shield is virtually indestructible, able to fight off and withstand any attack.

The phrase "This machine kills fascists" was first used by Woody Guthrie, the folk singer-songwriter and activist who wrote the classic American song "This Land Is Your Land." In the 1940s, he wrote the phrase on his guitar, as a way to denounce Hitler and to reflect his belief in the social and political power of music to make change. Guthrie supported the bitter struggle of people affected by the Depression to encourage them to fight for social justice, and he inspired musicians like Bob Dylan, Odetta, and Joan Baez to make music that spoke to change.

By combining the contemporary Captain America symbol with the anti-fascist message, the protester makes a strong statement that she is powerful, determined, and capable of resisting corrupt leaders and politicians and that the source of her power comes from the generations of resisters before her.

©Melanie Light

Her superpower is the legacy of resistance.
Women's March, Washington, DC, 2017.

In 2014, the Army Corps of Engineers approved Energy Transfer Partners' building of the Dakota Access Pipeline (DAPL). A potential oil spill would have poisoned the state capital's drinking water, so it was rerouted through Sioux Reservation property at Standing Rock, where it threatened sacred indigenous land, including the rivers and their burial grounds. The Standing Rock Sioux didn't want their drinking water jeopardized either so they took a stand against the toxic, invasive, dangerous operation.

In April 2016, Tokata Iron Eyes and her friends organized "ReZpect Our Water." The hashtags #NoDAPL, #WaterIsLife, and #StandWithStandingRock announced that the pipeline threatened their water, culture, and lives. LaDonna Brave Bull Allard, a Sioux, established the Sacred Stone Camp, which quickly grew to two thousand protesters.

Other Native nations and non-Native allies joined them; politicians and celebrities used their social media platforms to spread awareness.

The National Guard and local police bore down on the protesters. Violence broke out and hundreds of people were arrested. The movement to save Standing Rock became the largest intertribal alliance on the continent in centuries, with more than two hundred tribal nations involved—the first time the seven bands of the Great Sioux Nation had allied since the 1876 Battle of the Little Bighorn.

©Alyssa Schukar for *The New York Times*

Catcher Cuts the Rope, a Marine injured in Fallujah, leads a two-mile walk protesting the Dakota Access Pipeline, which would cut across several sacred indigenous sites, Standing Rock, Fort Yates, North Dakota, 2016.

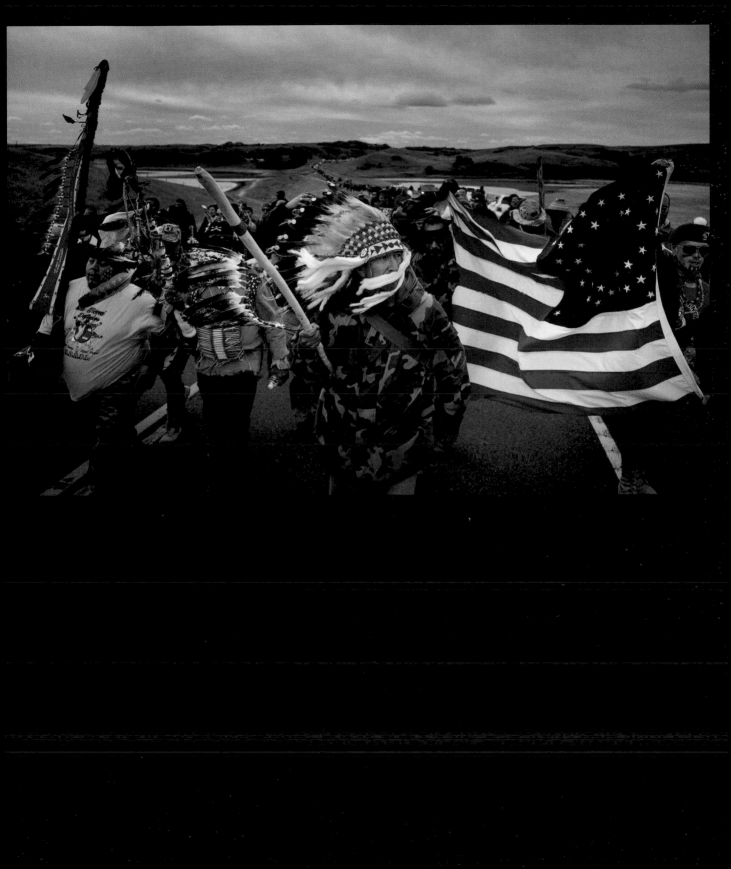

In December 2016, at least two thousand US military veterans deployed to Standing Rock, arriving in frigid cold to help serve as a human shield between the peaceful indigenous water protectors and the armed National Guards called in to clear the camps. The water protectors had been encamped for months, blocking access to the pipeline construction sites, raising over $1 million in donations, and receiving supplies and support from around the world.

Most of the veterans belonged to Veterans Stand for Standing Rock, a peaceful militia nonviolently defending the water protectors. The veterans drew national attention to the failings of the government they'd once served.

It was soon announced that the Army Corps of Engineers had denied a permit for the construction of a key section of the Dakota Access Pipeline, halting the construction of the 1,172-mile project. The veterans joined the water protectors in joyful but short-lived celebration. On his second day in office, Trump authorized the Army Corps of Engineers to move forward, ending the environmental impact assessment and public comment period. Two weeks later, the National Guard and local police evicted people from the encampment, and oil began flowing in May.

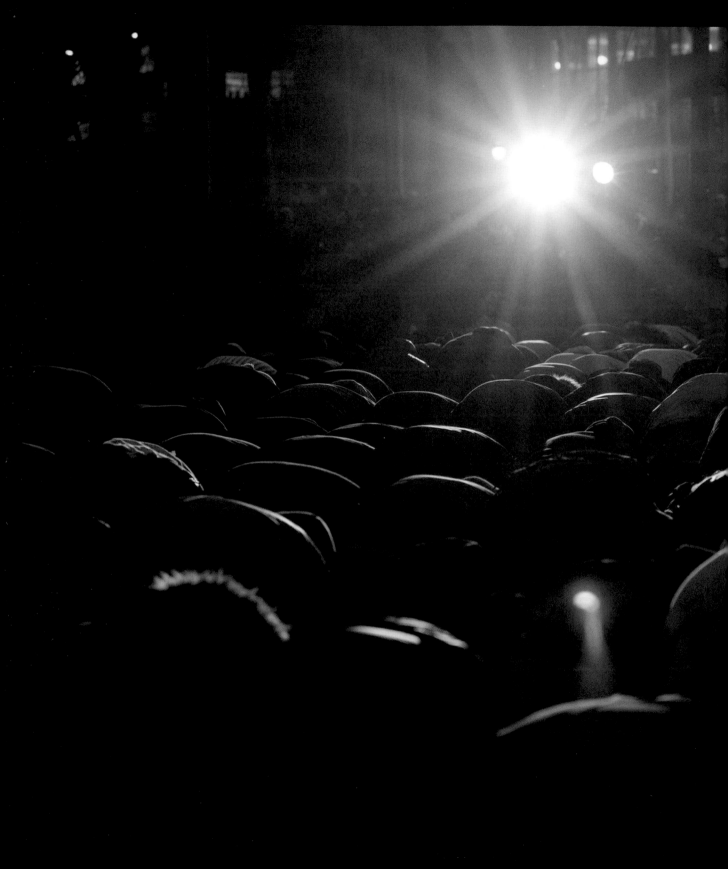

Trump's executive order signed on January 27, 2017, banned citizens of seven Muslim-majority nations from entering the US. Despite claims of terrorism prevention, the anti-Muslim bias was obvious. The Department of Homeland Security called the risk of terrorists entering the US from those countries negligible.

The order also blocked legal citizens and green card holders originally from the banned countries from reentering the US for ninety days, meaning people traveling abroad for work or pleasure suddenly couldn't return home. Those en route to the US on flights during the order signing were detained at airports. Massive spontaneous demonstrations erupted across the country, as thousands of people, particularly Japanese Americans, came to international airports to support detained travelers.

The majority-Muslim New York Taxi Workers Association directed its nineteen thousand members to go on a one-hour strike in solidarity. New York's Yemeni community declared #BodegaStrike, closing over a thousand Yemeni-owned bodega shops and marching and rallying with five thousand in Brooklyn.

The Supreme Court ultimately upheld the ban, refusing to consider the president's plan to secure the country's borders was influenced by his history of comments about the dangers of Muslims in the US. Justice Sotomayor dissented, likening the decision to the 1944 *Korematsu vs. United States* ruling that endorsed the detention of Japanese-Americans. Protests erupted anew.

©Nina Berman/NOOR

Yemeni New Yorkers staged a strike and protest at Brooklyn Borough Hall against Donald Trump's travel ban on visitors and immigrants from seven Muslim majority countries, then prayed en masse at sundown, Brooklyn, New York City, 2017.

In June 2015, Dylann Roof, a white supremacist, murdered nine Black churchgoers at the Emanuel African Methodist Episcopal Church in Charleston, South Carolina. The horrific attack stunned a nation grappling with increased racial tension and police brutality. In response, members of the Black community and their allies launched a campaign to have Confederate symbols removed from public spaces.

Most were built in the aftermath of the Civil War and during the Jim Crow era. Many celebrate pro-slavery Confederate soldiers and generals. Some Southerners claim them as cultural heritage; Black residents decry them as racist reminders of a brutal history.

In Memphis, Tennessee, activist Tami Sawyer founded a group called #TakeEmDown901, seeking to remove Confederate memorabilia from Memphis before the fiftieth anniversary of Dr. Martin Luther King, Jr.'s murder—especially the statues of KKK Grand Wizard Nathan Bedford Forrest and Confederate president Jefferson Davis. After four months of petition drives, regular protests, and powerful advocacy, Sawyer and other activists convinced the Memphis City Council to remove the statues.

Within several years of the Charleston massacre and the renewed push to eliminate Confederate monuments, over 110 monuments and symbols were removed from public spaces, and numerous schools, parks, buildings, and roads renamed to expunge Confederate ties.

©Justin Fox Burks

Tami Sawyer, Memphis Mayoral candidate, Memphis, Tennessee, 2017.

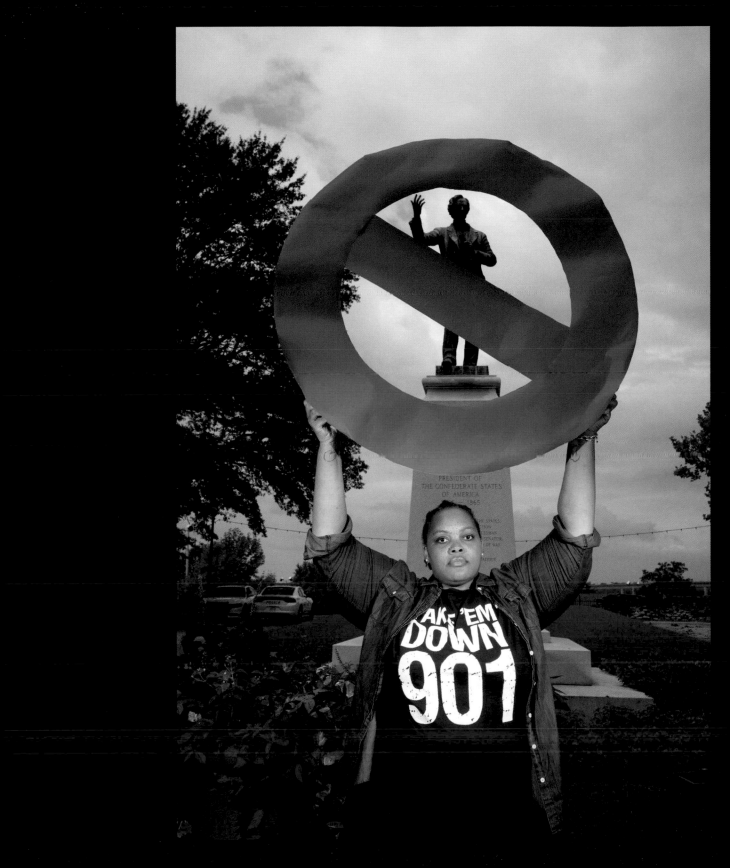

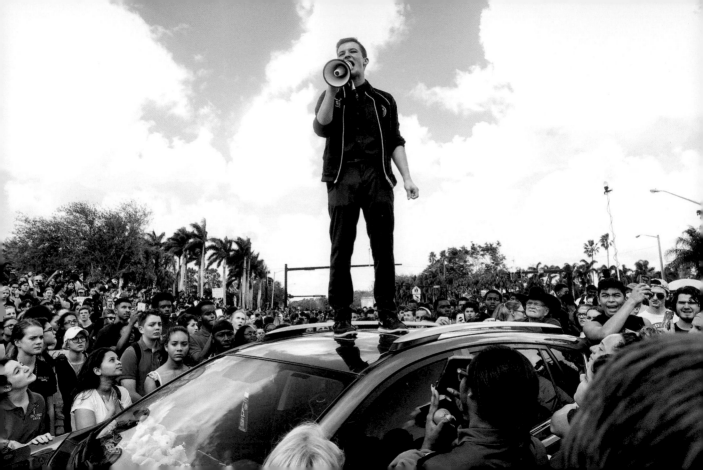

Marjory Stoneman Douglas High School student
Cameron Kasky addressing area students as they
rally at his school after participating in a countywide
school walkout, Parkland, Florida, February 21, 2018.

In February 2018, a teenage boy brought a semi-automatic weapon onto the campus of Marjory Stoneman Douglas High School (MSD) in Parkland, Florida. When his six-minute rampage ended, seventeen students and staff were dead. It was the sixth school shooting of 2018, and the 239th since the 2012 massacre at Sandy Hook Elementary. This was not a rare event in America—but the response from the students was unprecedented.

A group of surviving students refused to let it be just another school shooting. They started a Facebook page, #NeverAgain, and held a press conference on live television. Cameron Kasky said, "People are saying that it's not time to talk about gun control, and we can respect that. Here's a time: March 24, in every single city."

MSD students, families, and community members planned the March for Our Lives and started a youth-led movement against gun violence. They held walkouts, appeared on television, and met face to face with local, state, and federal politicians, demanding changes to gun laws.

They connected with young people affected by gun violence, especially youth from communities of color disproportionately harmed by gun violence, and on March 24, nearly two million people joined the March in eight hundred cities.

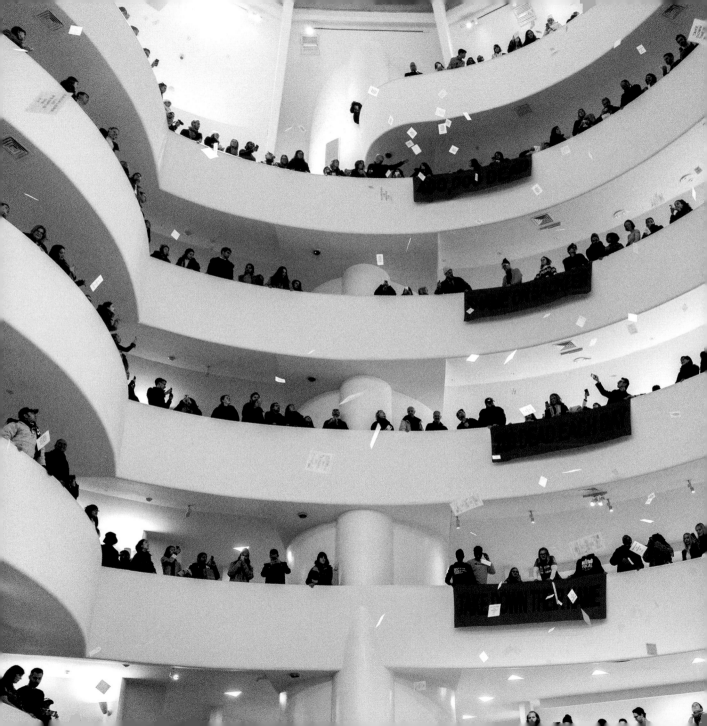

Between 1999 and 2017, over four hundred thousand people died in the US from prescription opioids, a national epidemic stemming from an industry-wide conspiracy to promote highly addictive pharmaceuticals and suppress data about chemical dependency and negative side effects.

The Sackler family, which owns pharmaceutical giant Purdue Pharma, is central to the battle to hold companies and physicians accountable. Americans' growing addiction to prescription medications like OxyContin and hydrocodone enriched Purdue, with about $35 billion in revenue from OxyContin alone.

The Sackler family, estimated to be worth $13 billion, finances prestigious museums all over the world, including New York's Guggenheim. In February 2019, artist Nan Goldin, a recovered prescription opioid addict and artist with work in many major museums, joined a group of activists including family members of people lost to opioid overdoses. They insisted that the Guggenheim stop taking donations from the Sacklers. The pressure has worked: the Guggenheim and the Metropolitan Museum of Art are refusing further donations, and the Louvre in Paris removed the Sackler name.

The Sackler family and other opioid producers have been sued thousands of

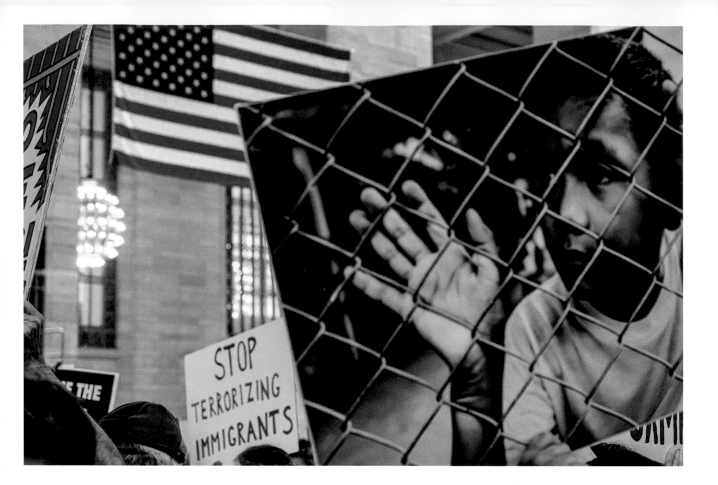

The Trump administration's treatment of children forcibly removed from their families is particularly reprehensible. Increased media coverage of the family separations and migrant detention centers motivated a limited number of politicians, journalists, and physicians to gain access to the heavily guarded facilities, almost all of which were owned by private companies. The reports from those who were able to visit were shocking.

Democratic Congresswomen and men tweeted about crying babies with soiled diapers, children sleeping on floors, and women living in cells with no running water and no idea where their children were. Physicians reported lice outbreaks, unsanitary conditions, extreme overcrowding, freezing temperatures, malnourishment, and the spread of dangerous but preventable communicable illnesses. They also reported disrespectful attitudes and aggressive behavior from guards, who often treated the visitors and the detained children and families with hostility and disdain.

One protest tactic used by demonstrators was to hold up photos of detained children, including ones who had died in the custody of Immigration and Customs Enforcement (ICE). While many rallies protesting the cruel treatment of migrants included yelling and chanting, some opted for the power of silence, allowing the haunting images of suffering children to speak volumes.

©Ken Schles

Rise and Resist silent protest in
the main hall of Grand Central Terminal,
New York City, 2019.

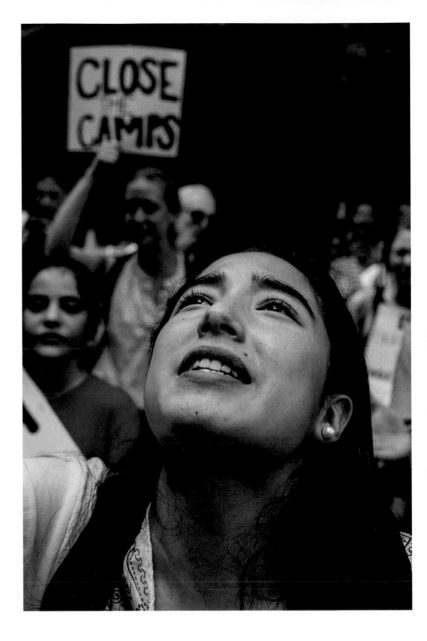

Indivisible Nation protesters during the "National Day of Action to Close the Camps" opposite New York Democratic Senator Schumer's residence in Brooklyn, New York City, 2019.

Intense violence in Central America sends waves of emigrants to America seeking safety, many of them women and their children.

Homeland Security began apprehending and splitting up migrant families to separate detention facilities, often with little to no information on when or whether they'd be reunited.

At least 2,700 children were separated from their parents. Protests demanding humane treatment and an end to the family separation policy began in 2018.

Hundreds gathered at Senate Minority Leader Chuck Schumer's home to pressure prompted Schumer to condemn the border policies on social media, but there's little chance of any bill passing the Republican-majority Senate.

Human-caused climate change is an urgent crisis. Scientists, educators, policymakers, and other climate activists work to slow or stop its dangerous consequences of record-breaking temperatures, extreme weather, and rising sea levels—with some researchers predicting four feet over the next century.

Response from world leaders and influential corporations has been too slow—and under Trump, the US (the world's second-largest carbon emitter) has abandoned the Paris Climate Accord and scrapped many critical environmental laws and policies.

But the climate movement has been energized by young people who form non-profits, organize strikes and marches, confront elected officials, educate their peers, and promote global awareness. Teen activist Greta Thunberg began skipping school on Fridays to strike for the climate outside the Swedish parliament. Her passion at the September 2019 UN Climate Action Summit and testimony to the US Congress stunned the world, and over four million young people joined in a global Fridays for Future protest, now ongoing.

The Rise for Climate March brought over thirty thousand to San Francisco before the Global Climate Action Summit. Organizers and participants pushed for local leaders to step up, resist the fossil fuel industry, and commit to investing in 100-percent renewable energy.

©Jared Stapp

Rise for Climate March, San Francisco, California, 2018.

The #MeToo concept was developed by youth worker Tarana Burke's nonprofit, Just Be Inc., which serves survivors of sexual harassment and abuse. As several girls shared their abuse stories, Burke did not know how to help, but whispered to herself, *"Me too."* It became a catch phrase for her campaign of "empowerment through empathy." She developed the program for ten years before #MeToo exploded in 2017 after actress Ashley Judd accused producer Harvey Weinstein of sexual harassment and assault.

In support of Judd and other women coming forward with accusations against Weinstein and other powerful Hollywood men, actor and activist Alyssa Milano tweeted: "If you've been sexually harassed or assaulted reply 'me too' as a reply to this tweet." Within twenty-four hours, #MeToo appeared in over twelve million Facebook posts in which people shared their stories.

The hashtag became a powerful rallying cry for people of all genders, showing that sexual harassment and assault are not isolated incidents. As more felt empowered to speak up, dozens of powerful men were accused of behaviors ranging from harassment to rape. Many lost their jobs, and a handful were criminally charged and convicted, including Weinstein. The movement has had many other positive effects on society as well. New state laws all over the country are requiring schools to teach sex education to prioritize medical accuracy, sensitivity to the spectrum of sexualities, and to include instruction on human trafficking.

©Scott Olson/Getty Images

McDonald's workers march to the company's headquarters to protest sexual harassment at the fast food chain's restaurants, Chicago, Illinois, September 18, 2018.

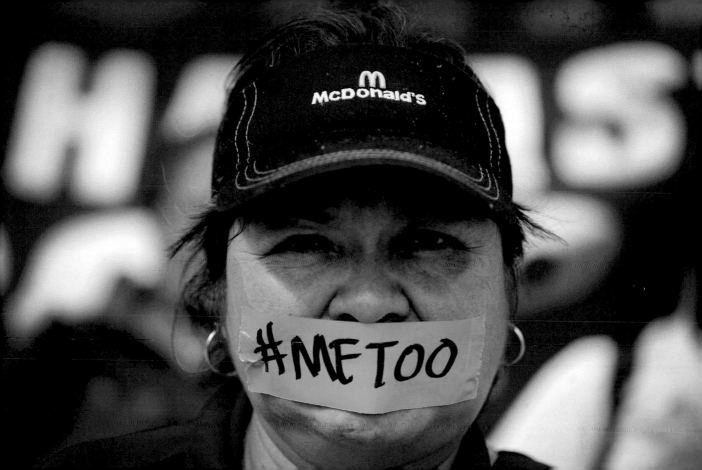

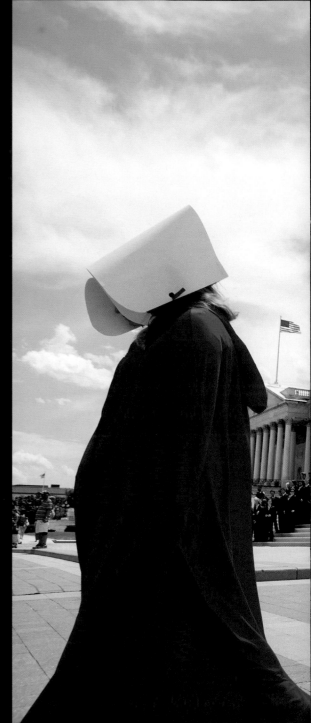

In 1985, Margaret Atwood published *The Handmaid's Tale*, depicting a dysto-pian society in which women live in extreme subjugation to men and a radical theocracy forces women whose reproductive systems have not been damaged by environmental toxicity to bear children for the patriarchs. Atwood's handmaids wear red gowns and white bonnets representing fertility and purity.

While Federal law still protects a woman's right to an abortion and the Pew Research Center found that 61 percent of US adults say abortion should be legal, state laws have been increasingly cut back for decades. For instance, Alabama has banned all abortions, even in the case of rape and incest, and Georgia has outlawed abortions at six weeks—before many women are even aware that they are pregnant. These state laws can be challenged, but appeals would reach a more conservative Supreme Court, ultimately resulting in the overturning of *Roe v. Wade*. The novel's previously unthinkable premise now seems like a real possibility.

In April 2017, a Hulu version of *The Handmaid's Tale* premiered, coinciding with efforts by emboldened Trump-era Republicans to roll back reproductive rights and health protections for the poor. Soon groups of women across the country—and the world—began wearing the red gowns and white bonnets at protests, state capitols, and marches and rallies, often standing or marching in

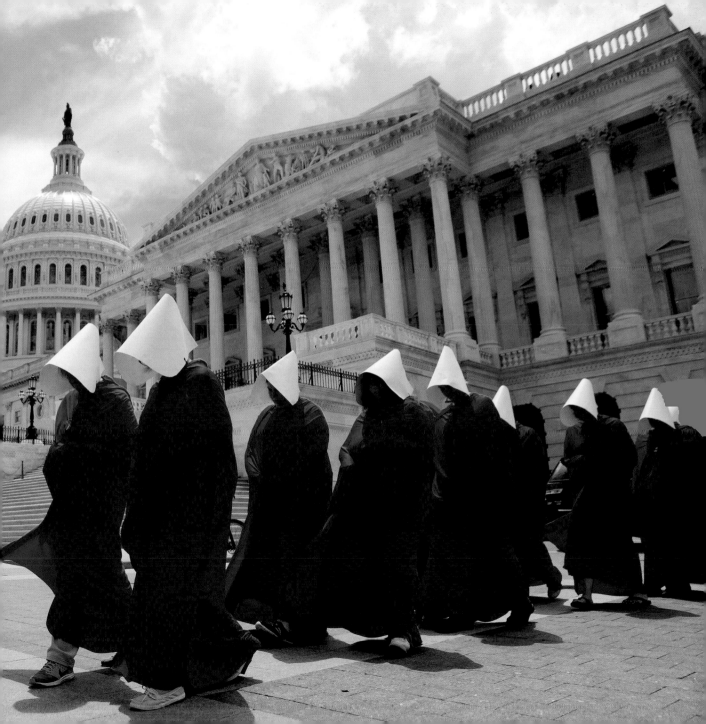

Our democracy's future is uncertain. We must take back the government for the people, find bipartisan ground, and address the needs of all. America must reclaim its higher mission and quell the existential fear that has been channeled into hatred. We must call a halt to the brawling, pick ourselves up, and start putting this country back together. The vision of social justice brought to life in the sixties by Dr. Martin Luther King, Jr. still lives on in our hearts. We cannot unlearn what we know to be true. We must insist on resistance to our darker nature because ". . . one day this nation will rise up, live out the true meaning of its creed: 'We hold these truths to be self-evident, that all men are created equal.'" Let that day come sooner rather than later.

©Maddie McGarvery, 2019.

People protest outside the hospital President Trump visited after a shooting that had killed nine people earlier that week in the Oregon Historic District neighborhood, Dayton, Ohio, 2019.

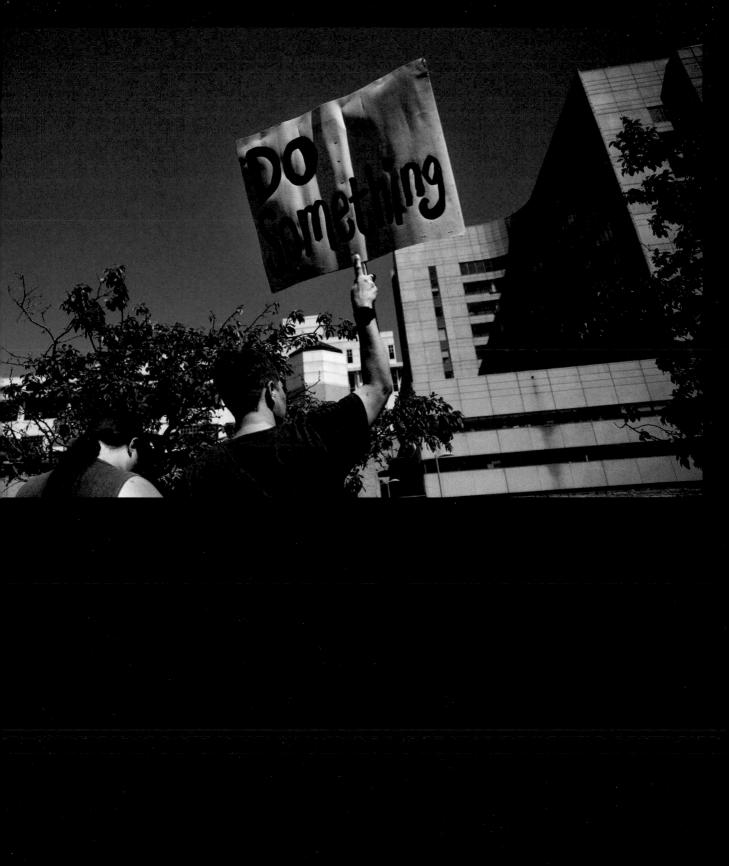

ACKNOWLEDGMENTS

We want to thank the many photographers who sent us images to consider for use in this book. We appreciate their patience and understanding as we culled through hundreds to make our selections. Choosing from a rich visual history of protest by dedicated and talented photographers was like trying to drink from a fire hose. We know we missed some events and images and had to exclude others. We were personally enriched by the passion, skill, and dedication of the many conflict and social documentary photographers who witnessed the hard work of social justice resistance over many decades.

Along our book-making journey, it took real detective work to find images for events that we knew happened but were often lost or hard to find. They reside as analog prints in manila folders in libraries, photographers' file cabinets, and newspaper morgues. We greatly appreciate the efforts of Jeffrey Smith at Contact Press Images for his advice and help with image selection, and we thank Michael Shulman at Magnum Photos for his help securing rights, too. Marcel Saba at Redux Pictures, Matthew Lutz at Associated Press, and Alamy Stock Photo were responsive and delivered the pictures quickly. Andrew Lichtenstein generously shared his photo contacts, enabling us to discover crucial images.

We especially want to thank the executors of the estates of photographers and public institutions who granted rights to use photographs: Bradley Cook of Indiana University; Oakland Museum of California; the estates of Bob Adelman, Jim Marshall, George Ballis, Peter Simon, Jill Freedman; The Peter Hujar Archive, and the Bob Fitch Photography Archive at Stanford University.

Lincoln Cushing offered his wisdom and expertise in sourcing posters and he photographed the political buttons used in this book. We enjoyed his passion for the history and design of political art. We send a big shout-out to the creative genius of the poster makers who were generous with their permissions: Shepard Fairey, Doug Lawler, Gran Fury collective, Eric Drooker, and the Public Media Center. We also want to acknowledge the anonymous button designers who gifted resisters with those small but powerful graphic statements that live on today.

Thanks to Sue Hamilton for the time and attentive reading of the manuscript. Danielle Parenteau Decker was a lifesaver for her lightning-quick skills at turning notes and scribbles into a bona fide bibliography. Jared Stapp jumped in to help clean digital files at a moment's notice.

We are grateful to our designer, Isabelle Gioffredi, assistant editor, Kimmy Tejasindhu, and production director, Serena Sigona, for their enthusiasm and conscientious input. Many thanks to Kaitlin Ketchum and Lorena Jones for bringing this project to us and believing that the story of American resisters needs to be told in these times of great upheaval and transition in our country.

Melanie Light writes about social issues and has written in collaboration with photographer Ken Light on two previous documentary books: *Coal Hollow* and *Valley of Shadows and Dreams*, for which she was awarded the California Book Award in 2013. She has published several special edition photography books and was the founding executive director of Fotovision, a nonprofit dedicated to supporting the international community of documentary photographers. Light is the recipient of grants from the Soros Documentary Fund and the Rosenberg Foundation. She teaches and lectures internationally. Currently, she manages a private art and book collection and is a certified fine art appraiser.

Ken Light works as a documentary photographer, focusing on social issues facing America for over fifty years. His work has been published in ten books, including *Midnight La Frontera, What's Going On? 1969-1974, Coal Hollow, Delta Time, To the Promised Land, With These Hands, Texas Death Row*, and *Valley of Shadows and Dreams*. He is also the author of the text *Witness in Our Time: Lives of Working Documentary Photographers*, now in its second edition. His new book, *Course of the Empire*, is forthcoming. He is the recipient of two National Endowment for the Arts Photographers Fellowships and the Dorothea Lange Fellowship. His work has been in numerous magazines, newspapers and a variety of media (electronic and film), and presented in more than 230 exhibitions worldwide, including one-person shows at the International Center for Photography (NYC), Oakland Museum of California, S.E. Museum of Photography, Visual Studies Workshop, Visa pour L'image Perpignan (France), and the San Jose Museum of Art. He is the Reva and David Logan Professor of Photojournalism at the Graduate School of Journalism at UC Berkeley. He was the first photographer to become a Laventhol Visiting Professor at Columbia University Graduate School of Journalism.

BIBLIOGRAPHY

INTRODUCTION

Lyon, Danny. *Memories of the Southern Civil Rights Movement*. Chapel Hill: University of North Carolina Press, 1992.

CHAPTER ONE

Bloom, Joshua, and Waldo E. Martin Jr. *Black against Empire: The History and Politics of the Black Panther Party*. Oakland: University of California Press, 2013.

Chadwick, Alex. "One of the 'Little Rock Nine' Looks Back." Interview by Alex Chadwick and hosted by Robert Smith. *Driveway Moments*, NPR, September 4, 2007. Transcript. https://www.npr.org/transcripts/14091050?storyId=14091050.

CMG Worldwide. "Biography." *Malcolm X*. https://www.malcolmx.com/biography/.

Daley, Jason. "After 52 Years, the 'Mississippi Burning' Case Closes." *Smithsonian*, June 23, 2016. https://www.smithsonianmag.com/smart-news/after-52-years-mississippi-burning-case-closed-180959533/.

Eckford, Elizabeth. "In Elizabeth Eckford's Words." Facing History and Ourselves. Accessed February 3, 2020. https://www.facinghistory.org/resource-library/audio/elizabeth-eckfords-words.

Fine, Carla. "Desegregation at Little Rock." Letter to the editor, *New York Times*, September 30, 2018. https://www.nytimes.com/2018/09/30/opinion/letters/desegregation-little-rock.html.

Gordon, Taylor. "10 American States with the Most Lynchings of Black People from 1882–1968." *Atlanta Black Star*, February 24, 2015. https://atlantablackstar.com/2015/02/24/10-american-states-with-the-most-lynchings-of-black-people-from-1882-1968/.

Haas, Jeffrey. *The Assassination of Fred Hampton: How the FBI and the Chicago Police Murdered a Black Panther*. Chicago: Chicago Review Press, 2010.

Harris, Adam. "New York City High Schools' Endless Segregation Problem." *Atlantic*, March 20, 2019. https://www.theatlantic.com/education/archive/2019/03/stuyvesant-high-schools-chronic-lack-black-students/585349/.

Higgins, Bill. "Throwback Thursday: Bob Dylan Sang for Civil Rights in 1963." *Hollywood Reporter*, August 28, 2014. https://www.hollywoodreporter.com/news/throwback-thursday-bob-dylan-sang-728240.

History.com editors. "Montgomery Bus Boycott." *History*, June 6, 2019. https://www.history.com/topics/black-history/montgomery-bus-boycott.

Hynes, Patricia H. *The Recurring Silent Spring*. Oxford: Pergamon Press, 1989.

The King Center. "The King Philosophy." https://thekingcenter.org/king-philosophy/.

Lomax, Louis E. *When the Word Is Given: A Report on Elijah Muhammad, Malcolm X and the Black Muslim World*. Westport, CT: Greenwood Press, 1979.

Margolick, David. "We Need More Enemies of the People." *New York Times*, September 21, 2018. https://www.nytimes.com/2018/09/21/opinion/enemies-of-the-people-jerry-dhonau.html.

Meier, Allison. "The 1960s Photographer Who Documented the Peace Sign as a Political Symbol." *Hyperallergic*, October 20, 2017. https://hyperallergic.com/397021/peace-sign-jim-marshall/.

NAACP. "NAACP History: Medgar Evers." http://www.naacp.org/naacp-history-medgar-evers/.

Oakland Museum of California. "Unforgettable Change: 1960s: Free Speech Movement & The New American Left." *Picture This: California Perspectives on American History*. http://picturethis.museumca.org/pictures/jack-weinberg-being-interviewed-inside-police-car-was-taking-him-away-after-his-arrest-viol.

OurDocuments.gov. "Official Program for the March on Washington (1963)." https://www.ourdocuments.gov/doc.php?flash=false&doc=96#.

Pinkney, Alphonso. *Red, Black, and Green: Black Nationalism in the United States*. Cambridge: Cambridge University Press, 1979.

Stanford University, The Martin Luther King, Jr. Research and Education Institute. "Montgomery Bus Boycott." https://kinginstitute.stanford.edu/liberation-curriculum/create-your-own-classroom-activity/montgomery-bus-boycott.

Thompson, Elizabeth Ann. "The Long, Ugly History of Bathroom Segregation." *Progressive*, May 31, 2016. https://progressive.org/op-eds/long-ugly-history-bathroom-segregation/.

Thompson, Krissah. "In March on Washington, White Activists Were Largely Overlooked But Strategically Essential." *Washington Post*, August 25, 2013. https://www.washingtonpost.com/lifestyle/style/in-march-on-washington-white-activists-were-largely-overlooked-but-strategically-essential/2013/08/25/f2738c2a-eb27-11e2-8023-b7f07811d98e_story.html.

X, Malcolm, and Alex Haley. *The Autobiography of Malcolm X: As Told to Alex Haley*. New York: The Ballantine Publishing Group, 1964.

CHAPTER TWO

Abramson, Michael. *Palante: Young Lords Party*. New York: McGraw-Hill, 1971.

Althaus, Sam. "The Throwing of the Medals: Operation Dewey Canyon III Historical Protest Project." *Sam Althaus INFO 303 Project Site*, October 14, 2016. https://publish.illinois.edu/samalthaus/2016/10/14/the-throwing-of-the-medals-operation-dewey-canyon-iii-historical-protest-project/.

Another Mother for Peace. "Another Mother for Peace." http://anothermother.org/.

Ashby, Steven. "In Defense of the Stunning Fight for Fifteen Movement." *Work in Progress*, June 6, 2018. http://www.wipsociology.org/2018/06/06/in-defense-of-the-stunning-fight-for-fifteen-movement/.

Baumann, Jason. "1969: The Year of Gay Liberation." New York Public Library. Accessed February 3, 2020. http://web-static.nypl.org/exhibitions/1969/year.html.

BBC. "1968: Black Athletes Make Silent Protest." *BBC on This Day*, October 17, 1989. http://news.bbc.co.uk/onthisday/hi/dates/stories/october/17/newsid_3535000/3535348.stm.

———. "1969: Millions March in US Vietnam Moratorium." *BBC on This Day*, October 15, 1969. http://news.bbc.co.uk/onthisday/hi/dates/stories/october/15/newsid_2533000/2533131.stm.

Bingham, Clara. *Witness to the Revolution: Radicals, Resisters, Vets, Hippies, and the Year America Lost Its Mind and Found Its Soul*. New York: Random House, 2017.

Bloom, Joshua. "Organizing Rage: Black Panther Political Strategy after the Watts Riots." *The Whole World's Watching*, Berkeley Art Center Association, pp. 65–66, 2001.

Brown, DeNeen L. "'I Am a Man': The Ugly Memphis Sanitation Workers' Strike That Led to MLK's Assassination." *Washington Post*, February 12, 2018. https://www.washingtonpost .com/news/retropolis/wp/2018/02/12/i-am-a-man-the-1968-memphis-sanitation-workers-strike-that-led-to-mlks-assassination/.

Carlsson, Chris. "The Castro: The Rise of a Gay Community." *FoundSF*, 1995. http://www .foundsf.org/index.php?title=The_Castro:_The_Rise_of_a_Gay_Community.

Chertoff, Emily. "Occupy Wounded Knee: A 71-Day Siege and a Forgotten Civil Rights Movement." *Atlantic*, October 23, 2012. https://www.theatlantic.com/national/ archive/2012/10/occupy-wounded-knee-a-71-day-siege-and-a-forgotten-civil-rights-movement/263998/.

Civil Rights Digital Library, Digital Library of Georgia. "Watts Riots." January 27, 2020. http://crdl.usg.edu/events/watts_riots/.

Columbus Dispatch. "Riots of 1970: A Volatile, Deadly Spring." October 5, 2017. https://www .dispatch.com/photogallery/OH/20171005/NEWS/428009998/PH/1.

Cortright, David. "Antiwar Resistance within the Military during the Vietnam War." *Vietnam Peace Commemoration Committee*, October 17, 2017. http://www.vietnampeace.org/blog/ antiwar-resistance-within-the-military-during-the-vietnam-war.

Dallek, Matthew. "The Conservative 1960s." *Atlantic*, December 1995. https://www.theatlantic .com/magazine/archive/1995/12/the-conservative-1960s/376506/.

Daloz, Kate. "The 'Back to the Land' Movement." *Utne*, September 2016. https://www.utne .com/environment/back-to-the-land-movement-ze0z1609zfis.

Diamond, Anna. "Remembering Resurrection City and the Poor People's Campaign of 1968." *Smithsonian*, May 2018. https://www.smithsonianmag.com/history/ remembering-poor-peoples-campaign-180968742/.

Earth Day Network, www.earthday.org.

Earth Day Network. "The History of Earth Day." Accessed February 3, 2020. https://www .earthday.org/history/.

Encyclopedia.com. "Environmental Movement." Updated January 28, 2020. https:// www.encyclopedia.com/earth-and-environment/ecology-and-environmentalism/ environmental-studies/environmental-movement.

The Famous Pictures Collection. "Black Power." http://www.famouspictures.org/black-power/.

Farber, M. A. "Concern about War and Racism Alters Commencement Rites." *New York Times*, June 7, 1970. https://www.nytimes.com/1970/06/07/archives/concern-about-war-and-racism-alters-commencement-rites.html.

Farmer, Ashley. "The Third World Women's Alliance, Cuba, and the Exchange of Ideas." *Black Perspectives*, April 7, 2017. https://www.aaihs.org/the-third-world-womens-alliance-cuba-and-the-exchange-of-ideas/.

Forest, Jim. "The Catholic Worker Movement." *Catholic Worker Movement*. https://www .catholicworker.org/forest-history.html.

Harris, Brandon. "The Most Important Legacy of the Black Panthers." *New Yorker*, September 5, 2015. https://www.newyorker.com/culture/culture-desk/ the-most-important-legacy-of-the-black-panthers.

Harrison, Scott. "From the Archives: 1971 Chicano March to Sacramento." *Los Angeles Times*, February 2, 2018. https://www.latimes.com/visuals/photography/la-me-fw-archives-chicano-march-to-sacramento-20171017-story.html.

History.com editors. "Nixon Defends Invasion of Cambodia." *History*, July 28, 2019, https://www.history.com/this-day-in-history/nixon-defends-invasion-of-cambodia.

Kalish, John. "'Winter Soldier,' a Remembrance of Vietnam Atrocities." Interview by John Kalish and hosted by Steve Innskeep. *Morning Edition*, NPR, August 15, 2005. Transcript, https://www.npr.org/templates/story/story.php?storyId=4800067.

Kauffman, L. A. *Direct Action: Protest and the Reinvention of American Radicalism*. Brooklyn: Verso, 2017.

Kifner, John. "4 Kent State Students Killed by Troops." *New York Times,* May 5, 1970. https://www.nytimes.com/1970/05/05/archives/4-kent-state-students-killed-by-troops-8-hurt-as-shooting-follows.html.

Kihss, Peter. "Malcolm X Shot to Death at Rally Here." *New York Times*, February 22, 1965. https://www.nytimes.com/1965/02/22/archives/malcolm-x-shot-to-death-at-rally-here-three-other-negroes-wounded.html.

Kim, Inga. "The 1965–1970 Delano Grape Strike and Boycott." *United Farm Workers*, March 7, 2017. https://ufw.org/1965-1970-delano-grape-strike-boycott/.

Kukura, Joe. "The Hellraising History of the SF Mime Troupe." *SFist*, July 1, 2016. https://sfist.com/2016/07/01/the_hellraising_history_of_the_sf_m/.

Lewis, John, and Michael D'Orso. *Walking with the Wind: A Memoir of the Movement*. New York: Simon & Schuster, 1998.

McLaughlin, Katie. "The Vietnam War: 5 Things You Might Not Know." *CNN*, August 25, 2014. https://www.cnn.com/2014/06/20/us/vietnam-war-five-things/index.html.

Native Village. "1969 Occupation of Alcatraz." https://www.nativevillage.org/Inspiration-/Occupation%20of%20Alcatraz%20and%20the%20Alcatraz%20Proclamation%20alcatraz_proclamation.htm.

Ohio History Central. "Vietnam War Protestors." https://ohiohistorycentral.org/w/Vietnam_War_Protestors.

Olney, Warren. "Open Carry Was Legal until Armed Black Panthers Protested." *San Francisco Chronicle,* May 2, 2018. https://www.sfchronicle.com/opinion/openforum/article/Open-carry-was-legal-until-armed-Black-Panthers-12875998.php.

Pawel, Miriam. "Dorothy Day and the Farmworker Movement." *Miriam Pawel*, March 19, 2015. https://miriampawel.com/2015/03/19/dorothy-day-and-the-farmworker-movement/.

PBS. "The Watergate Scandal." http://www.pbs.org/johngardner/chapters/6c.html.

Poor People's Campaign. "About the Poor People's Campaign: A National Call for Moral Revival." https://www.poorpeoplescampaign.org/about/.

Powers, Rod. "What You Need to Know about the U.S. Military Draft." *The Balance Careers*, December 8, 2018. https://www.thebalancecareers.com/all-about-the-draft-3332963.

Redford, Robert. "An Ecosystem Runs Through It." *San Francisco Chronicle*, September 29, 2019. https://www.pressreader.com/usa/san-francisco-chronicle-late-edition-sunday/20190929/281745566119372.

Reuters. "Bolivia Confirms Guevara's Death; Body Displayed." *New York Times*, October 11, 1967. https://www.nytimes.com/1967/10/11/archives/bolivia-confirms-guevaras-death-body-displayed-army-reports.html.

Riemer, Matthew, and Leighton Brown. *We Are Everywhere: Protest, Power, and Pride in the History of Queer Liberation*. Berkeley: Ten Speed Press, 2019.

Sahagun, Louis. "East L.A., 1968: 'Walkout!' The Day High School Students Helped Ignite the Chicano Power Movement." *Los Angeles Times*, March 1, 2018. https://www.latimes.com/nation/la-na-1968-east-la-walkouts-20180301-htmlstory.html.

Sale, Kirkpatrick. *SDS: The Rise and Development of the Students for a Democratic Society*. New York: Random House, 1973.

San Francisco Mime Troupe. "About the Troupe." Accessed February 3, 2020. https://www.sfmt.org/about-us.

Save the Bay. "A Brief History." https://savesfbay.org/who-we-are/a-brief-history.

Shalby, Colleen. "The Assassination of Robert Kennedy, as Told 50 Years Later." *Los Angeles Times*, June 4, 2018.

Shames, Stephen, and Bobby Seale. *Power to the People: The World of the Black Panthers*. New York: Abrams, 2016.

Siff, Stephen. "The Illegalization of Marijuana: A Brief History." *Origins* 7, no. 8 (May 2014). http://origins.osu.edu/article/illegalization-marijuana-brief-history/page/0/0.

Simpson, Craig. "The 1969 Nixon Inauguration: Horse Manure, Rocks & a Pig." *Washington Area Spark*, January 9, 2013. https://washingtonareaspark.com/2013/01/09/the-1969-nixon-inauguration-horse-manure-rocks-a-pig/.

The Sixties Project. "Winter Soldier Investigation." http://www2.iath.virginia.edu/sixties/HTML_docs/Resources/Primary/Winter_Soldier/WS_23_POW.html.

Skarda, Erin. "Moratorium against the Vietnam War, Nov. 15, 1969." *Time*, June 28, 2011. http://content.time.com/time/specials/packages/article/0,28804,2080036_2080037_2080024,00.html.

Smith, Sharon. "The Workers' Rebellion of the 1960s." *Socialist Worker*, August 26, 2011. http://socialistworker.org/2011/08/26/workers-rebellion-of-the-1960s.

Sonnenberg, Zoë. "Daughters of Bilitis." *FoundSF*, 2015. http://www.foundsf.org/index.php?title=Daughters_of_Bilitis.

Stanford University, The Martin Luther King, Jr. Research and Education Institute. "Selma to Montgomery March." https://kinginstitute.stanford.edu/encyclopedia/selma-montgomery-march.

Steinem, Gloria. "Letters." *Time*, September 16, 2000.

Switzer, Kathrine. "The Real Story of Kathrine Switzer's 1967 Boston Marathon." Accessed February 3, 2020. https://kathrineswitzer.com/1967-boston-marathon-the-real-story/.

Theophano, Teresa. "Daughters of Bilitis." *GLBTQ Archives*, 2004. http://www.glbtqarchive.com/ssh/daughters_bilitis_S.pdf.

Torgoff, Martin. "Allen Ginsberg: Marijuana Legalization Pioneer." *Freedom Leaf*, February 23, 2017. https://www.freedomleaf.com/allen-ginsberg-grass-history/.

United States Drug Enforcement Administration. "Drug Scheduling." https://www.dea.gov/drug-scheduling.

United States Senate. "Vietnam Hearings." https://www.senate.gov/artandhistory/history/minute/Vietnam_Hearings.htm.

University of Wisconsin-Madison Libraries. "Second Wave Feminism: Magazines and Newspapers, Researching the Women's Liberation Movement." Accessed February 3, 2020. https://researchguides.library.wisc.edu/c.php?g=177763&p=1171119.

Weller, Sheila. "Suddenly That Summer." *Vanity Fair*, June 14, 2012. https://www.vanityfair.com/culture/2012/07/lsd-drugs-summer-of-love-sixties.

Wiener, Jon. "Nixon and the 1969 Vietnam Moratorium." *Nation*, January 12, 2010. https://www.thenation.com/article/archive/nixon-and-1969-vietnam-moratorium/.

Wozniacka, Gosia. "Less Than 1 Percent of US Farmworkers Belong to a Union. Here's Why." *Civil Eats*, May 7, 2019. https://civileats.com/2019/05/07/less-than-1-percent-of-us-farmworkers-belong-to-a-union-heres-why/.

Zelizer, Julian E. "A Template for 'Incivility.'" *Atlantic*, June 27, 2018. https://www.theatlantic.com/ideas/archive/2018/06/incivility-vietnam-protests/563837/.

CHAPTER THREE

Aizenman, Nurith. "How to Demand a Medical Breakthrough: Lessons from the AIDS Fight." Interview by Nurith Aizenman. *Weekend Edition Saturday*, NPR, February 9, 2019. https://www.npr.org/sections/health-shots/2019/02/09/689924838/how-to-demand-a-medical-breakthrough-lessons-from-the-aids-fight.

Alice Paul Institute. "Two Modes of Ratification." *EqualRightsAmendment.org*. https://www.equalrightsamendment.org/pathstoratification.

American Archive of Public Broadcasting. "Protesting in 1980s and Beyond." *Speaking and Protesting in America*. Accessed February 3, 2020. https://americanarchive.org/exhibits/first-amendment/protests-80s-andbeyond.

Associated Press. *Singer Bette Midler with Actor Jack Nicholson at an Equal Rights Amendment Gathering at Joan Hackett's Home in Beverly Hills, Calif., March 1978*. Photograph. *Winston-Salem Journal*, June 11, 2018. https://www.journalnow.com/historical-photos-equal-rights-amendment-fight/collection_5b93edf2-3cc8-5f6e-8c02-8d18c2a8c5a5.html#21.

Barret, Elizabeth, dir. *Coalmining Women*. 1981; Whitesburg, KY: Appalshop Films. https://www.appalshop.org/media/coalmining-women/.

Berndt, Jerry, photographer, and Maik Schluter, ed. *Jerry Berndt: Beautiful America: Protest, Politics, and Everyday Culture in the USA*. Göttingen, Germany: Steidl, 2018.

Borger, Julian. "Fleeing a Hell the US Helped Create: Why Central Americans Journey North." *Guardian*, December 19, 2018. https://www.theguardian.com/us-news/2018/dec/19/central-america-migrants-us-foreign-policy.

The Bronx Documentary Center. "Housing." *Whose Streets? Our Streets!* Accessed February 3, 2020. http://www.whosestreets.photo/housing.html.

Cataldo, Mima. "North Bay Fires: 2017–18." http://www.mimacataldo.com/fire.

Cummings, Judith. "Coast A-Plant Construction Error Tied to Missing Guide to Blueprint." *New York Times*, October 2, 1981. https://www.nytimes.com/1981/10/02/us/coast-a-plant-construction-error-tied-to-missing-guide-to-blueprint.html.

Felshin, Nina, ed. *But Is It Art? The Spirit of Art as Activism*. Seattle: Bay Press, 1994.

The Foundation for AIDS Research. "Thirty Years of HIV/AIDS: Snapshots of an Epidemic." *amfAR*. https://www.amfar.org/thirty-years-of-hiv/aids-snapshots-of-an-epidemic/.

Glass, Andrew. "Grand Jury Indicts Former White House Aides, March 16, 1988." *Politico*, March 16, 2018. https://www.politico.com/story/2018/03/16/this-day-in-politics-march-16-1988-460679.

Griffith, Gary. "Remember Seabrook? Battles Are Quieter Now." *New York Times*, March 5, 1978. https://www.nytimes.com/1978/03/05/archives/remember-seabrook-battles-are-quieter-now.html.

Hipperson, Sarah. "Greenham Common Women's Peace Camp." *Greenham Common Women's Peace Camp.* http://www.greenhamwpc.org.uk/.

History.com editors. "The 1980s." *History,* June 7, 2019. https://www.history.com/topics/1980s/1980s.

Hornblower, Margot. "Painful 'Renaissance' in Harlem." *Washington Post,* July 31, 1984. https://www.washingtonpost.com/archive/politics/1984/07/31/painful-renaissance-in-harlem/af0fcd9e-24df-4a12-b645-bbb7ddaee3d1/.

International Court of Justice. *Case Concerning Military and Paramilitary Activities in and against Nicaragua (Nicaragua v. United States of America), Merits, Judgment, ICJ Reports, 1986.* June 27, 1986. https://www.icj-cij.org/files/case-related/70/070-19860627-JUD-01-00-EN.pdf.

Kaufman, Leslie. "Japan Crisis Could Rekindle U.S. Antinuclear Movement." *New York Times,* March 18, 2011. https://www.nytimes.com/2011/03/19/science/earth/19antinuke.html.

Knight, Michael. "20,000 Gather at Site of Seabrook Nuclear Protest." *New York Times,* June 26, 1978. https://www.nytimes.com/1978/06/26/archives/20000-gather-at-site-of-seabrook-nuclear-protest-debating-into-the.html.

Lamis, Alexander P., ed. *Southern Politics in the 1990s.* Baton Rouge: Louisiana State Press, 1999.

National Coalition for the Homeless. "#TBT—Hoboes, Bums, Tramps: How Our Terminology of Homelessness Has Changed." *NationalHomeless.org,* June 14, 2018. http://nationalhomeless.org/tag/history/.

New York Times. "Chronology of Seabrook: Plans, Protests, Building." March 2, 1990. https://www.nytimes.com/1990/03/02/us/chronology-of-seabrook-plans-protests-building.html.

New York Times. "Farm Union Begins a Protest March." February 23, 1975. https://www.nytimes.com/1975/02/23/archives/farm-union-begins-a-protest-march-workers-to-walk-110-miles-on.html.

———. "Feminist Group Assails Coal Industry." May 12, 1978. https://www.nytimes.com/1978/05/12/archives/feminist-group-assails-coal-industry-time-for-support-new-jobs.html.

People's World. "Today in Labor History: United Farm Workers Launch the Lettuce Boycott." August 24, 2015. https://www.peoplesworld.org/article/today-in-labor-history-united-farm-workers-launch-the-lettuce-boycott/.

Stewart, Jill. "Thousands Protest U.S. Support of the Contras." *Los Angeles Times,* November 2, 1986. https://www.latimes.com/archives/la-xpm-1986-11-02-me-15852-story.html.

United Press International. "President Reagan's Plan to Deploy 572 Intermediate Range Missiles…" *UPI,* September 13, 1983. https://www.upi.com/Archives/1983/09/13/President-Reagans-plan-to-deploy-572-intermediate-range-missiles/8303230924762/?ur3=1.

U.S. Department of Labor, Office of the Secretary, Women's Bureau. 1985. *The Coal Employment Project—How Women Can Make Breakthroughs into Nontraditional Industries.* Washington, DC: U.S. Department of Labor.

U.S. Energy Information Administration. "Frequently Asked Questions: How Many Nuclear Power Plants Are in the United States, and Where Are They Located?" December 30, 2019. https://www.eia.gov/tools/faqs/faq.php?id=207&t=3.

United States Nuclear Regulatory Commission. "Backgrounder on the Three Mile Island Accident." June 21, 2018. https://www.nrc.gov/reading-rm/doc-collections/fact-sheets/3mile-isle.html.

Washington Post. "Seabrook Nuclear Plant Protesters Quietly End Three-Day Demonstration."

June 27, 1978. https://www.washingtonpost.com/archive/politics/1978/06/27/seabrook-nuclear-plant-protesters-quietly-end-three-day-demonstration/bd3ca79a-59af-461f-ba52-a36c55353d62/.

Wikipedia, s.v. "Seneca Women's Encampment for a Future of Peace and Justice."

Women's Encampment for a Future of Peace and Justice. *Every Woman Here: Remnants of Seneca 1982–2006*. PeaCe enCaMPeNT HeRSTory PRoJeCT video (32:09). http://peacecampherstory.blogspot.com/2015/02/video-every-woman-here-remnants-of.html.

Wong, Ryan Lee. "Closed to Protest Police Brutality." *Hyphen*, January 8, 2017. https://hyphenmagazine.com/blog/2017/01/closed-protest-police-brutality.

Yang, Alice. "Redress Movement." *Densho Encyclopedia*. http://encyclopedia.densho.org/Redress_movement/.

Yoshino, William, and John Tateishi. "The Japanese American Incarceration: The Journey to Redress." *Japanese American Citizens League*. https://jacl.org/redress/.

Zinn Education Project. "May 19, 1975: Peter Yew/Police Brutality Protests." Accessed February 2, 2020. https://www.zinnedproject.org/news/tdih/chinatown-police-brutality-protests/.

CHAPTER FOUR

Amadeo, Kimberly. "Black Monday in 1987, 1929, and 2015." *The Balance*, August 20, 2019. https://www.thebalance.com/what-is-black-monday-in-1987-1929-and-2015-3305818.

Anderson, Ruby. "Dyke March Is the Radical Pride Event You Should Be Paying Attention To." *Thrillist*, June 24, 2019. https://www.thrillist.com/travel/nation/dyke-march-queer-protest-pride-parade.

Anti-Defamation League. "A Brief History of the Disability Rights Movement." https://www.adl.org/education/resources/backgrounders/disability-rights-movement.

Carmon, Irin. "A Brief History of Abortion Law in America." *Moyers*, November 14, 2017. https://billmoyers.com/story/history-of-abortion-law-america/.

Cushing, Lincoln. "Fighting Fire with Water: The Bay Area Peace Navy's Large-Scale Visual Activism." *Docs Populi*, May 23, 2016. http://docspopuli.org/articles/FightingFireWithWater.html.

Delta Center. "CIL Frequently Asked Questions." https://www.dcil.org/about-us/faq-independent-living-centers/.

Desilver, Drew. "For Most U.S. Workers, Real Wages Have Barely Budged in Decades." *Pew Research Center*, August 7, 2018. https://www.pewresearch.org/fact-tank/2018/08/07/for-most-us-workers-real-wages-have-barely-budged-for-decades/.

EarthTalk. "What Impact Has Activism Had on the Fur Industry?" *Scientific American*, June 15, 2009. https://www.scientificamerican.com/article/impact-activism-on-fur/.

Egan, Timothy. "Violent Backdrop for Anti-Gay Measure." *New York Times*, November 1, 1992. https://www.nytimes.com/1992/11/01/us/violent-backdrop-for-anti-gay-measure.html.

Encyclopedia.com, s.v. "Anti-Apartheid Movement." *Encyclopedia of Race and Racism*. https://www.encyclopedia.com/social-sciences/encyclopedias-almanacs-transcripts-and-maps/anti-apartheid-movement.

FinAid. "Historical Interest Rates." Accessed February 2, 2020. https://www.finaid.org/loans/historicalrates.phtml/.

The Friends of the Pink Triangle. "The Pink Triangle History: The Symbol." *The Pink Triangle*. http://www.thepinktriangle.com/history/symbol.html.

Grossman, Zoltan. "Remember the '80s." *CounterPunch*, January 3, 2008. https://www .counterpunch.org/2008/01/03/remember-the-80s/.

Heifetz, Bob. "Bay Area Peace Navy." *FoundSF*. http://www.foundsf.org/index. php?title=Bay_Area_Peace_Navy.

History.com editors. "Persian Gulf War." *History*. https://www.history.com/topics/middle-east/ persian-gulf-war.

Holland, Joshua. "The First Iraq War Was Also Sold to the Public Based on a Pack of Lies." *Moyers*, June 27, 2014. https://billmoyers.com/2014/06/27/the-first-iraq-war-was-also-sold-to-the-public-based-on-a-pack-of-lies/.

Iovannone, Jeffry J. "Avram Finkelstein: Silence = Death." *Medium*, June 16, 2018. https:// medium.com/queer-history-for-the-people/avram-finkelstein-silence-death-5359a41d7752.

Itkowitz, Colby. "Joe Biden Apologized to Anita Hill, But She's Not 'Satisfied.'" *Washington Post*, April 25, 2019. https://www.washingtonpost.com/politics/joe-biden-apologized-to-anita-hill-but-shes-not-satisfied/2019/04/25/0f2ff1d8-679a-11e9-82ba-fcfeff232e8f_story .html.

Jacobs, Julia. "Anita Hill's Testimony and Other Key Moments from the Clarence Thomas Hearings." *New York Times*, September 20, 2018. https://www.nytimes.com/2018/09/20/us/ politics/anita-hill-testimony-clarence-thomas.html.

Kindig, Jessie. "Northwest Antiwar Activism: A Brief History." *Antiwar and Radical History Project—Pacific Northwest*, Civil Rights and Labor History Consortium, University of Washington. https://depts.washington.edu/antiwar/pnwhistory_home.shtml.

Kupersmith, Joel, and Michael O'Hanlon. "Gulf War Illness 25 Years after Desert Storm." *Health Affairs*, August 4, 2016. https://www.healthaffairs.org/do/10.1377/ hblog20160804.056038/full/.

Kurtz, Lester R. "The Anti-Apartheid Struggle in South Africa (1912–1992)." *International Center on Nonviolent Conflict*, June 2009. http://www.nonviolent-conflict.org/wp-content/ uploads/2019/03/South-Africa-Anti-Apartheid-Summary.pdf.

Lawrence, Jill. "Protests, 1980s Style: Cooperation Replaces Tear Gas and Night Sticks." *Associated Press*, July 26, 1987.

Malek, Alia. "If You Were There, You Remember Mandela's 1990 Tour of the US." *Al Jazeera America*, December 12, 2013. http://america.aljazeera.com/articles/2013/12/12/if-you-were-thereyouremembermandelas1990touroftheus.html.

Mydans, Seth. "Rodney King Is Awarded $3.8 Million." *New York Times*, April 20, 1994. https://www.nytimes.com/1994/04/20/us/rodney-king-is-awarded-3.8-million.html.

National AIDS Memorial and NAMES Project Foundation. "The AIDS Memorial Quilt." https://aidsmemorial.org/theaidsquilt/.

National Organization for Women. "History of Marches and Mass Actions." https://now.org/ about/history/history-of-marches-and-mass-actions/.

Nelson Mandela Foundation. "Anti-Apartheid Movement Archives." https://www .nelsonmandela.org/content/page/anti-apartheid-movement-archives1.

The New York City Dyke March. "Herstory of the Dyke March." https://www.nycdykemarch .com/herstory.

Recchiuti, John Louis. "The Gulf War." *Khan Academy*. https://www.khanacademy.org/ humanities/us-history/modern-us/1990s-america/a/the-gulf-war.

Roy Rosenzweig Center for History and New Media, George Mason University. "An Outline of the Anita Hill and Clarence Thomas Controversy." http://chnm.gmu.edu/courses/122/hill/hillframe.htm.

Sanger, David E., and Edward Wong. "U.S. Ends Cold War Missile Treaty, with Aim of Countering China." *New York Times*, August 1, 2019.

Sastry, Anjuli, and Karen Grigsby Bates. "When LA Erupted in Anger: A Look Back at the Rodney King Riots." *The Los Angeles Riots, 25 Years On*, NPR, April 26, 2017. https://www.npr.org/2017/04/26/524744989/when-la-erupted-in-anger-a-look-back-at-the-rodney-king-riots.

Specter, Michael, and Malcolm Gladwell. "Protesters Take Over AIDS Event." *Washington Post*, June 25, 1990. https://www.washingtonpost.com/archive/politics/1990/06/25/protesters-take-over-aids-event/71097f96-e553-465d-acbf-077571fb5973/.

Steven. "1990–1991: Resistance to the Gulf War." *Libcom.org*, September 9, 2006. http://libcom.org/history/1990-1991-resistance-to-the-gulf-war.

———. "Iraqi Mass Mutiny in the Gulf War, 1990–1991." *Libcom.org*, September 9, 2006. http://libcom.org/history/articles/iraq-mass-mutiny-gulf-war-1990.

Sun, Christine. "A Federal Ban on Fur Farming across the United States: Long Overdue Legislation." *Law School Student Scholarship*, May 1, 2013. https://scholarship.shu.edu/student_scholarship/313.

Walker, Theresa. "LA Riots 25 Years Later: Rodney King's 'Can We All Get Along' Still Matters." *Orange County Register*, April 30, 2017. https://www.ocregister.com/2017/04/30/la-riots-25-years-later-rodney-kings-can-we-all-get-along-still-matters/.

Wells, Rachel. "Lessons from the LA Riots: How a Consent Decree Helped a Troubled Police Department Change." *CNN*, May 1, 2017. https://www.cnn.com/2017/04/28/us/lapd-change-since-la-riots/index.html.

Wolfson, Andrew. "Muhammad Ali Lost Everything in Opposing the Vietnam War. But in 1968, He Triumphed." *Louisville (Ky.) Courier-Journal*, February 19, 2018. https://www.usatoday.com/story/news/2018/02/19/1968-project-muhammad-ali-vietnam-war/334759002/.

Yen, Marianne. "Animal-Rights Groups Harass Fur Wearers." *Washington Post*, March 11, 1989. https://www.washingtonpost.com/archive/politics/1989/03/11/animal-rights-groups-harass-fur-wearers/13d66093-53f6-4a4a-a988-1c8d928180d1/.

Zimmerman, Jess. "'Capitol Crawl'—Americans with Disabilities Act of 1990." *History by Zim*, September 9, 2013. http://www.historybyzim.com/2013/09/capitol-crawl-americans-with-disabilities-act-of-1990/.

CHAPTER FIVE

Amadeo, Kimberly. "President Bill Clinton's Economic Policies." *The Balance*, May 30, 2019. https://www.thebalance.com/president-bill-clinton-s-economic-policies-3305559.

Andersen, Kurt. "The Protester." *Time*, December 14, 2011.

Andrew, Owen. "The History and Evolution of the Smartphone: 1992–2018." *Text Request*, August 28, 2018. https://www.textrequest.com/blog/history-evolution-smartphone.

Berman, Mark, and Wesley Lowery. "The 12 Key Highlights from the DOJ's Scathing Ferguson Report." *Washington Post*, March 4, 2015. https://www.washingtonpost.com/news/post-nation/wp/2015/03/04/the-12-key-highlights-from-the-dojs-scathing-ferguson-report/.

Biography.com editors. "Barack Obama Biography." *Biography.com.* https://www.biography.com/
us-president/barack-obama.

Black Lives Matter Global Network. "Herstory." https://blacklivesmatter.com/herstory/.

Blumenthal, Paul. "The Largest Protest Ever Was 15 Years Ago. The Iraq War Isn't Over.
What Happened?" *HuffPost*, March 17, 2018. https://www.huffpost.com/entry/
what-happened-to-the-antiwar-movement_n_5a860940e4b00bc49f424ecb.

Bond. www.bond.org.uk.

Buchanan, Larry, Ford Fessenden, K.K. Rebecca Lai, Haeyoun Park, Alicia Parlapiano, Archie
Tse, Tim Wallace,et al. "What Happened in Ferguson?" *New York Times*, August 10, 2015.
https://www.nytimes.com/interactive/2014/08/13/us/ferguson-missouri-town-under-siege-
after-police-shooting.html.

Burton, Lynsi. "WTO Riots in Seattle: 15 Years Ago." *Seattle PI*, November 29, 2014.

Cable News Network. "Senate Passes Immigration Bill." *CNN*, May 26, 2006. https://www.cnn
.com/2006/POLITICS/05/25/immigration/index.html.

———. "This GM Strike Is Different." *CNN Money*, June 12, 1998. https://money.cnn
.com/1998/06/12/companies/gm/.

Chivers, Danny. "Anti-Fracking Protests: The Frack Fight Goes Global." *Utne*, March/April
2014. https://www.utne.com/environment/anti-fracking-protests-zm0z14mazros.

Cooper, Helene. "Globalization Foes Plan to Protest WTO's Seattle Round Trade Talks." *Wall
Street Journal*, July 16, 1999. https://www.wsj.com/articles/SB932078387145002064.

Crichton, Kyle, Gina Lamb, and Rogene Fisher Jacquette. "Timeline of Major Events in the
Iraq War." *New York Times*, August 31, 2010. https://archive.nytimes.com/www.nytimes.
com/interactive/2010/08/31/world/middleeast/20100831-Iraq-Timeline.html?src=tptw.

Economic Policy Institute. "After the Longest Period in History without an Increase, the
Federal Minimum Wage Today Is Worth 17% Less than 10 Years Ago—and 31% Less than
in 1968." https://www.epi.org/multimedia/after-the-longest-period-in-history-without-an-
increase-the-federal-minimum-wage-today-is-worth-17-less-than-10-years-ago-and-31-less-
than-in-1968/.

Fight for $15. "About Us." *Fight for $15.* https://fightfor15.org/about-us/.

Fishwick, Carmen, and *Guardian* readers. "'We Were Ignored': Anti-War Protesters Remember
the Iraq War Marches." *Guardian*, July 8, 2016. https://www.theguardian.com/uk-news
/2016/jul/08/we-were-ignored-anti-war-protestors-remember-the-iraq-war-marches.

Fleming, Andrew. "Adbusters Sparks Wall Street Protest." *Vancouver Courier*, September 27,
2011. https://www.vancourier.com/news/adbusters-sparks-wall-street-protest-1.374299.

Haskell, Bob. "G8 Summit Creates Double Duty for Georgia Guard General." *U.S. Department
of Defense.* https://archive.defense.gov/news/newsarticle.aspx?id=26306.

History.com editors. "Gay Marriage." *History*, November 27, 2019. https://www.history.com/
topics/gay-rights/gay-marriage.

Jones, Ashley. "Million Man March, 1995." *BlackPast*, February 24, 2008. https://www.blackpast
.org/african-american-history/million-man-march-1995/.

Khan Academy. "The Presidency of George W. Bush." https://www.khanacademy.org/
humanities/us-history/modern-us/us-after-2000/a/george-w-bush-as-president.

Kinniburgh, Colin. "The Fracktivists." *Dissent*, Summer 2015. https://www.dissentmagazine.org/
article/anti-fracking-new-york-global-algeria-poland.

Knickerbocker, Brad. "Officials Crack Down on Occupy Wall Street Camps around the Country." *Christian Science Monitor*, November 12, 2011. https://www.csmonitor.com/USA/2011/1112/Officials-crack-down-on-Occupy-Wall-Street-camps-around-the-country.

Lallanilla, Marc. "Facts about Fracking." *Live Science*, February 10, 2018. https://www.livescience.com/34464-what-is-fracking.html.

The Learning Network. "Nov. 29, 1947: U.N. Partitions Palestine, Allowing for Creation of Israel." *New York Times*, November 29, 2011. https://learning.blogs.nytimes.com/2011/11/29/nov-29-1947-united-nations-partitions-palestine-allowing-for-creation-of-israel/.

Marquis, Erin. "5 Largest Manufacturing Strikes in United Automotive Workers History." *Autoblog*, March 12, 2015. https://www.autoblog.com/2015/03/12/5-largest-manufacturing-strikes-in-united-automotive-workers-his/.

Matsu, Kono. "A Million Man March on Wall Street." *Adbusters*, February 2, 2011. www.adbusters.org/blogs/adbusters-blog/million-man-march-wall-street.html. *Internet Archive*, web.archive.org/web/20150402104218/https://www.adbusters.org/blogs/adbusters-blog/million-man-march-wall-street.html.

MoveOn.org Civic Action. "A Short History of MoveOn." *MoveOn*. https://front.moveon.org/a-short-history/.

Occupy Solidarity Network. "About." *OccupyWallStreet*. http://occupywallst.org/about/.

Panzar, Javier. "It's Official: Latinos Now Outnumber Whites in California." *Los Angeles Times*, July 8, 2015. https://www.latimes.com/local/california/la-me-census-latinos-20150708-story.html.

Picasso, Pablo. *Guernica*. 1937. Painting, 350.5 × 777 cm. *PabloPicasso.org*. https://www.pablopicasso.org/guernica.jsp.

Power, Nina. "The Meaning of *Time* Magazine's Celebration of the Protester." *Guardian*, December 16, 2011. https://www.theguardian.com/commentisfree/2011/dec/16/meaning-time-magazine-celebration-protester.

Rivera, Ray. "Times Square Rally Protests Fighting in Gaza." *New York Times*, January 3, 2009. https://www.nytimes.com/2009/01/04/nyregion/04march.html.

Roberts, Frank Leon. "How Black Lives Matter Changed the Way Americans Fight for Freedom." *ACLU*, July 13, 2018. https://www.aclu.org/blog/racial-justice/race-and-criminal-justice/how-black-lives-matter-changed-way-americans-fight.

Roberts, Nigel. "5 Things That Changed After the 1st Million Man March." *The Root*, October 9, 2015. https://www.theroot.com/5-things-that-changed-after-the-1st-million-man-march-1790861372.

Sledge, Matt. "Reawakening the Radical Imagination: The Origins of Occupy Wall Street." *HuffPost*, November 10, 2011. https://www.huffpost.com/entry/occupy-wall-street-origins_n_1083977.

Sliwinski, Michael. "The Evolution of Activism: From the Streets to Social Media." *Law Street*, January 21, 2016. https://legacy.lawstreetmedia.com/issues/politics/evolution-activism-streets-social-media/.

Stiglitz, Joseph E. "Of the 1%, by the 1%, for the 1%." *Vanity Fair*, May 2011.

Wikipedia, s.v. "2006 United States Immigration Reform Protests." https://en.wikipedia.org/wiki/2006 United States immigration reform protests.

Wikipedia, s.v. "Anti-Abortion Violence." https://en.wikipedia.org/wiki/Anti-abortion_violence.

Wilson, Simone. "Occupy, the Art Show: Ted Soqui, Our Photographer Who Did *Time* Cover with Shepard Fairey, Gets an Exhibit." *LA Weekly*, January 19, 2012.

World Trade Organization. "10 Things the WTO Can Do." https://www.wto.org/english/
thewto_e/whatis_e/10thi_e/10thi00_e.htm.

CHAPTER SIX

Abramsky, Sasha. "Trump Is Legalizing Concentration Camps for Immigrant
Families." *Nation*, August 23, 2019. https://www.thenation.com/article/archive/
immigration-kids-trump-flores-concentration-camps/.

American Civil Liberties Union of Southern California. "Colin Kaepernick Receives ACLU
Award." *ACLU Southern California*, December 3, 2017. https://www.aclusocal.org/en/
press-releases/colin-kaepernick-receives-aclu-award.

Bulloch, Marilyn. "How Oxycodone Has Contributed to the Opioid Epidemic." *Pharmacy
Times*, August 2, 2018. https://www.pharmacytimes.com/contributor/marilyn-bulloch-
pharmd-bcps/2018/08/how-oxycodone-has-contributed-to-the-opioid-epidemic.

Burke, Tarana. "The Inception." *Me too*. https://metoomvmt.org/the-inception/.

Cable News Network. "Greta Thunberg Will Sail across the Atlantic on a Zero-Emissions
Yacht for the UN Climate Summit." *CNN Travel*, August 18, 2019. https://www.cnn
.com/2019/07/29/europe/greta-thunberg-sailboat-scli-intl/index.html.

Centers for Disease Control and Prevention, National Center for Injury Prevention and
Control. "Opioid Overdose." https://www.cdc.gov/drugoverdose/index.html.

Chicago Tribune. "#MeToo: A Timeline of Events." *Chicago Tribune*, January 6, 2020. https://
www.chicagotribune.com/lifestyles/ct-me-too-timeline-20171208-htmlstory.html.

Cooney, Samantha. "Here Are Some of the Women Who Made History in the Midterm
Elections." *Time*, November 19, 2018.

De Pinto, Jennifer. "Majority of Americans Don't Want Roe v. Wade Overturned,
CBS News Poll Finds." *CBS News*, May 21, 2019. https://www.cbsnews.com/news/
majority-of-americans-dont-want-roe-v-wade-overturned-cbs-news-poll-finds/.

Dixon, Amanda. "Survey: Nearly 1 in 3 Side Hustlers Needs the Income to Stay
Afloat." *Bankrate*, June 5, 2019. https://www.bankrate.com/personal-finance/
side-hustles-survey-june-2019/.

Germanos, Andrea. "UN Experts to United States: Stop DAPL Now." *Common
Dreams*, September 25, 2016. https://www.commondreams.org/news/2016/09/25/
un-experts-united-states-stop-dapl-now.

Gessen, Masha. "Nan Goldin Leads a Protest at the Guggenheim against the Sackler Family."
New Yorker, February 10, 2019.

Gregory, Sean. "Colin Kaepernick Wins Amnesty International's Highest Honor." *Time*,
April 21, 2018. https://time.com/5248606/colin-kaepernick-wins-amnesty-
internationals-ambassador-of-conscience-award/.

Griffith, Janelle. "Olympic Fencer and Hammer-Thrower Who Kneeled, Raised Fist in Protest
Put on Probation." *NBC News*, August 21, 2019. https://www.nbcnews.com/news/news/
nbcblk/olympic-athletes-who-kneeled-raised-fist-protest-put-probation-n1044826.

Gruss, Susanne. "An Interview with Margaret Atwood." *Gender Queeries 8 (2004)*, Gender
Forum. http://web.archive.org/web/20160427013239/http://www.genderforum.org/
fileadmin/archiv/genderforum/queer/interview_atwood.html.

Gumbel, Andrew. "Man Behind Gutting of Voting Rights Act: 'I Agonise' over Decision's
Impact." *Guardian*, January 5, 2016. https://www.theguardian.com/us-news/2016/jan/05/

edward-blum-voting-rights-act-civil-rights-affirmative-action.

Hahn, Jason Duaine. "The Most Prominent Athletes Who Have Taken a Knee." *People*,
January 24, 2019.

Harvard University. "Eight to Be Honored as W.E.B. Du Bois Medalists." *Harvard
Gazette*, September 20, 2018. https://news.harvard.edu/gazette/story/2018/09/
kaepernick-and-chappelle-among-eight-du-bois-medalists-at-harvard/.

Higgins, Eoin. "'Chuck Schumer Has Some Guests': Protesters Outside of Minority Leader's
Home Demand Action on Detention Camps." *Common Dreams*, July 3, 2019. https://www
.commondreams.org/news/2019/07/03/chuck-schumer-has-some-dinner-guests-
protesters-outside-minority-leaders-home-demand#.

History.com editors. "Women's March." *History*, January 5, 2018. https://www.history.com/
this-day-in-history/womens-march.

Hoffman, Jan. "Why Was Johnson & Johnson the Only Opioid Maker on Trial in Oklahoma?"
New York Times, August 26, 2019. https://www.nytimes.com/2019/08/26/health/opioids-
johnson-and-johnson-oklahoma.html.

Ioby. "#Takeemdown901." *Ioby*. https://ioby.org/project/takeemdown901.

Johnson, Ramon. "The Benefits of Gay Marriage." *LiveAbout*, February 12, 2018. https://www
.liveabout.com/the-benefits-of-gay-marriage-1411846.

Katz, Brigit. "At Least 110 Confederate Monuments and Symbols Have Been Removed
Since 2015." *Smithsonian*, June 8, 2018. https://www.smithsonianmag.com/smart-news/
least-110-confederate-monuments-and-symbols-have-been-removed-2015-180969254/.

Kazakina, Katya, and Benjamin Stupples. "Artists Protest Sackler Family through Museums
That Bear Their Name." *Bloomberg*, March 6, 2019. https://www.bloomberg.com/news/
articles/2019-03-06/sackler-family-faces-art-world-protests-with-purdue-under-siege.

Keefe, Patrick Radden. "The Family That Built an Empire of Pain." *New Yorker*, October 23,
2017.

Landman, Keren. "How #MeToo Is Changing Sex Ed Policies, Even in Red States." *Kaiser
Health News*, August 12, 2019.

Levin, Josh. "Colin Kaepernick Won." *Slate*, August 18, 2017. https://slate.com/sports/2017/08/
colin-kaepernicks-protest-cost-him-his-job-but-started-a-movement.html.

Liptak, Adam, and Michael D. Shear. "Trump's Travel Ban Is Upheld by Supreme Court."
New York Times, June 26, 2018. https://www.nytimes.com/2018/06/26/us/politics/supreme-
court-trump-travel-ban.html.

Locker, Melissa. "This Map of Abortion Ban Proposals and Laws Shows Where Rights Are
Under Fire in 2019." *Fast Company*, May 15, 2019. https://www.fastcompany.com/90350385/
this-map-shows-abortion-bans-by-u-s-state-in-2019.

Lopez, German, and Kavya Sukumar. "After Sandy Hook, We Said Never Again.
And Then We Let 2,369 Mass Shootings Happen." *Vox*, https://www.vox.com/a/
mass-shootings-america-sandy-hook-gun-violence.

McKirdy, Euan, Susanna Capelouto, and Max Blau. "Thousands Take to the Streets to Protest
Trump Win." *CNN Politics*, November 10, 2016. https://www.cnn.com/2016/11/09/politics/
election-results-reaction-streets/index.html.

McMahon, Tim. "Inflation Adjusted Gasoline Prices." *InflationData*. https://inflationdata.com/
articles/inflation-adjusted-prices/inflation-adjusted-gasoline-prices/.

Nixon, Ron. "People from 7 Travel-Ban Nations Pose No Increased Terror Risk, Report Says." *New York Times*, February 25, 2017. https://www.nytimes.com/2017/02/25/us/politics/travel-ban-nations-terror-risk.html.

OBOS. "Our Story." *Our Bodies Ourselves*. https://www.ourbodiesourselves.org/our-story/.

Our Children's Trust. "Juliana v. United States: Youth Climate Lawsuit." https://www.ourchildrenstrust.org/juliana-v-us.

Piper, Kelsey. "The Sacklers Made Billions off the Opioid Crisis. The Louvre Is Taking Their Name off Its Walls." *Vox*, July 17, 2019. https://www.vox.com/future-perfect/2019/7/17/20697901/sacklers-louvre-opioid-crisis-philanthropy-donors-protests.

Plumer, Brad. "The Battle over the Dakota Access Pipeline, Explained." *Vox*, November 29, 2016. https://www.vox.com/2016/9/9/12862958/dakota-access-pipeline-fight.

Poe, Ryan. "From 'Take Em Down' to 'Took Em Down': A Q&A with Activist Tami Sawyer." *Commercial Appeal*, December 22, 2017. https://www.commercialappeal.com/story/news/government/city/2017/12/22/q-tami-sawyer-tookemdown-901/976783001/.

Pussyhat Project. "Our Story." *Pussyhat Project*. https://www.pussyhatproject.com/our-story.

The Real News Network. "Native Americans Hold Largest Convergence in a Century to Oppose Oil Pipeline." *Real News Network*, September 2, 2016. https://therealnews.com/stories/kbulls0902pipeline.

Smithsonian National Museum of the American Indian. "Treaties Still Matter: The Dakota Access Pipeline." *Native Knowledge 360*. https://americanindian.si.edu/nk360/plains-treaties/dapl.cshtml.

Strickler, Laura. "Purdue Pharma Offers $10–12 Billion to Settle Opioid Claims." *NBC News*, August 27, 2019. https://www.nbcnews.com/news/us-news/purdue-pharma-offers-10-12-billion-settle-opioid-claims-n1046526.

Taylor, Alan. "A Weekend of Protest against Trump's Immigration Ban." *Atlantic*, January 30. 2017. https://www.theatlantic.com/photo/2017/01/a-weekend-of-protest-against-trumps-immigration-ban/514953/.

Thomas, Katie, and Tiffany Hsu. "Johnson & Johnson's Brand Falters over Its Role in the Opioid Crisis." *New York Times*, August 27, 2019. https://www.nytimes.com/2019/08/27/health/johnson-and-johnson-opioids-oklahoma.html.

Vaughan, Adam. "China Is on Track to Meet Its Climate Change Goals Nine Years Early." *New Scientist*, July 26, 2019. https://www.newscientist.com/article/2211366-china-is-on-track-to-meet-its-climate-change-goals-nine-years-early/.

Weiser, Benjamin, Ali Watkins, and Joseph Goldstein. "Jeffrey Epstein, R. Kelly and a Change in How Prosecutors Look at Sexual Assault." *New York Times*, July 25, 2019. https://www.nytimes.com/2019/07/25/nyregion/epstein-kelly-metoo-sex-charges.html.

Witt, Emily. "From Parkland to Sunrise: A Year of Extraordinary Youth Activism." *New Yorker*, February 13, 2019.

———. "Greta Thunberg's Slow Boat to New York." *New Yorker*, September 9, 2019. https://www.newyorker.com/magazine/2019/09/09/greta-thunbergs-slow-boat-to-new-york.

Wyche, Steve. "Colin Kaepernick Explains Why He Sat during National Anthem." *NFL*, August 27, 2016. http://www.nfl.com/news/story/0ap3000000691077/article/colin-kaepernick-explains-protest-of-national-anthem.

Younge, Gary. "A Journey in Search of the American Left: Fragile and Feisty, Hopeful and Fearful." *Guardian*, September 3, 2019. https://www.theguardian.com/us-news/2019/sep/03/democrats-progressives-trump-2016-election.

INDEX

A

Abalone Alliance, 105

Abernathy, Ralph, 7, 11

abortion rights, 78, 99, 121, 134, 165, 208

ACLU (American Civil Liberties Union), 181

ACT UP (AIDS Coalition to Unleash Power), 118, 133, 134, 137

Adbusters magazine, 167, 170

Affordable Care Act (2010), 149

African National Congress (ANC), 137

Agnew, Spiro, 53

Agricultural Workers Organizing Committee, 32

AIDS activism, 3, 118, 121, 137, 147

AIDS Memorial Quilt, 147

Alcatraz Island, occupation of, 63, 93

Alfano, Joe, 162

Ali, Muhammad, 125, 182

Allard, LaDonna Brave Bull, 190

Amazon, 149

American Federation of State, County, and Municipal Employees (AFSCME), 42

American Friends Service Committee, 122

American Indian Movement (AIM), 54, 63, 93

Americans with Disabilities Act (ADA), 129

American Youth Congress, 26

Angelou, Maya, 85

Animal Liberation Front, 126

animal rights movement, 126

Another Mother for Peace, 61

anti-apartheid movement, 121, 125, 137

antinuclear movement, 5, 14, 104–5, 121

Apple, 149

Asian Americans for Equal Opportunity, 106

athletes, protests by, 51, 125, 182

Atwood, Margaret, 170, 208

B

Baez, Joan, 90, 189

Baldwin, James, 85

Bank of America, 169

Bates, Daisy, 22

Bernstein, Carl, 96

Berry, Gwen, 182

Bevel, James, 31

Biden, Joe, 140

Big Brother and the Holding Company, 65

Big Ten, 21

Black Arts Movement (BAM), 45

Black Cat bar, 66

Black Liberators, 43

Black Lives Matter (BLM) movement, 3, 5, 176, 178, 182

Black nationalism, 18, 43

Black Panthers, 43, 53, 54, 57, 69, 82, 85

Black Power movement, 18, 51

Black Woman's Alliance, 81

Black Women's Liberation Committee, 81

Blair, Tony, 154

Bland, Sandra, 176

Bloody Sunday, 31

Boston Marathon, 48

Boston University, 77

Bowen, Michael, 65

Boynton, Amelia, 31

Bread and Puppet Theater, 95

Briggs, Arnie, 48

Brown, Jerry, 85

Brown, Michael, 69, 176, 178

Brown Berets, 82

Browne, Jackson, 105

Brown v. Board of Education of Topeka, 2, 5, 12

Burke, Tarana, 206

Bush, George H. W., 121, 130

Bush, George W., 149, 154

C

Cairo Nonviolent Freedom Committee (CNFC), 17

cannabis, 44

Capley, Frank, 162

Carlos, John, 51

Carmichael, Stokely, 17

Carson, Rachel, 15

Carter, Jimmy, 99

Cassady, Neal, 44

Castile, Philando, 176, 182

Catcher Cuts the Rope, 190

Catholic Worker Movement (CWM), 90

Central American solidarity movement, 115, 122

Chavez, Cesar, 32, 90, 100

Cheney, Dick, 130

Chevron, 133

Chicano Moratorium, 82

Citizen Action, 175

Civil Rights Act (1964 and 1968), 12, 21, 31, 42, 121

civil rights movement, 2, 5–12, 17–22, 25, 26, 29, 31, 38, 41, 65, 81

Clamshell Alliance, 104, 105

Clarenbach, Kathryn, 78

Clean Air Act (1970), 70

Clean Water Act (1972), 70

Cleghorn, Stephen, 174

climate change, 181, 205

Clinton, Bill, 149

Clinton, Hillary, 181, 185

Coal Employment Project (CEP), 103

COINTELPRO, 57

Cole, Echol, 38

Columbia University, 77

Colvin, Claudette, 7

Committee to Save East Harlem, 112

Comprehensive Anti-Apartheid Act (1986), 138

Compton's Cafeteria riot, 66

Confederate monuments, 196

Congress on Racial Equality (CORE), 12, 25, 26

Controlled Substances Act (1970), 44

Criss, Nicholas, 7

Cullors, Patrisse, 178

D

Dakota Access Pipeline (DAPL), 190, 192

Dalits, 54

Daughters of Bilitis, 66, 161

Davis, Jefferson, 196

Davis, R. G., 95

Day, Dorothy, 90

Day, Thomas, 1

DDT, 15

Declaration of Independence, 1

Dellums, Ronald, 138

Dent, Harry, 99

Diablo Canyon Nuclear Power Plant, 105

disability rights movement, 129

Don Edwards San Francisco Bay National Wildlife Refuge, 73

draft-card burnings, 37

DuBois, W. E. B., 43

dyke marches, 144

Dylan, Bob, 20, 189

E

Earth Day, 70

Eckford, Elizabeth, 9

Eisenhower, Dwight, 9

Ellis, Perry, 118

El Salvador, 115

Emanatian, Mark, 175

Emanuel African Methodist Episcopal Church, 196

Emergency Response Network, 115

EMILY's List, 181

Endangered Species Act (1973), 70

Energy Transfer Partners, 190

environmental activism, 70, 73, 174

Equal Rights Amendment (ERA), 99, 111

Evans, Ieshia, 176

Evers, Medgar, 8, 20

Executive Order 9066, 109

F

Facebook, 149

Fair Labor Standards Act (1938), 32, 100

Farrakhan, Louis, 150

Faubus, Orval, 9

feminist movement, 2, 99, 103, 144. *See also* women's movement

Fight for $15 movement, 5, 175

fire hydrants, uncapping, 23

Fisk University, 26

Foley, Tom, 129

Ford, Gerald, 96, 109

Forrest, Nathan Bedford, 196

Fourteenth Amendment, 162

fracking, 174

Freedom of Access to Clinic Entrances Act (1994), 165

Freedom Rides, 2

Freedom Summer, 12

Free Speech Movement, 2, 5, 25–26

Fridays for Future, 205

Friedan, Betty, 78, 144

Fulbright, J. William, 89

fur, protests against, 126

G

Gallo, 100

Garner, Eric, 176

Garvey, Marcus, 43

Garza, Alicia, 178

Gay Liberation Front (GLF), 54, 69

Gay Pride movement, 144

Gay Rights movement, 66, 69

Gaza Strip, 164

G8 summit protests, 157

General Motors (GM), 151

gentrification, 112

Gibb, Roberta "Bobbi," 48

Ginsberg, Allen, 44

Global Climate Action Summit, 205

globalization, 149, 153, 157

Goldin, Nan, 201

Gonzalez, Lucinda Hart, 174

Google, 149

Gore, Al, 149

grape boycott, 32

Grateful Dead, 65

Great Depression, 3, 149, 189

Great Recession, 149, 151

Great Society, 29

Greenpeace, 122

Greensboro lunch counter sit-ins, 26

Gregory, Dick, 150

Guerrilla Girls, 117

Guggenheim Museum, 201

Gulf War, 121, 130, 133

Gulick, Esther, 73

gun control, 199

Guthrie, Woody, 189

H

Hamas, 164

The Handmaid's Tale, 208

Harlins, Latasha, 143

Hart, Lois, 69

Hatfield, Mark, 89

Hedgeman, Anna Arnold, 22

Height, Dorothy, 22

Hernandez, Aileen, 78

Hill, Anita, 117, 140

hippies, 47, 65

Hitler, Adolf, 189

Holliday, George, 142

Holtom, Gerald, 14

Horton, Willie, 121

Howard, T. R. M., 8

Hudson, Rock, 118

Huerta, Dolores, 32, 100

Huggins, Ericka, 85
Human Be-In, 65
Humphrey, Hubert, 53
Hussein, Saddam, 130, 154
Hutton, Bobby, 53

I

immigration policy, 158, 195, 202–3
income inequality, 169
Independent Living Center, 129
Indians of All Tribes, 63
Indivisible, 181, 203
Intercommunal Youth Institute, 85
Iran-Contra affair, 115
Iraq war, 154
Israel, 164

J

Jackson, Jesse, 150
Jackson, Jimmie Lee, 31
Jackson, Shaila, 129
Japanese American Citizens League, 109
Jay, Karla, 69
Jefferson Airplane, 65
Jerusalem, 164
Johnson, Lyndon, 21, 29, 31
Jones, Cleve, 147
Judd, Ashley, 206
Just Be, 206

K

Kaepernick, Colin, 182
Kasky, Cameron, 199
Kasmir, Jan Rose, 34, 176
Kennedy, John, 15, 21
Kennedy, Robert, 29, 53
Kent State massacre, 29, 74, 77
Kerr, Kay, 73
Kerry, John, 86
King, Coretta Scott, 38, 41
King, Martin Luther, Jr., 2, 5, 7, 11,
 18, 21, 29, 38, 41, 53, 121, 150,
 196, 210
King, Rodney, 121, 142–43
Kochiyama, Yuri, 109
Korematsu v. United States, 195
Kramer, Larry, 137

L

Lange, Dorothea, 2–3
Latinx activists, 52, 57, 82, 95, 158
Leary, Timothy, 44, 65
LEMAR (LEgalize MARijuana), 44
Lennon, John, 58
Lesbian Avengers, 144
Lewis, Ike, 2
Lewis, John, 17
LGBTQ+ activists, 3, 69, 118, 121,
 137, 144, 161–62
Lincoln, Abraham, 54
Little Rock Nine, 9
Living Theatre, 95
Louvre, 201
LSD, 44
Lyon, Phyllis, 66, 161

M

Malcolm X, 18, 29, 54
Malone, Tom, 129
Mandela, Nelson, 138
La Marcha de la Reconquista, 82
March for Our Lives (2018), 199
March on the Pentagon (1967), 34
March on Washington for Jobs
 and Freedom (1963), 21–22
March on Washington for
 Lesbian, Gay, and Bi Equal
 Rights (1993), 144
marijuana, 44
Marjory Stoneman Douglas High
 School, 199
marriage equality, 161–62
Marshall, Thurgood, 140
Martin, Bob, 69
Martin, Del, 66, 161
Martin, Trayvon, 176, 178
Mason, Sarah, 167
May Day protests, 89, 95, 169
McCarthy, Eugene, 53
McCloskey, Paul, 70
McDew, Chuck, 2
McDonald's, 206
McLaughlin, Sylvia, 73
#MeToo movement, 5, 206
Metropolitan Museum of Art, 201
Michel, Robert, 129
Milano, Alyssa, 206

Milk, Harvey, 147
Miller, Big Tom, 48
Million Man March (1995), 150
minimum wage, 175
Mondale, Walter, 121
Montgomery bus boycott, 5, 7, 11
Moratorium to End the War, 58
Moses, Robert, 2, 17
MoveOn.org, 149
Mulford, Don, 54
murals, 43
Murray, Pauli, 78
Museum of Modern Art, 117
Muslims, discrimination
 against, 195

N

NAACP (National Association
 for the Advancement of
 Colored People), 8–9, 150
NAMES Project, 147
NARAL (National Abortion
 and Reproductive Rights
 Action League), 121
Nash, Diane, 22
National Farm Workers
 Association, 32
National March on Washington
 for Lesbian and Gay
 Rights (1987), 147
National Mobilization
 Committee to End the
 War in Vietnam (the
 Mobe), 34, 37
National Organization for
 Women (NOW), 78, 134, 161
National Welfare Rights
 Organization, 41
Nation of Islam (NOI), 18, 150
Native American activists, 63,
 93, 190
Nelson, Gaylord, 70
New Right, 99
Newsom, Gavin, 161
Newton, Huey P., 54
New York Historical Society, 170
New York Taxi Workers
 Association, 195
New York University, 77
NFL (National Football
 League), 182

Nicaragua, 115, 122
Nineteenth Amendment, 78
Nixon, Ed, 7
Nixon, Richard M., 29, 53, 58, 74, 96, 99, 104
Nixon, Tricia, 53
Norman, Peter, 51
Nuclear Freeze campaign, 121

O

Oakland Community School (OCS), 85
Obama, Barack, 149
Obergefell v. Hodges, 162
Occupy movement, 149, 167–73
Odetta, 189
Ohio University, 42
Olympic Games, 51
Olympic Project for Human Rights, 51
Operation Desert Storm, 130, 133
Operation Dewey Canyon III, 86
Operation Rescue, 121, 134, 165
opioid epidemic, 201

P

Palestine, 164
Parks, Rosa, 6–7, 22, 150
Paul, Alice, 111
Peace Navy, 122
peace sign, 14
People for the Ethical Treatment of Animals (PETA), 126
Perdue, Sonny, 157
Picasso, Pablo, 154
Pine Ridge Reservation, 63, 93
Pink Saturday, 137
Planned Parenthood, 134, 165
Plessy v. Ferguson, 5
police brutality, 106, 121, 142–43, 157, 176, 178
Poor People's Campaign, 41
Port Huron Statement, 26
Powell, Colin, 154
Pro-Life Action League, 165
Pryor, Richard, 85
Purdue Pharma, 201
Pure Food and Drug Act (1906), 44
Pussyhat Project, 186

R

RAICES, 181
Randolph, A. Philip, 21
Rapinoe, Megan, 182
La Raza Unida, 82
Reagan, Ronald, 99, 112, 115, 116, 118, 121
Regional Council of Negro Leadership, 8
Reid, Eric, 182
Religious Right, 99, 121
Resendez, Freddie, 52
Resurrection City, 41
Rice, Tamir, 176
Rise and Resist, 202
Rise for Climate March (2018), 205
Roberts, Ed, 129
Robertson, Pat, 121
Robinson, Jo Ann, 7
Roe v. Wade, 99, 134, 165, 208
Roof, Dylann, 196
Roosevelt, Franklin D., 21, 109
Ross, Fred, Jr., 100
Run for Something, 181
Rushdie, Salman, 170
Rustin, Bayard, 21, 22
Rutgers University, 77

S

Sackler family, 201
same-sex marriage, 161–62
Sanders, Ed, 44
Sandy Hook Elementary, 199
San Francisco Bay, 73, 122
San Francisco Mime Troupe, 95, 122
San Jose State University, 51
Sarria, Jose, 66
Save the Bay, 73
Savio, Mario, 25
Sawyer, Tami, 196
Schlafly, Phyllis, 99, 111
Schneider, Lorraine Art, 61
school shootings, 199
Schumer, Chuck, 203
Seabrook Nuclear Power Plant, 104
Seale, Bobby, 54
Seeger, Pete, 20, 58

Selective Service Act (1948), 37
Self-Determination and Education Assistance Act (1975), 63
Selma to Montgomery March for Voting Rights, 31
Semple, Jock, 48
sexual harassment, 140, 206
Shelley, Martha, 69
Shook, Teresa, 186
Silent Spring, 15
Simone, Nina, 43
Sister District, 181
Smith, Casey, 165
Smith, Mary Louise, 7
Smith, Tommie, 51
Smithsonian Institution, 170
Sotomayor, Sonia, 195
South Africa. *See* anti-apartheid movement
Southern Christian Leadership Conference (SCLC), 5, 31, 34, 41, 78
Standing Rock, 190, 192
Stanton, Elizabeth Cady, 116
Statue of Liberty, 134
Sterling, Alton, 176, 182
Stonewall Inn, 66, 69
Student Nonviolence Coordinating Committee (SNCC), 5, 17, 20, 26, 78, 81
Students for a Democratic Society (SDS), 26, 78
Suh, Krista, 186
Summer of Love, 65
Swing Left, 181
Switzer, Kathrine, 48

T

Talbert, Robert, 2
Tavern Guild, 66
Teamsters Union, 90, 100
Tea Party movement, 149
El Teatro Campesino, 95
Third World Liberation Front, 63
Third World Women's Alliance (TWWA), 81
Thomas, Clarence, 117, 140
Thoreau, Henry David, 47
Three Mile Island nuclear power accident, 105

Thunberg, Greta, 205

Tiananmen Square, 176

Till, Emmett, 5, 6, 8

Tiller, George, 165

Till-Mobley, Mamie, 6

Title IX, 29

Tokata Iron Eyes, 190

Tometi, Opal, 178

Trump, Donald, 111, 151, 181, 182,
 185–86, 192, 195, 202, 205,
 208, 210

U

UC Berkeley, 25, 26, 77, 129, 138, 185

UCLA, 52

Underground Railroad, 5, 116

United Auto Workers (UAW), 151

United Farm Workers (UFW), 32,
 90, 95, 100

United We Dream, 181

University of Mississippi, 8

V

Vanguard Party, 54

Veterans Stand for Standing
 Rock, 192

Vietnamese National Liberation
 Front, 54

Vietnam Veterans Against the
 War (VVAW), 86

Vietnam War, 2, 14, 26, 29, 34, 37,
 51, 53, 58, 61, 74, 77, 86, 89

Voting Rights Act (1965), 12, 21,
 29, 31

W

Walker, Alice, 170

Walker, Robert, 38

War on Poverty, 29

Watergate scandal, 29, 96

Watkins, Hollis, 2

*Webster v. Reproductive Health
 Services*, 134

Weinberg, Jack, 25, 26

Weinstein, Harvey, 206

Wilson, Darren, 178

Wilson, Dick, 93

Window Peace Project, 116

Wolfe, Tom, 99

Women's Encampment for a
 Future of Peace and
 Justice, 116

Women's Health Action and
 Mobilization
 (WHAM), 134

Women's International Terrorist
 Conspiracy from Hell
 (W.I.T.C.H.), 53

Women's March (2017), 186, 189

women's movement, 5, 42, 78. *See
 also* feminist movement

Women's Political Council, 7

Women's Strike for Equality
 march, 78, 81

Women Strike for Peace, 14, 32

Wood, Grant, 47

Woodward, Bob, 96

World Trade Organization
 (WTO), 153

World War II, 109, 164

Wounded Knee, South Dakota,
 63, 93

Y

Yellow Panthers, 54

Yew, Peter, 106

Young Lords, 54, 57

Youth International Party
 (Yippies), 34

Z

Zimmerman, George, 178

Zuccotti Park, 169, 173

Zweiman, Jayna, 186

Copyright © 2020 by Melanie Light and Ken Light

Published in the United States by Ten Speed Press, an imprint of Random House,
a division of Penguin Random House LLC, New York.
www.tenspeed.com

Ten Speed Press and the Ten Speed Press colophon are registered trademarks of
Penguin Random House LLC.

Library of Congress Cataloging-in-Publication Data
Names: Light, Ken, author. | Light, Melanie, 1958–author.
Title: Picturing resistance : moments and movements of social change from the
 1950s to today / by Ken Light and Melanie Light.
Description: [Emeryville], California : Ten Speed Press, [2020] | Includes bibliographical
 references and index.
Identifiers: LCCN 2020004849 (print) | LCCN 2020004850 (ebook) | ISBN 9781984857583
 (hardcover) | ISBN 9781984857590 (ebook)
Subjects: LCSH: Social movements—United States—History. | Protest movements—
 United States--History. | Social movements—United States—Pictorial works. |
 Protest movements—United States—Pictorial works.
Classification: LCC HN57 .L527 2020 (print) | LCC HN57 (ebook) |
 DDC 303.48/40973—dc23
LC record available at https://lccn.loc.gov/2020004849
LC ebook record available at https://lccn.loc.gov/2020004850

Hardcover ISBN: 978-1-9848-5758-3
eBook ISBN: 978-1-9848-5759-0

Printed in Italy

Design by Isabelle Gioffredi

10 9 8 7 6 5 4 3 2 1

First Edition

LIGHT²
MEDIA

Cover image, ©Leonard Freed/Magnum Photos

Marchers joining hands in front of the Lincoln
Memorial during the March on Washington,
Washington, D.C., August 28, 1963.

Back Cover, ©Ken Schles

New York Immigration Coalition and partners
rally against the Muslim Ban, Washington
Square Park, New York City, 2017.